GALLERY OF ATHENIAN MARBLES.

Phigalian Marbles

Office

GALLERY OF EGYPTIAN ANTIQUITIES.

185 feet long

Quadrangle 238 feet by 317 feet.

The Library of Printed Books

Reading Room.

Gardens of the Houses in Montague Place.

300 feet long

THE ROYAL LIBRARY.

Officer | for Printed Books | Officer | Proposed additional Room for Printed Books.

Gardens of the Houses in Montague Street.

Those parts not shaded are the Buildings not yet erected.

Scale

200 Feet

Approach from Montague Place.

Ordered by the House of Commons to be Printed 14th July 1836.

James & Luke G. Hansard & Sons, Printers.

440.

GHOSTS

OF THE

BRITISH
MUSEUM

GHOSTS
OF THE
BRITISH
MUSEUM

A TRUE STORY OF COLONIAL LOOT AND RESTLESS OBJECTS

NOAH ANGELL

With Illustrations by Hendrik Wittkopf

monoray

First published in Great Britain in 2024 by Monoray, an imprint of
Octopus Publishing Group Ltd
Carmelite House
50 Victoria Embankment
London EC4Y 0DZ
www.octopusbooks.co.uk

An Hachette UK Company
www.hachette.co.uk

ISBN 978 1 80096 134 0

A CIP catalogue record for this book is available from the British Library.

Typeset in 12/16pt Garamond Premier Pro by Jouve (UK), Milton Keynes.

Printed and bound in Great Britain.

1 3 5 7 9 10 8 6 4 2

This FSC® label means that materials used
for the product have been responsibly sourced.

This monoray book has been crafted and published by Jake Lingwood,
Sybella Stephens, Caroline Taggart, Mel Four and Peter Hunt.

To all those spending an eternity in museum storage.

Dear, dear jackass! Don't you understand that the past is the present; that without what *was*, nothing *is*?

W E B Du Bois, *The World and Africa* (1947)

CONTENTS

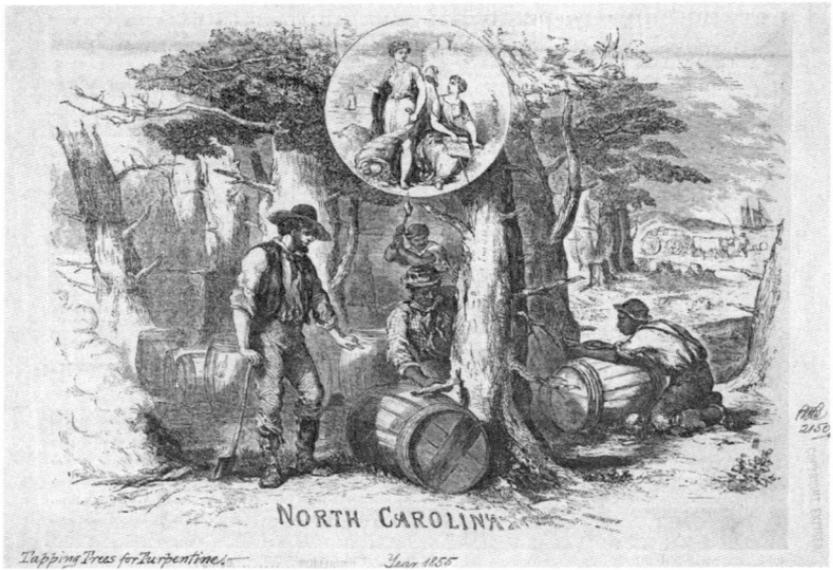

Tapping Trees for Turpentine. — Year 1855.

NORTH CAROLINA

From *Ballou's Pictorial*, 1855.
Image courtesy The Louis Round Wilson Special Collections Library,
University of North Carolina at Chapel Hill.

PROLOGUE

It all began in the pub – the Prince George or "the George" as it's called locally, nestled in the dense network of narrow, leafy backstreets connecting the Dalston and London Fields neighbourhoods of East London. It was the summer of 2015, and I was attending a friend's birthday drinks. Aside from the guest of honour, a curator I was working with at the time, I didn't know anyone present, and the acoustics were such that I couldn't hear a thing. The table of strangers I'd just been introduced to were miming an apparently exhilarating story. I was at a loss, smiling along responsively, all the while trying to puncture the bar-room cacophony of slurred voices, uproarious laughter, the clinking of glasses and the tabling of drinks. I couldn't catch a word to save my life.

I had to know what could possibly have everyone gathered around the table so absorbed in laughter, hanging on to each note of the unfurling yarn. I gave up my poor attempts to read lips and asked my friend what they were on about. She smiled, "We all went to uni together, and while we were studying together, we all worked at the British Museum. They're telling ghost stories."

I thought that was curious. I wanted to make sure that I understood properly; maybe my ears hadn't yet found their proper footing. "You mean, like, the museum itself is haunted?" She looked me square in the eye and nodded. I didn't interject. I didn't want to

trouble those seated at the table by asking them to run the stories back, they seemed to be having such a good time. No longer bothered by the pub noise, I resolved that soon I would learn these stories.

At this point, I'd already lived in London for a decade, and had still never set foot in the British Museum. Early on, in my naivete as a newcomer, I was under the mistaken impression that the British Museum was full of solely British things. Later I learned different but, whatever its contents, like most sensible people I tended to avoid situations where I'd come up against hordes of tourists. I worked in a museum for six years in Washington DC, and later on here and there as an exhibiting artist, but I never much liked museums. They smell faintly of death, and Lord knows there's enough of that in this world as it is, so for a number of negligible reasons, I hadn't yet got around to going.

My hunch then was that there must be a finite number – maybe a half-dozen or so ghost stories that everyone at the British Museum knows, that are often told, and that it'd be a relatively straightforward task to document them. At this time, my art practice was rooted in the study of oral tradition – song, storytelling and much more. I had hundreds of ethnographic field recordings on LP, and was beginning to get my feet wet in sound archives. I also began to develop a fascination with the form of the interview – I paid attention to the way the interviewer carried their ignorance, the fertile silences, what the subject concealed when they decided to reveal information and vice versa. I figured there might even be a few interesting mutations that occurred in the retelling of these ghost stories. I started asking around, to see who I knew with contacts at the museum.

*

At this point, I should probably rewind a little, and tell you about where I'm from and how my early years prepared me for collecting ghost stories at the British Museum.

I was born in North Carolina, a land of many ghosts, where the telling of ghost stories serves as a way of mapping the pain that is lodged in the land, and of paying tribute to those who have gone on, and yet are still with us.

Roanoke Island, located in the northeast of what is now called North Carolina, was the first place in North America to be colonised by the British, in 1584. This Lost Colony was a disaster by any metric. Everyone vanished, whether from starvation, assimilation, conflict or some combination thereof – no one knows why.

The word "Carolina" was derived from *Carolus*, Latin for Charles, in honour of King Charles I (1625–49), but back then the British considered all of the land that wasn't claimed by the French or the Spanish to be a part of one undifferentiated territory known as Virginia, named somewhat perversely for the "Virgin Queen", Elizabeth I (1558–1603). Colonial thinking frequently eroticises unconquered land by comparing it to a woman's body, just waiting to be overtaken and mined mercilessly for whatever value she holds. Needless to say, the many bands of Indigenous people who had already long inhabited this land did not recognise Virginia. They had little reason to concern themselves with these strange, faraway English monarchs, or their lack of experience in matters of love.

The United States of America as it was first formulated was a British colonial project – with the British imposition of 13 slave-holding states, the plantation became the backbone of the country's nascent infrastructure. The plantation system was upheld through extraordinary violence – torture, sexual abuse and killings materialised with dizzying frequency and in ever more jarringly

sadistic forms. All the while the planters played bossman, dressed up, drank and counted money.

Hans Sloane, whose collections formed the nucleus of the British Museum, was a planter too. His fortune was derived in large part from sugar plantations in Jamaica. I never lost sight of this fact as I walked through the British Museum. A planter isn't what the word suggests – they didn't plant a damn thing, but when harvest time came they were the only ones who saw a profit. Sloane's manic 18th-century accumulation would not have been possible without enslaved labour, without extracting the knowledge of the enslaved, or without the brutal destruction and reconfiguration of ecosystems that had sustained humanity for eons.

Beyond the plantation's borders, regimes of policing and other extra-legal forms of vigilante and mob violence were forged in accordance with planters' interests, ensuring that even Black people who had been born free or who had bought their freedom could be pulled back to the plantation, in a strong undertow refusing even a single step forward. In antebellum times, poor whites were commonly arrested for occupying public space on charges of vagrancy, loitering and public drunkenness. The planters feared that an alliance of the poor – poor whites, Native people and enslaved or free Black people – would topple the system that their wealth was premised upon.

My mother's side of the family were poor Irish who probably came over during the Great Famine of the 19th century – my late grandfather's grandparents were sharecroppers in East Carolina, and that's about as far back as anyone has any recollection of. My father's side were Quakers from up north; they left England, where they were considered blasphemers and a threat to the political order, so that they could attend their meeting houses in peace. The Quakers

were against the institution of slavery, and very often functionally tied in to abolitionist networks. I must have been around five years old when I became aware that, although my skin isn't dark, neither were we counted among the descendants of planters who frequented the country clubs and debutante's balls. Before I was able to add or subtract, I understood that catastrophe structured the only world I knew. I've been trying to work out what happened ever since.

As an adult, after years of living in London and getting a better grasp of British culture and politics, I sometimes found it instructive to understand and to frame North Carolina as a former colony, still reeling from the violence of the colonial era and its surviving institutions and actors. For instance, when we see police kill innocent, unarmed people in the United States today, especially Black people, we're reminded of the patterrollers, the armed slave patrols who were the prototype for policing in America, whose obligation was foremost to uphold the plantation system and to defend private property over human life. These extra-judicial killings can in many ways be seen as a legacy of the British-implemented plantation system. When I say that the plantation system is the backbone of the country's infrastructure, I mean not only economically and legally, but – and this is crucial – psychically too. Even after the economy shifted from chattel slavery, the plantation was internalised and unyielding, not only in the collective memory of the people of North Carolina, and in their knowledge of the land, but in the nation's psyche.

Moses Grandy, who was born enslaved in 1786 in Camden, North Carolina, and became a noted abolitionist, describes how when his mother became too old, "worn out" and blind to work the fields,

she was put out in the woods of the Great Dismal Swamp to fend for herself. He'd bring her food after dark, hearing her cries and those of other ailing, arthritic and forsaken elders mingling with the ambient sounds of the forest. Many who sought to escape slavery would spend years living in these same woods as maroons, birthing children, straining tadpoles from puddles for drinking water, and scavenging in muted secrecy, under the unending threat of a return to the plantation, where punishment could exceed death and leave the babies in bondage.

Such trauma doesn't wash away with the first rain. In the sediment of the forest floor, amid the disintegrated shade trees and dead leaves that not so long ago camouflaged makeshift caves, embers of past anguish are still aglow. From my earliest memories, I recall a sense of deep unease in this land, a gnawing feeling that was hard to reconcile with North Carolina's bountiful, florid natural beauty.

In 2016, I was in Eastern Carolina, riding a bike on Oak Island at night. On nights when there was a late low tide, I'd go down around midnight to the freshly firmed sand, where the waves had just receded back into the Atlantic, and there I'd glide along in the darkness, at the edge of the world as the island slept. On my way home, I rode past a long stretch of woods. There I was hit with a vivid impression, and realised that I'd had this same impression for years, whenever I had been to Oak Island, and had repeatedly put it out of my head. It was a vision of someone running out of the woods, swinging an axe with both hands, with all of their body weight arced behind it, looking to split my head open. Now, this isn't something I've thought of anywhere else. I asked myself if it was some sort of

fantasy I'd adopted – having my head split open is not the sort of thing I fantasise about – or whether there was some sort of reality behind this vision. I focused on this image as I would in meditation, hoping to detect if there was any substance to it. I tried to key into it, and the longer I tried the worse I felt, so I left it alone, accelerating as I pedalled on.

Days after leaving Oak Island, I told my mother about the axe-wielding man I saw coming out of the woods, and how it left me feeling disturbed. She told me that the Swains, a still-resident family who like to remind folks that they once owned half of the island, used to run turpentine encampments using enslaved labourers, and that they'd lost it all – their fortune, their operations – after the Civil War ended.

Turpentine is made from distilling the resin of live longleaf pines, hacking a "V"-shape into them with an axe and bleeding the sap, which is then collected and distilled off-site by naval workers. This immediately situated the image of the axe – in these sprawling turpentine encampments axes swung and split non-stop, splinters flying by the light of the sun, and by the moth-shadowed oil lamp and the moon. When conflict arose, the axe was at arm's reach, if it wasn't already in motion.

So, perhaps I had experienced energetic flashes of an axeman from the distant past. Up until Oak Island was established as a township in 1826, it was known as a wildlife refuge, which likely meant untrammelled exploitation and no one to hear the shooting. The "axeman" could have been a foreman gone mad, killing a worker to make an example out of them or to keep from paying them, or it could have been a turpentine labourer in revolt. My feeling was more the former, but one can't be too sure. The island only got paved roads about 50 years ago and nowadays lots of building

is taking place, so it made sense to me that the old energies were perhaps being roused. All I knew for sure was that I had definitely seen and felt *something*, and it wasn't the first or last time I'd pedal into a silent war on Oak Island.

When I was a child, it wasn't unusual to find Native American arrowheads and rifle balls from the Civil War while playing in the dirt. My still-forming fingers gleaned soil from off the rifle balls, disclosing them as misshapen metallic blobs, their shape signifying that they'd passed through something – that is, most likely killed someone. Over a half a million people passed on in the American Civil War. Ole Virginny would not again be confused with virgin land. Even once the blood seeped way down deep in the Earth's soil, defying retinal visibility, she was irrevocably stained. By the onset of the Civil War, the British Crown had long since been run out of the States, and in trademark fashion had washed its hands of it all.

As I got older, I was less compelled by archaeological evidence and increasingly grounded in the study of oral tradition which informed my work as an artist. North Carolina is home to vast bodies of vernacular song and speech that still circulate as living traditions. Field hollers, tobacco auctioneering chants, Jack tales from England, Br'er Rabbit tales from Africa, spirituals and ballads, and an endless, hyper-local body of ghost stories. Not only are the calamities of the colonial and antebellum periods and their aftermath reflected in our stories, but the oral cultures and theologies of the Irish, African, Native American, Scottish, English, German, Swedish and many others all coalesce in ghost lore. The haints are never far off. "Haint" is the vernacular word

for ghost used widely in the Southern United States, effectively meaning "one who haunts".

North Carolina's ghost stories are populated with warring, wandering and undisturbed Native people, lost and starved colonialists, pirates who shot it out with the law or were hanged, African-Americans who died enslaved, on the run or separated from family at the auction block, roustabouts, moonshiners, blockaders, highway robbers and those who died of a broken heart waiting for soldiers, sailors and seasonal labourers who never returned. It goes on and on. They've all been idling for centuries, reliving exit-less catastrophes, pulling passers-by back into former times, trying to get them to remember, to bear witness to what the ghost can't seem to forget, hoping that the witness, in perceiving their plight, will be able to offer a way home.

Haints are known to grandmothers and country schoolteachers, those given to sensing spirits and those with sense enough to know that time operates differently on the other side; it may seem late in the day here, among the hurried world of the living, but there's no expiry date for atonement. Ghosts call us back to the overlooked, to the unspoken, to unmet pleas, reminding us that we cannot simply choose to forget, that if the past isn't done with us, it will call.

That I was born into a world shaped by British colonialism and the long shadow of its plantation system wasn't really on my mind when I first set foot in the British Museum. The way I remember it is that I fell down a hole. I met with overnight and daytime Security staff, Visitor Services, collections managers, Storage assistants, museum assistants, administrators, curators, maintenance workers,

cloakroom and post-room attendants and auxiliary workers of all kinds – surveyors, tour guides and all manner of independent researchers. We met in quiet corners of the museum, in their homes, Back-of-House offices and in the pub.

Once I got home, I'd plug in the headphones and start transcribing the recordings. More memorable than the stories, their phrasings or pace, was the feeling, lightly fossilised in the museum workers' tone of voice, when everything goes sideways and they are no longer sure what's going on. It's the sound of the floor giving way beneath their feet, and the gravity of knowing suspended. These voices took up residence in my body. Every syllable stored away, kneading its meaning in the recesses of my mind.

Once I fell down that hole, as if handling a thorned object in a dark closet, I saw how the museum and my home state were intimately connected. I understood the museum and the plantation as twin pillars of colonial infrastructure. When colonial plantations, mines and labour camps were established, the people who were forced to work in them were in turn forcibly separated from their communal ways of being; their material culture was crated up and shipped off to museums abroad, where it was stored and presented as having been saved from extinction.

And, gradually, I came to understand that museums breed ghosts.

It's an open secret among museum workers that colonial and ethnological museums are prone to hauntings. It is also a matter of consensus across cultures that hauntings arise from untended trauma, festering in its irresolution, and made worse by on-going injustice in the world of the living. Perhaps simply to put material heritage in a museum is to make a ghost of it. After all, the creation of a collection often involves the violent or underhanded extraction

of artefacts from their original settings, and their indefinite exile as a mere object in the cell-like setting of the museum display.

Just as folklore abounds with hauntings by orphans, widows, prisoners, those separated from loved ones or those unable to return home, similar themes are found in the internal folklore of museum employees, among the orphaned objects that are amassed in their workplace. As I collected stories and first-hand accounts, I started to see that by attempting to force a split between an object – a piece of material heritage – and its rightful place in the world; by doing the utmost to sever the spiritual underpinnings of these collections from their longstanding keepers; and by reducing a presence with utility in this world, with people who depend on it, to "art", to a mere catalogued item, museums breed ghosts.

This book is a distillation of what I have learned and experienced over the past seven years of interviewing current and former employees of the British Museum. Some of these staff, who may or may not share my interpretation of the events that they experienced, have requested anonymity and, in a few cases, details have been altered to obscure those who appear within these pages. While I was writing the book, the institution became entangled in its own set of very worldly problems – suspected thefts, sackings, recriminations and resignations abounded. None of this is unconnected – this upheaval, like the staff's experiences of spirits, speaks to something dangerously out of balance in the heart of Bloomsbury. In light of all that has transpired, it's easy to understand why some people felt the need to withhold their identity.

I will take you on a walk through the British Museum: together

we'll survey a side of it that you haven't been shown before – its psychic underbelly. The chapters are organised according to spaces in the museum: gallery by gallery, through the Back-of-House and into the consuming depths of Storage.

If you're the praying type, now is the time to do so. I advise you all to enter the building respectfully, to practise at least as much discretion as you would upon entering a graveyard. Over the years, some visitors have come to mock the idea that spirits are present in the galleries, and have left with injuries. We've come to gather stories, not to trouble errant spirits, so be cool and step lightly.

In the British Museum I found that if you look past the displays and listen to staff, you'll find that the ghosts proliferate unchecked, each new acquisition potentially adding to the hive of psychic unrest. They stage revolts against keepers and warders, and stew in quiet corners and cellars, their exile-induced heartache building and breaking in the maddeningly idle tides of museological time. Many of the stories in these pages indicate that the ghosts simply want people to know that they are there, and so I try to trumpet their cries.

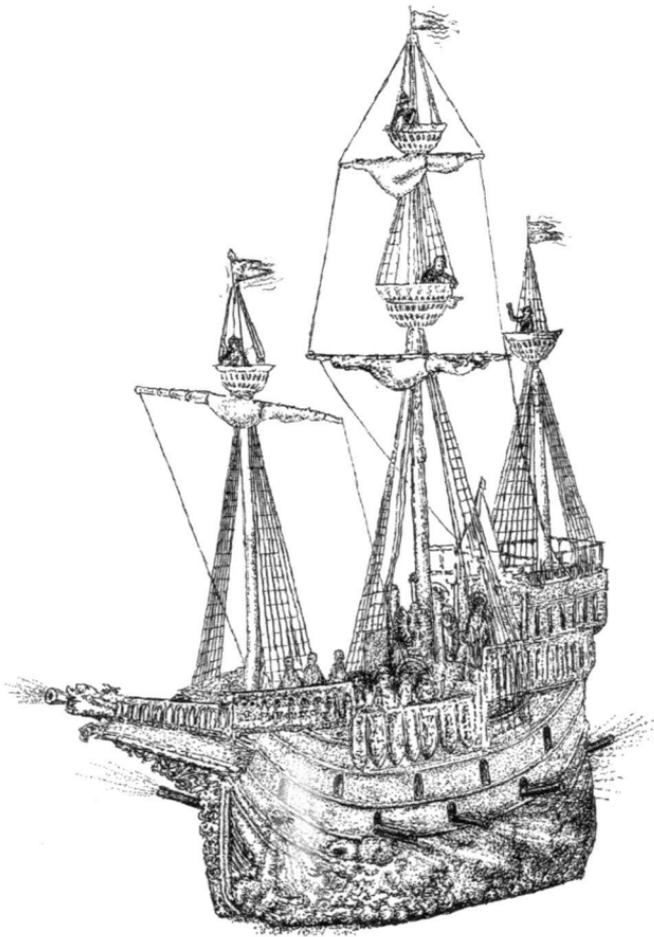

CHAPTER 1

"WHEN YOU PLAY A VIOLIN, THE VIOLIN RETAINS YOUR ENERGY"

With Hans Sloane's death in 1753, the British Museum comes into being. The executors of his will gather to decide where his collection will reside, so that it won't be broken up and it can occasionally be made accessible to scholars. With 63 influential friends of Sloane's acting as trustees, some of the collections are placed in the Bank of England's vaults while his executors approach Parliament with terms.[1]

Parliamentary debate focused on the running costs of the proposed museum, and the value of Sloane's collections, which were the subject of much scepticism and ridicule. Horace Walpole, writer and prime minister's son, wrote that "Sir Hans Sloane valued his Museum at four score thousand, and so would anybody who loves hippopotamuses, sharks with one ear, and spiders as big as geese!" Nevertheless, not wanting to lose the collection to the foreign institutions listed as worthy repositories in Sloane's will, in June of 1753 George II gave royal assent to the British Museum Act, and the government agreed to pay £20,000 to Sloane's daughters for 79,575 objects (not counting the plant specimens in the herbarium), a quarter of Sloane's valuation.[2]

The government settled on Montagu House as the site of the proposed museum. This was a decaying, damp and chilly residence in Bloomsbury, which had not returned to its former glory since surviving a fire in 1686, but the price was right. A national lottery was organised to fund the construction of the museum and the purchase of Sloane's collections, in which £95,194 was put towards the costs of the museum initiative and £200,000 paid out in winnings. Several high-profile figures of the day gamed the lottery by buying thousands of tickets under fake names, reselling them at a mark-up and multifarious other forms of profiteering. When one of the lottery managers was discovered to have grossed £40,000 by illegally purchasing thousands of tickets, he was dismissed from his post and ordered to pay a £1,000 fine. Even as the building was being conceived, before construction was underway, the British Museum was tainted by unethical dealings.

The British Museum island is a foreboding compound set in London's Bloomsbury district, occupying a bit over 5 hectares (about 13 acres) of land. The main entrance on Great Russell Street is its public face, immortalised in numerous films, postcards and tourists' camera rolls. The authoritative Greek revivalist-style building, designed by Sir Robert Smirke and completed in 1852, has a facade of Portland stone, and is lined with 44 columns in the Ionic order, each standing at a lofty 14m (45ft) high. The building is meant to announce the British Museum as the heir to the Western classical tradition, though it looks to me more like a government building with Greek pretensions. Tall iron gates weighing 5 tonnes apiece, with their pointy tips painted gold, mark the museum as not simply a house of learning, but a place of fortified knowledge. Clouds and

crows gather around its glass dome, held in place by cast-iron ribs, a thin veil and a skyward swell that takes on an emerald hue when photographed from above.

Past the iron gates, stanchions delineate queues that snake around the perimeter of the courtyard in a roundabout path towards the entrance, stopping momentarily in a tent, carpeted in blue with folding tables, a rainproof mini-border station. Waiting in the tent, it's a bit like being at the airport, standing between teachers nervously taking stock of their boisterous school groups, Soho residents out for a wander, taciturn researchers, loud Americans and visitors making a pilgrimage to see their own heritage. Rucksacks and purses are given a cursory rummage. "Anything sharp in there, mate?" the Security personnel ask, for what must be the thousandth time today. Those without bags are waved through.

The pediment high above the heads of the entrants, sculpted by Sir Richard Westmacott in 1847, depicts "The Progress of Civilisation", a left-to-right evolutionary mock-up that takes us from humankind's primordial origins through savagery, religion and art, arriving at the enlightened subject of scientific understanding, the museum-goer. The promise of progress hangs over the museum like a warning sign, unheeded by the crowds below, who surge ahead up the front steps.

The interior glass doors of the front entrance are propped open during visiting hours to make way for the continual flow of visitors. As soon as you step into the vestibule, you're at a crossroads of yet more soaring columns, stepping through blurred currents of museum-goers migrating at speed towards the cloakroom on the left and the Egyptian Sculpture gallery just beyond. Folded wheelchairs and scattered fire extinguishers are tucked into the front wall. A Roman caryatid stares down at you from the mid-level of the

South stairs, with stone lions from Turkey lying on either side of the vast chasm of a stairwell, gazing at each other like twins in a pasture. To the right, a gift shop mimics an exhibition space, hawking cheap facsimiles of artefacts on its glass shelves. A massive Perspex donations box shaped like a flying saucer and lit like a fish tank is full of wrinkled notes and pound coins.

Faint sunlight filters through the iron-webbed glass dome of the Great Court, illuminating the Reading Room, a cylindrical internal tower that forms the museum's pinnacle. Visitors take selfies in a landscape dotted with palpably lost giants – the Lion of Knidos, a big, docile, blind-looking marble cat with sunken eyes from 2nd-century Turkey; a regal cedar memorial pole for Chief Luuya'as of the Eagle-Beaver clan of the Nisga'a nation. This pole with majestic crests carved into it once communed with still-rooted cedars in the open air in the Pacific Northwest of North America. It's so tall that you wonder how they ever got it across the sea. There's a commemorative slab of sandstone from around 5th-century Ireland inscribed in Ogham; half of the Pharaoh Amenhotep III's head in quartzite, looking very alive nonetheless. The deep time of the museum is startlingly uneven. You quickly ascertain that the British Museum can't be seen in its totality, or known comprehensively – there's just too much going on. You're in the belly of a whale, bustling with other undigested and unexpelled beings. It's no place for study.

A standalone Perspex kiosk houses a waist-high stack of paper maps of the museum in case you need to steady yourself and re-establish exactly where you are. At this point I could reliably draw a map of the British Museum's floor plans from memory – from the Enlightenment gallery and the Parthenon sculptures flanking each side of the ground floor, to the Upper Egyptian and European

collections occupying the North and South quadrants of the top floor, and most points in between. But truthfully, I don't experience the British Museum in this way, as a place unto itself. The shards of place, the "objects" in the museum, are much more distinct. I experience the British Museum as a void, a black hole. Like a hermit crab, this void has made a home inside a Greek revivalist architectural shell. The void captures other times within it – it has a sinister gravitational pull all its own – but even when I began to understand some of its inner workings, and to hear about the museum as a workplace, the void grew much louder still. With a mere 1 per cent of an "estimated" 8 million artefacts on display, the British Museum is only marginally an exhibition space; in material terms it's mostly a site of disappearance.

There's a raised, circular information desk nearby where three or four Visitor Services staff lean forward, eager to help visitors find their way. A woman who worked at this information desk in 2016 taught me that every museum worker who encounters this phenomenon of ghosts, of haunted museums, however we come to understand it, does so at the level of their labour. For Visitor Services staff, who are tasked with opening and closing the museum, keeping watch over the galleries during visiting hours and interfacing with the visiting public, this sometimes means that gallery-goers come to them after an encounter that's left them shaken, seeking an explanation from the first person they see in uniform.

I came into contact with this Visitor Services staff member after a prompt was posted on the museum's internal message board on my behalf, asking if I could meet staff with knowledge of the British Museum's ghosts. She agreed to meet so long as she was granted anonymity, as she was worried the museum might not look kindly on those who air its secrets to outsiders. We sat on a stone bench on

the front porch during her break and had coffee in the long shadows of the late-afternoon sun. She was curious as to why I was collecting the museum's ghost stories and apologised for only having one first-hand experience to share.

In 2015 a Dutch couple approached the information desk in the Great Court with one of their phones out. Visitors frequently come to the desk phone in hand, flashing an image of the object they wish to be directed to, and so my interlocutor greeted them expectantly. This couple, however, was not asking after the location of an object or gallery, but an explanation for something unusual that appeared in a photograph they'd just taken.

They breathlessly explained that they had just come from Rooms 38 and 39 – the Clocks and Watches gallery, two dimly lit rooms of tall, stately timekeepers swaying hypnotically, alternately ticking together in quiet unison and brimming with discordant, ceremonious clanging. They foregrounded the camera-phone image by noting that it was an overcast day, and that no one save themselves had been present. That is to say, there was no sunlight to stimulate the photographic distortions resulting from interfacing panes of glass, nor any stray figure in the gallery whose image could have been caught up in the gallery's reflecting tangle of glass cases. The couple showed the Visitor Services worker every photograph that they'd taken in the Clocks and Watches gallery in sequence; each shot was "normal", until they reached the Mechanical Galleon.

The Mechanical Galleon is a nef, an elaborate article of clockwork automata in the form of an ornamental warship. Crafted in 1585 by Hans Schlottheim of Augsburg, southern Germany,

this nef once belonged to Augustus, Elector of Saxony. In the 16th century, rich heads of state were enraptured by warships, the technological revelation that brought them their wealth and enabled European expansion. They commissioned miniature warships as monuments to their own power, to be admired as table-top displays or, in the case of this wheeled galleon, rolled across a lengthy banquet table for Augustus to show off to his guests. Its automata include an inbuilt music box in the form of a wind-up organ below deck. Soldiers perch at the bow and atop its hoisted sails, keeping watch while 16 cannons poke out of its sides, just above the waterline. Centuries ago, these mini-cannons were stuffed with gunpowder and made to fire before guests by attendant servants. Sitting on a golden throne in the midst of a raised platform is a miniature Rudolf II, the Holy Roman Emperor, encircled by a procession of the seven electors (including Augustus of Saxony) who appointed him.

The Mechanical Galleon is a model of an empire's inner circle, deterministic as a model of heavenly bodies in orbit, divinely engineered to steer a sea vessel that would have been readily understood during its time as a metaphor for the state, floating as if by birthright above the world whose labour and resources fuel its ascent. At the Emperor's feet is a cyclopean clock face, denoting that nothing is more foundational to the imperial endeavour than the power to shape time. The imagined trade winds that would have propelled this nef were the type to carve out seasons of mass labour across continents, time zones to coordinate harvest and trade calendars, and leisure time for its planners.

When the Dutch couple photographed the Mechanical Galleon,

a figure appeared – glaring back in sharp focus, as if a reflection from the surface of the glass case. It was a woman, or perhaps a young girl, a bit "like a dwarf". She smiled mischievously, "as if she'd just told a joke". Clumps of her hair were missing, as if they'd fallen out. She had strange clothes on – the warder was confident that they were from the 16th century, that is, consistent with the period of the Mechanical Galleon. The warder was stunned by the Dutch couple's approach, and double-checked that there hadn't been a child in the gallery; they were adamant that they had been completely alone and, from the rhythm they were tapping out on the counter, it was clear they wanted answers. It was a digital photograph, the warder thought to herself: if it were film it could be a double exposure, but this is not so easily explained.

"You said she was smiling as if she'd just told a joke?" I asked, tickled by this detail.

"Yeah, maybe like, 'I'm going to be in your picture!' ", confirming with her own mischievous laughter that the figure appeared to be photo-bombing the tourists. I laughed along with the warder on the museum's sunlit front porch, but the Dutch couple had found no humour in the incident.

"And so they asked me, 'What do you think? Because you know, we can assure you that it was empty – *no one* was around . . . ' "

This is a dilemma familiar to several museum workers I've spoken with. They're put on the spot, asked to explain an anomalous, sometimes frightful photograph taken only a minute before and that they've only just laid eyes on. The warders would like to comfort the visitor, but they too are baffled, and constrained by their position as a representative of the museum, "What can you

say to that?" the warder asks rhetorically, bewildered. They stare at the photograph alongside the visitor, struggling to improvise a response, until the visitor realises that no words of comfort will be forthcoming, at which point they thank the warder and head for the exit.

This particular Visitor Services worker would not be caught flat-footed. "I sent them to the Spiritualist Association of Great Britain. It was founded by Arthur Conan Doyle, who was very fond of ghosts." Perhaps there someone more qualified, someone whose training covered the behaviour of ghosts, could be of better service to them.

Most of the museum workers I've spoken with do not self-identify as believing in ghosts. They're alert, vigilant that anything out of the ordinary could constitute a security breach. If an alarm goes off without apparent cause, if a visitor is seen in a space where they shouldn't be or an entranceway is blocked or left unbarred against operational protocol, the incident has to be pursued until a cause is established. What does seem to be a matter of consensus among museum employees is that "objects hold energy", an oft-repeated formulation that encompasses and bypasses questions of belief, while acknowledging the power of the material heritage that dominates their workspace. Haydyn Williams, a former research assistant at the British Museum, put it that, "Objects carry memories, same as people do. They inherit feelings, if you like, recorded in them."

The warder at the information desk positioned herself on the permissive end of agnosticism, recognising that the senses have their limitations. "I don't exclude anything because you cannot see it, or

you cannot touch it. When you play a violin, the violin retains your energy, and the energy of people who've played the violin before, so I don't exclude that there can be something attached to an object, or a particular environment. Maybe that was someone near the clocks at the time that they were made, but to be honest I don't know."

She asked if I'd like to go and see the Mechanical Galleon. In time I learned that when a museum worker offers to take you to the site of a haunting, additional information comes to the surface. As we got up from the bench on the front porch and made our way up the South stairs, towards the Clocks and Watches gallery, she told me that in addition to her conviction that the costume in the photograph was from the 16th century, in Spanish paintings of that time, particularly in the works of Velázquez, we find little people as jesters, hired to entertain at the royal court. This practice stretched across European gentry in the medieval period, and the physique, costume and playful smile of the figure in the photograph suggested to the warder that they may have indeed been a jester, someone who once shared a place at court with the Mechanical Galleon and who performed such pranks as a career during her earthly life.

"I still remember that face," the warder laughed, drawn back to that peculiar smile as she peered around the glass that holds the Mechanical Galleon. Searching, as if for a silk strand of an arachnid's web, or a scratch in the faultless gleam of the vitrine, neither materialising, and no sly smile.

I heard this story early in the course of my interviews with museum staff. In digesting it, I was struck that at first glance the Mechanical Galleon is a fundamentally ornamental object, without any apparent sacred function, or known history of trauma or theft.

If the Mechanical Galleon is unquiet, the same could be true of any of the millions of so-called objects held here.

The warder's observation that "When you play a violin, the violin retains your energy, and the energy of people who've played the violin before" stayed with me. This phrase stood as an early and eloquent explanatory framework for why we experience museums as haunted, and a testimony that some notes carry far and can't be unplucked.

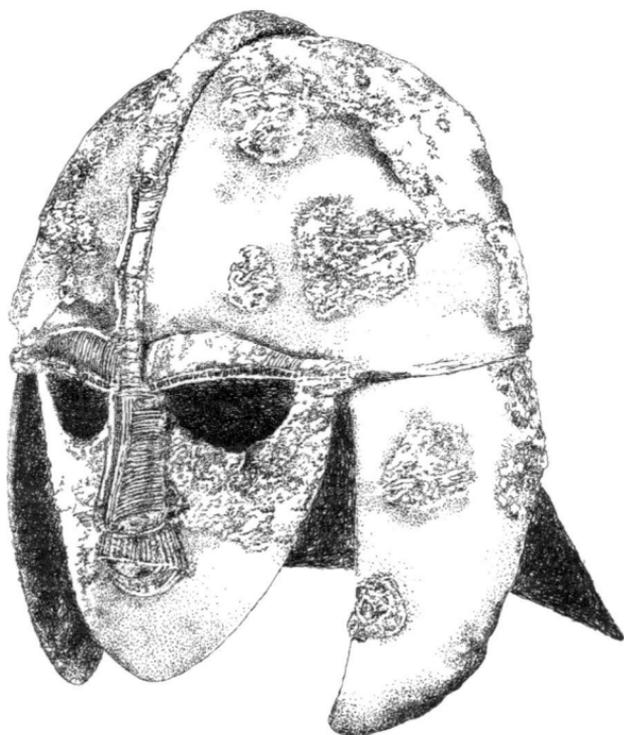

WHO RUNS SUTTON HOO?

Room 41 of the British Museum is known as the Sutton Hoo gallery. A tower block of conjoined vitrines looms over it, containing the contents of two burial mounds uncovered at Sutton Hoo, a windswept heath in Suffolk, where the Anglo-Saxon king of East Anglia was inhumed in a ship burial in the early 7th century.

In the summer of 2022, I spoke by phone with Haydyn Williams, an Irishman now resident in Scotland, about his time working as a research assistant at the British Museum back in the early 1990s. In those days, he was a lanky punk in his late twenties, clad in chains, Celtic bracelets and Doc Martens, who never quite fit in at the BM, and was known as the "torc of the department", on account of the protective pendant he wore around his neck.

Williams once oversaw the Sutton Hoo archive at the British Museum, and was able to confirm a bit of lore that I'd long heard intimations of. Edith Pretty, who owned the land in Suffolk that the earth mounds sat upon, said that in 1937 she saw a free-floating march of torchlights gathered around the reedy entombment at night. Williams noted that this sighting had a compelling logic to it, since "there would have been a torchlight procession around the ship". These flames, unsupported by human hands, tarried alone in the night air, replaying the rite of the king being lowered into the ground with his afterlife accompaniments.

The sight of these roving torchlights stoked a curiosity in Pretty.

"She wanted to know more about what these mounds were," Williams continued. "She had seen these lights and she couldn't understand them, because she didn't think the phenomena was natural, and she didn't think that the mounds were natural either." Pretty hired Basil Brown, a local self-taught archaeologist, to initiate the dig at Sutton Hoo in 1937. The next year the British Museum moved in and appointed Charles Phillips to take over the excavation, once it was determined that they were Anglo-Saxon burial mounds, rather than the more commonplace ship burials of the Danes who ruled parts of England a few centuries later.

The discovery of the Sutton Hoo burial site reshaped historians' and archaeologists' conception of early medieval Britain to a degree that can hardly be overstated. Nothing remotely like it had ever been found before: the trove's still-legible details illumined the East Anglian king's time in a way that was unimaginable before Basil Brown got his fingers in the muck.

The ship's 27m (89ft) long frame had rotted over a millennium in the soil, yet its shape was perfectly preserved in the blackened sand underneath. The chamber grave was located under the ship's belly, set within a bouquet of accoutrements: drinking vessels, Byzantine dining utensils, gold coins and fine textiles, and jewellery set with garnets from as far afield as Sri Lanka and India.

The human remains at the core of the chamber grave had long since dissolved in a mixture of rainwater filtered through sandy soil, flooding the burial chamber in an acidic bath that ate away at the king's bones. The body of the king is not so much absent as diffuse, permeating his belongings. All of the grave goods were arranged with purpose around the monarch's body. He wore a belt buckle of 400g (14oz) of gold – probably not coincidentally the contemporaneous unit price of a nobleman's life. A strong showing of wealth for an

ordinary man, but a mere accessory for the inhumed ruler. An ornate and unwieldy wooden shield and a long, smooth sharpening stone adorned with carvings of human faces and a mounted mini-stag lined the west wall of the chamber grave, positioned near the king's head. An engraved, bejewelled sword lay at the ready.

The centrepiece of the Sutton Hoo collection is an iron helmet with an armoured face whose imposing nose, lips and eyebrows double as a flying serpent, cast in highly stylised bronze. Pagan and Christian, Nordic and Roman motifs of boars, dragons and warriors incised in vestiges of intricate comic strip-like tableaus read like passport stamps granting entry to battlefields, underworlds and aftertimes. Despite the helmet's eyes being hollow, they hold a deep, cavernous gaze. I've often seen visitors stand transfixed on the gallery floor, staring back into the helmet as if caught in a beaming vacuum.

The dig was carried out under the time pressure of impending war, within the phantasmic threat of German warplanes parting the clouds above and disrupting the excavation's delicate proceedings. News of the dig was a rallying point during the war, but any acknowledgement of shared Anglo-Germanic heritage was avoided, for fear of complicating nationalist narratives, and thereby undermining the war effort. Today, the Sutton Hoo horde is frequently presented as an emblem of British national identity, despite the fact that it pre-dates the political formation of Great Britain by over a thousand years, and far more reflects the culture of Germanic peoples who had only recently settled in England. While German warplanes were not to scupper the dig at Sutton Hoo, they would soon strike the British Museum in the Blitz.

*

The doors that border and enclose Room 41 are of tall, 200-year-old oak, standing at some 3m (10ft) high, and they're heavy and stubborn. They're said to be "fireproof" too, as they would take four hours to burn through. "You have to really put your whole body into them, just to shut them," one warder told me, leaning in with their shoulder square to the make-believe door between us.

Once again, museum workers meet these hauntings in the course of their labour; for those who open and close the Sutton Hoo gallery, the "spirits of the place" are known to make a plaything of these doors. In order to secure them, the warder shuts one door, holding it in place and twisting its handle, which sends bolts into the floor and the arch of the doorway. They then close the second door, twisting a key that bolts the doors into one another. It's a well-choreographed bit of tedium that Visitor Services and Security staff perform with a dutiful groan, but the daily unlocking and locking up of the Sutton Hoo gallery is not without its unnerving surprises.

One anonymous warder recounted locking up Room 41 at the close of day as if mentally striking tasks from a long-internalised to-do list. "We've locked it all up, carried on, control have confirmed that all the alarms are on, that we're done with that area . . ." The warder then headed down to the front gate to relieve a colleague from their post so that the colleague could have a short break. As they sat under the fluorescent light of the Security booth by the front gates, the control room radioed again, to ask the warder if they'd locked up Room 41. The warder, who was friendly enough with the control-room personnel, couldn't help but take this as an affront, calling their work into question. "Yeah, of course we locked them," they radioed back. "How would you have set an alarm if they weren't locked?" The control room responded that, in any case, the doors were open. Irked and in mild disbelief, the warder left the front gate

to find that the doors were indeed open wide, and then made their way down to the control room to examine the CCTV playback.

"When we reviewed the CCTV back, you can see me and my colleague walk through, and then these doors, you see them just go like that . . ." The warder uncrossed their hands, their fingers spreading slowly apart. "Opening up for no reason whatsoever. You'd need a very, very big breeze to open them up like that."

The doors of the neighbouring galleries remained closed and locked throughout. No alarms went off; in fact, it seemed that the alarm for the door in question was deactivated when the doors opened. The warder and I sat outside the lecture theatre underneath the Great Court, eyeing each other with a rekindled disbelief. I've heard many museum workers puzzle over how such heavy doors, which sometimes refuse to close, can open in the absence of a key holder. Another warder, who recalled a near-identical incident in the Sutton Hoo gallery, wholly rejected any possibility of wind blowing the doors open. "Someone tried to put it down to wind. Well, if it was wind, how is it that the other doors didn't open up? Where would the wind come from?"

Opening on their own isn't the only strange behaviour exhibited by these doors. According to yet another warder, "Between Rooms 42 and 41, the doors were notoriously old and warped and difficult to shut. We got the one door, but then it just wouldn't quite meet the other, and so my colleague slammed it, and kept slamming it, and then all of a sudden, the door that was closed flung back open. He felt something push against his chest." The warder pantomimed a wrist thrust forth from between the doors, pushing into his colleague's sternum and launching him – "a big lad" – into the air. His supervisor watched helplessly as "he got knocked right back off his feet, and onto his backside. And then the doors slammed. Bang!"

Yet another former warder had an identical experience closing up Sutton Hoo: "She felt something push her on the chest. She ended up sitting on the ground, and she screamed."

Accounts of the doors' forceful and contrary ways are plentiful. Some warders even report that sometimes the doors feel like they're being pulled from the other side. One warder told of a supervisor who radioed for back-up and was found cowering alone in the far corner of Room 46, refusing to walk back through the gallery alone, asking the warder who'd come to their rescue if they'd seen anyone on their way in. They found the door to 45, which they had never seen open before, ajar, and when they went to lock it, a door that they'd only just locked inexplicably popped open. It felt like a trap, like being lured in only for the spirits to toy with them, a spectral flex to let them know who really holds power inside the museum.

I first met Patsy Sorenti on a cloudy Saturday afternoon at the start of November 2019, the type of cloudy day that convinces everyone under it that something immovable is blocking London's light; the cloud cover refuses to break in your favour. I was conducting a walking tour of the British Museum, where I practised telling the ghost stories I'd collected thus far, varying the pauses, timbre and details to test the material, to see what connected with the different groups who showed up. That day my audience was mostly occultists, middle-aged with thinning hair of varying lengths and black jackets, people who prided themselves on their esoteric knowledge, but were happy to be thrown a curveball. The trains were delayed and I arrived at the information desk in the Great Court with a thin sheen of sweat and a quickened pulse, an egregious 15 minutes late for my own tour. After apologising to the group, I was introduced to

Patsy, a psychic medium and historian of the Anglo-Saxon period. Patsy is a warm and supportive presence, with chin-length brown hair and bright eyes. Along with her husband Ricardo, a lean, still and attentive Italian, she has published *Haunted Hounslow and Feltham* and *Ghosts of Brentford and Isleworth*, works akin to the sort of hyper-local ghost lore I was engaged with at the British Museum.

During the tour I noticed Patsy silently flitting about at the margins of the group, rather like a cat following something unseen, only much more restrained. I could tell she was reading the energy of the gallery spaces. She told me afterwards that I had a lot of "spirit people" around me. I told her that I pray like hell every time I go in the museum and that I was glad that someone had showed up. She then asked if I had a friend who passed early on in life.

"You'll have to give me more to work with, Patsy," I chuckled, not wishing to challenge her. "You've got to remember, I'm from the States. I've got a few friends that died young." I felt a tinge of shame, aware that I might sound cavalier, while a shallow grief welled up in my chest.

"His name starts with a 'T', and he's always been with you, ever since he passed." Patsy said it as if he'd been looking out for me, like I should know that I always have a friend nearby. I drew a blank, raised my bottom lip and shook my head. "T"? Naw, no one came to mind. We went for drinks across the street at the Museum Tavern. I'd head to the pub with whoever came along on the tour, to get their read on the material, to hear their stories and to receive tips in the form of beer after an hour and a half of storytelling. After a couple of hours, when the occultists had cleared out, I was sitting in a red leather booth with the last remaining couple, who were American. They were friendly and we'd been chatting for a while, but I hadn't

gotten around to asking them where they were from. Maryland, they said. Whereabouts? I inquired. I lived in Washington DC for six years and knew a bit about Maryland.

"There's a windy country road in Bowie, Maryland" – pronounced *boo-ey* – "that has a lot of ghost stories associated with it. A lot of people died on that road."

I actually knew Bowie, Maryland. It's about halfway to the Eastern Shore from DC. My friend Tom, who I went to school with at the Corcoran, was from out that way. One night in 2003, he hopped in a hatchback and hit a fire truck head on, on that same road. We were close, but his passing affected everyone I graduated with, and the teachers too. Sitting there in the pub, it was as if the couple had stayed behind to remind me of that windy country road. I've felt Tom's presence many times over the years. He still shows up in my dreams like a groundskeeper or neighbour who's just passing through to make sure that everything's okay. After he passed, there were times late at night when I found myself speaking to him, when the landline would ring once and then a dial tone sounded when I picked up. The odds of meeting this couple from Bowie, just after Patsy asked me about someone whose name began with a "T", were minuscule. Now I knew exactly whose name started with a "T" and, from that point on, I knew Patsy was for real.

A week after our initial meeting, Patsy sent me an email, kind as could be, showing her enthusiasm for exploring the museum further.

"You know, at times, I felt rather queasy and ill-at-ease in some of the galleries, especially the one with the mummy remains. I am

quite convinced that some things lurk just behind the doors, out of sight, just waiting and watching. I think these things wait their turn, emerging when everyone has left for the day." She asked if I'd be interested in speaking to the ladies group she belongs to and signed off "Cheerio, Patsy Sorenti."

By the time I met Patsy, my modest inquiry had ballooned and I was four years into interviewing staff about their experiences of spirits in the museum. I had planned to take a medium around the building after I felt I had a sufficient base of stories, to see how their readings might map onto, correlate with or diverge from the narratives I knew. I'd met people who'd offered to bring in ghost-detecting devices, but I was less interested in what those contraptions were able to register, and more interested in what people see, hear and feel, and the histories underlying these sensations. In any case, one of my best friends was training as a medium, so I thought I had a pretty good idea of how it worked. But Patsy really surprised me. She was no beginner, and her readings added considerable dimension to the warders' mounting storylines.

On a Sunday morning in February 2020, just weeks before COVID-19 made its way to London and emptied the British Museum of visitors for a long spell, I found myself strolling there with Patsy and Ricardo, who worked together as a team, to gather readings of the galleries.

The technical term for the practice of reading the energy of a physical object is psychometry. Mediums will sometimes request that the person they're reading for bring a photograph of the deceased, allowing them to see their still-speaking eyes, or an object that bears their energetic investment, something that they once handled. For some mediums, this provides an "in" if the signal is otherwise unsteady. In the museum, where touching the artefacts

is prohibited, a distanced variant on this practice would be termed "remote psychometry".

Patsy has a gift for connecting to the spirits that "come along with" or "are attached to" material heritage. She'd whisper effusively, "Thank you, darling, thank you, thank you so much" to a nearby, impalpable presence and relay to me her findings. I'd listen attentively, attempting to fine-tune the incoming information by zeroing in on details and teasing out undercurrents, while Ricky mostly stood quietly at a distance, with an air of focused support. Patsy was in rapt conversation with the spirit stewards of ancient Persian instruments when we ran into my buddy Stuart Westerby.

Stuart has been in the Visitor Services department for over 30 years. A South Londoner who's now in his early sixties, he has the slightly frazzled, still eager-to-assist manner of someone who's spent decades on the museum floor.

Stuart wanted to have me along for a pint with his mate Ned. Ned is the supervisor who stood by and watched the "big lad" who was propelled by an unseen force and took flight in the Sutton Hoo gallery. Stuart explained that in 2005, around the time when the kid went flying, the Medieval Christian Relics gallery was in the process of being converted into the Islamic gallery.

"This is the old 42, before they knocked it all down to make it into the Islamic gallery," Stuart wanted to clarify.

Patsy was zeroing in on something. Stuart further explained that during this period, not only was the Medieval Christian gallery demolished, its relics were moved from Room 42 across the floor to Room 40. This clearing of Christian relics made way for the Islamic gallery, which is now in Rooms 42 and 43. Sutton Hoo was unchanged, it was merely in between the two galleries that were being remodelled.

After following Stuart's words with rapt attention, Patsy started to speak in low, rolling tones:

"They shouldn't have been moved. They should not have been moved . . . This is all about religion, this is all about religion, and this is all about . . . not a Knights Templar, but something like that." Her repetition seemed to serve the purpose of steadying the signal. Patsy took a deep and controlled breath and, like locking into a station on a radio dial, she began to speak for a nearby spirit. "Whoever was looking after that, whoever was linked to those objects, maybe more than one person, has got the hump, because you swapped Christianity for Islam, and in the medieval world, in those times, that was the devil. Because you represent the people who work here, therefore, ergo, you are responsible. That's why the doors closed on you, and that's why your man was thrown. That's what it is – you've replaced Christianity, you have replaced it with something that's a devil to us. You displaced us for that."

According to Patsy, the worldview of those who ejected staff from the Sutton Hoo gallery is suspended, with no regard for the passing of centuries, in the prejudices of the medieval world. These bear a vexingly close resemblance to those of our own time, and a crusading spirit is running wild as a buck through the galleries, in a conflict catalysed by their holiest relics being switched around and displaced by those of their earthly enemies.

After curators at colonial museums research, catalogue and prepare artefacts for exhibition, they retreat to their offices in the Back-of-House. Here, at a safe distance from the galleries, they are able to overlook the energetic import of the collections that

they work with – what the artefacts bring into the museum as live carriers of memory. For warders, cleaners and Overnight Security staff this is not so easily done.

It is the lower-waged employees who spend the majority of their working hours on the museum floor, and the frontline museum staff who are driven out of the galleries. The "big lad", the airborne warder, quit his post at the museum soon after being hurled across the floor. He is one of many who never felt quite right working there, and who slipped out the back door without fanfare when their misgivings were confirmed, in a slow-drip exodus from the museum's ranks.

Warders hesitate to assign a cause to their experiences, but are quick to point out that the Sutton Hoo horde was excavated from a subaltern resting place, which may have been better left undisturbed. Even domestic grave-robbing runs the risk of producing disquiet in the unearthed artefacts. On top of that, "We have Oliver Cromwell's wax death mask in Gallery 46," one warder pointed out. "Or we have a cast of Napoleon's death mask in 47. So, there is a theme of death." Wax casts peeled from the cold cheeks and blueing lips of some of Europe's most prominent warmongers are just a sample of the potentially malefic presences in the galleries numbered in the 40s. But there is another dimension still to the hauntings there. A one-time Visitor Services supervisor who I spoke with related a particularly memorable episode that occurred at closing time:

"We'd cleared all the visitors out, my team had left to go and I was just hanging around to have a last sweep of the area, to make sure we were clear of the public and everything else, because the galleries at that time were full of nooks, crannies and hiding places.

I'd locked every door, and done a sweep to make sure I was alone."
He had paused in the gaze of the Sutton Hoo helmet, as I've seen
so many visitors do, and then "from nowhere, I felt someone run
past me very close behind, from left to right. I could feel the wind
of it, and I felt the floorboard creak, and give under me, and move
me a little." A further sweep of the area showed that there was
"absolutely nobody there, all doors were still locked. I was the only
one in the area."

This encounter caused the warder to reconsider the museum, not
only as a place that houses objects, but as a storeroom of bottled and
unbound energies.

"I'm not really either side of the whole ghost thing, but it made
me think about what associations the objects in that gallery might
have had, and what had come along with the actual physical objects
themselves," he said. As he collected himself, in the wake of the ghost
sprinting past, questions arose: "If there are things associated with
people, where would they sit? Would they stay where the person was,
where they died? Or would they move on with the artefact of that
person? Certainly, these things are designed to have some kind of
resonance, they're important to people. So, I don't know."

In the spaces between the supervisor's questions, I heard the
question the warder asked earlier – "Where would the wind come
from?"

On that same Sunday in February 2020, a little later in the day,
the Sorentis and I were standing not too far from the Sutton Hoo
helmet when Patsy said, "There's a man running through here."
I must have blinked, stiffened or let some sort of reaction slip,
because she immediately sought to clarify. "Yeah, there's a running

man. I'm running. I'm running." Patsy's low, rolling tone now took on the rhythm of the cyclical tumble of feet gaining speed. "There's a running man. There were two spirits here, Noah . . . One's a suicide. One's a suicide. I'm deliberately jumping off, from a high place."

My stomach sank. I tried to play it cool and not let on. I nodded solemnly and led the Sorentis from Sutton Hoo through Room 40 – now Medieval Europe – to the viewing platform at Gallery 36, the balcony near the cafe, where tourists lean over the top of the silver rail, taking selfies with the Great Court as their backdrop.

In September of 2000, a young man from abroad flung himself over the railing, landing 13m (43ft) below, smack onto the marble floor, in the path of the museum's main entrance. An average of 17,000 people a day visit the British Museum, and the majority of them enter here. It's a wonder he didn't land on one of them. The incident was kept out of the papers. The consensus among staff was that someone well connected at the British Museum made a call to ensure that the story didn't run, but everyone remembers where they were when he hit the floor. Visitors were corralled away from the scene, staff in the Back-of-House were unaware of what was going on, but were asked to stay in place until further notice. In the one scant, searchable trace of the suicide found online, in a thread on the Londonist website titled "Suicide Attempt at the British Museum?", staff and visitors confirmed the incident.[1] "The images of his broken body on the floor of the Great Court will stay with me for a long time and sadly it'll be the same for the visitors to the museum on that day (some of them with children) who had to witness it." Another poster to the site recounted "the stress of being crammed up at the back of the museum with a huge

crowd clamouring to be let out" as the young man was loaded into the ambulance.

"I can remember this great big crash. Thud. A loud echoing around the Great Court," recalled a warder who was on the scene that day. "I didn't see what happened, but I hear this echo, and then these Japanese tourists come away from the viewing area and they're shrieking, they're screaming. A woman in particular is, is just shrieking uncontrollably."

"He's the one who runs." Patsy was tuning in as she looked over the railing. "He's the runner. He's the runner . . . I've got to do it. I've got to do it. He's the runner. I'm jumping. I'm jumping. No more than 20 years ago. No more than that." She was spot on. It was 19 years and 5 months since the young man hit that marble floor.

"I'm here. He came to England especially to do this. He'd been here before." Patsy began to retrace his steps. "He came from abroad. He didn't do it on the day he landed, pardon the pun. But he came before to recce the place. He knew about everything. A recce, I'm gonna recce first. I'm on a recce first. There was a space where nobody was. That's why he was running. He was on this floor, running and running. I didn't even stop. I went straight over. A running start, I'm running around and I'm going over, because if he'd have stopped, that gives them time to think. They didn't. I'm going over . . ."

"Now the official line, that we were told by the museum, was that he died on the way to the hospital," the warder who was present had told me over a pint in a noisy Covent Garden taproom. Indeed, he wasn't pronounced dead until he was in the ambulance. "But I looked." The warder turned his head to the side. "I looked at him on the floor. He was grey in colour, and had a big pool of blood behind his head so . . . Yeah, no way he was still alive at that point. He was gone already. Poor kid was a mess."

I asked Patsy what this was all about. Looking over the shiny silver rail, my knee pressed against the Perspex pane below, watching the tourists churn in a slow frenzy. Why would he throw his life away, and why so publicly?

"Why did you go over? Why did you go over?" She put the question to the now-departed visitor and waited, like an operator at an old-timey switchboard.

"He had money problems. Tax problems." Patsy took a deep breath as if the enormity of the young visitor's burdens weighed on her in the act of channelling him. "He had a wife, children that he'd broken up with, and he had to pay her money. People don't commit suicide for one reason. He went over the side."

I knew that after the museum had been emptied of visitors, his rucksack was still in the cloakroom. He'd paid a pound to leave it there, and now the cloakroom staff were left holding a dead man's bag.

"And he's still here?" I looked to Patsy.

"Still here," she affirmed with a curt nod, her eyes downcast.

I wondered aloud if there was anything we could do to help him move on. Patsy answered that he should move on, skirting the question. She said that "when he went over the side" there had been people waiting for the nearby lift. She suggested that we'd better do the same and take the lift to the ground floor.

The source of the unrest in the Sutton Hoo gallery may well be the ancestral remains of an East Anglian king, or a stir-crazy crusader, or a recent suicide. Or perhaps Oliver Cromwell is still warring out of habit after all these years. Here personal struggles of heartbreak and debt are superimposed onto those of epochal violence, treading

disparate temporalities but finding a common crossroads in Gallery 41. Any of the above could be fooling with the doors, could have thrown one guard or run past the other. Museums weave a tangled web. When the British Museum opened its doors in 1753, it did so as the first national museum. The museum was then a recent and untested invention – it had not yet become the institution we know it as today, where schoolchildren are bussed in to observe the dismembered building blocks of our shared world. When Europe's powers opened their storerooms of colonial loot to the public, they didn't think about the power retained by the artefacts, or what it would mean to shove them all in together, in such unnatural proximity. The whole point was to present these objects as remnants of worlds that were no longer. But what if these worlds are of a much longer duration than they thought? What then? And what now? The warders' efforts to police spirits invariably fall short.

"That door should never have been open," said the mystified warder, but there it is. The doors, blown apart by some spirit wind, defiant, insisting upon a continuity that runs counter to the museum's glass cases and its neatly demarcated space and time. The museum remains a grand experiment, where kingdoms are squeezed into corners and graves are emptied onto spot-lit tables, like work-worn dancers pushed out on stage night after night. Who among us could blame them if they do decide to up their bones and dance, if only to frighten off their captors, buying a brief interval of peace before the museum opens again?

CHAPTER 3

PERMANENT NIGHTS

If there's one group of workers at the British Museum that is best placed to have first-hand knowledge of the disquiet kicked up by its resident spirits, or to be well versed in the museum's internal ghost lore, it's the Overnight Security staff, or the "Permanent Nights", as they're called, a scheduling shorthand reminiscent of William Blake: "Some are born to sweet delight, some are born to endless night." For those who spend decades on nightly patrol, "endless night" is no hyperbole.

There is an element of class divide in the understanding of these incidents, the contours of which can be heard in their telling. Many of the Security and Visitor Services staff I spoke with are practised storytellers. It's easy to imagine them bantering during the twilight hours – they are charismatic and concise, with an intuitive sense of dramatic structure and timing, and a firm grasp of the museum's material workings. Curators have a tendency to theorise at length, citing historical precedent while avoiding claims of direct experience. Some curators enjoy flirting with the suggestion of being the keepers not only of objects, but also of spirits. However, most wouldn't wish to erode their own credibility or to undermine the institutional line by characterising these presences as anything more than a slight, whimsical improbability. By contrast, Overnight Security must be prepared for whatever crosses their path as they secure the building. They respond to alarms and chase down

intruders. When it all goes sideways they can't run the other way, or avoid areas that make them feel uneasy.

Camden-born Phil Heary is in his sixties, stout and full of charm, a 29-year veteran of Visitor Services now retired from the museum. When I tracked him down at his current place of employment, his manager introduced me without hesitation, saying that Phil would never quit talking about the British Museum. Over coffee, he touched on workplace hierarchy within the British Museum, and the spots of blindness that come along with specialisation.

"The curators are so cocooned in their own environments, sometimes they don't realise what goes on around them, you know?" I laughed, and Phil sought to spell out that he wasn't taking the piss. "That's no disrespect to them as people, I mean they're very academically clever, but streetwise – they're not streetwise, you know? They could talk you to death about a certain stone or a certain sculpture down there, but if you ask them anything about what's happening in the world today, about modern society, they wouldn't know . . . They never really got involved with the galleries."

When Phil speaks of being streetwise, it's with a nod towards the subject of our inquiry – ghosts. While curators stay sequestered in the Back-of-House, Security, Visitor Services and cleaning staff put in years on the museum floor. Only they know what goes on after the museum shuts its doors every evening.

Many senior curatorial staff agree that during daylight hours, noisy crowds numb the senses, and that far from being a respite from the congested streets outside, the museum is akin to a crowded train station or shopping centre. "It's a complete melee during the day," one former curator conceded. In the still of the night, when the rhythm of the warders' footfall is in perfect time and the shadows of sleeping sculptures blanket the museum, then they come out to

play, amongst themselves or for a select audience of wakeful warders. If there are ghosts, "if that is something which can be registered," the ex-curator granted, "at night . . . that will be when it happens."

This view of the overnight shift is something of a consensus belief among museum workers. When I'd approached British Museum staff, to gently inform them that I was collecting ghost stories and to ask if they'd had any relevant experiences, those with nothing to share would unfailingly, without missing a beat, suggest that Overnight Security were the ones I should be talking to. When I did approach Overnight Security, ready to pivot on my heel and turn away as they laughed in my face, they'd often shoot me a glint of recognition; an outsider has somehow gained knowledge of a world that they are initiates of, that few know exists and even fewer bother to ask about. Where others more concerned with advancing their careers didn't want to be seen speaking to me, fearing retribution for airing the museum's secrets out of turn, Overnight Security are used to no one paying them any mind, and know full well that without their expertise the museum won't open tomorrow morning. What, are they gonna lose their job after decades of service for telling a ghost story?

I met Fiona Candlin, a Professor of Museology at Birkbeck, for a chat in her living room on a weekday afternoon, between bouts of marking papers. Candlin accompanied the warders on their nocturnal rounds for a research project on the night shift in 2001. Her watchful eyes and precise speech evince a vivid memory; her testimony is a portal to a nightly world that I would never gain direct access to.

Candlin recognised that the study of museums was heavily

weighted towards the curatorial perspective, with some space allocated for the discussion of education and architecture, but, "Nobody ever talks to the Security staff, or the cleaners, or Visitor Services, or the accountants even, or the caterers."

Candlin wanted to view the museum from these less-understood perspectives, and besides, "I've always wanted to spend the night at the British Museum," she confessed. "So I used it as an excuse to get permission to do so." Her reflections on her time with the Permanent Nights grant us lucid entry to their umbral realm. Their shift begins at 10pm, at which point they're the only ones left in the building, and so they begin to patrol.

"The thing that struck me is how it was like being in this different world at night, it was like being in this little contained universe that you just went round and round and round in." Each night the warders circulate in twos, their soles shuffle over absolute miles of mangy carpet in the Back-of-House, freshly polished marble in the galleries and dusty, untreated cement in the cold grounds of the basement, covering every bit of room, corridor and stairwell in the museum.

"You're doing these very intricate circular walks around the building, and you might walk five or six miles on each walk." Fiona described marching all night, with intermittent breaks, your footpath illumined by torches in the consuming, borderless shade. "You walk these incredible distances, it's knackering. But you're within the building. So the building seems to just get bigger, and you lose a sense of the scale of it. It just seems to expand as you walk these seemingly endless bloody corridors."

The warders talk to the mummies on the rounds. They speak to Lindow Man, whose body was found preserved in a Cheshire bog and whom the warders jestingly refer to as Pete Marsh.

They ask him and the other mummies if they're all right – "All quiet in here tonight?" – and say goodnight. There was an archival blanket used to shield Lindow Man from daylight, which the curators pulled up at a certain hour deemed safe. "The warders would roll it back at night, so that they didn't have to look at him, and as a gesture of tucking him into bed." Perhaps those on the night shift are better able to commiserate with the newly exhumed: neither will see sleep or home tonight or the next; instead they share a recurring, waking dream of overactive silence and shadow, amid airy glass caskets.

The warders told Candlin that their experience of time changed when they went on the rounds. The repetition of the walks, the hours flitting away as the teams circled one another, chatting football and listening to the echo of their footsteps over the industrial hum of the air conditioning revving up. "They found it incredibly calming . . . But the rest of their lives were just slipping past outside, cause they're there for years."

"The night shift takes you out on the roof as well." Candlin took a pause to formulate the feeling of being on the roof, but also in remembrance of the warders taking a breath after hours of imbibing only the stale air of the museum. "So you walk across the roof, and the weird thing is you realise how close the other buildings are, so all the hotels and the flats, you can see into the backs of them because they're lit, it's night time. You suddenly realise that you're surrounded by people running their daily lives and the BM feels like a time slip – that somehow you're not on the same bit of earth as those people in those hotels, in those lighted rooms. You're kind of sitting on the roof of this place, which is just dark and *full of stuff* . . . strange, amazing, beautiful, curious, rare, ordinary objects, and there you are on the roof of it, and it's all underneath you, and yet you're surrounded by people cleaning their teeth in some hotel

bathroom and it makes you feel like a ghost, because you're the person that's in the dark, in this strange dark place looking out on . . ."

". . . the world of the living?" I heard myself say aloud.

It's a hard row to hoe. That glint of recognition in the eyes of Security staff when asked about ghosts is not just because *they know*, or because a stranger is honouring their experience. In some cases they know by name who died in the museum, they patrolled with those who have passed on or have considered the eventuality of passing in the building themselves. They know the rooms and neglected corners where the dead are astir. They know that despite the fact that we meet in the daylight, it's been years now that they've had one foot in the world of the living, and as time goes by their weight gradually shifts to the other foot, sinking deeper into the soil of the endless night.

On an autumn night in 2014, the British Museum settled into its nocturnal register. The murmurs of the daytime public, which are said to resound for hours after close due to some unaccounted for dynamic in the acoustics of the building, become ever more faint as the night wears on. After midnight, the museum slumbers. The Security warders' roving torches cut through the curtains of night like stray signs of life, looking for survivors.

The "Germany: Memories of a Nation" exhibition was on in Gallery 35, inside the cylindrical stone building known as the Reading Room at the centre of the Great Court. The Reading Room prevents you from seeing clear across the Great Court, an omnipresent tower so wide and imposing that you don't always

perceive its shape, an inaccessible centre that seems to house the museum's hidden fulcrum or secret heart valve behind its curved wall. At night, its shadow is as imposing as the tower itself. The Reading Room houses toilets and a gift shop on the lower and ground levels. Room 35 on the first floor is reserved for special exhibitions, and on the second floor a restaurant is situated outside the Mesopotamian exhibit in Room 56. A lift runs throughout. Atop the lift, a patinaed crest, the museum's highest point, pokes through the swell of the Great Court's glass dome.

This construction is called the Reading Room because inside on the ground floor, now closed year round, is the last vestige of the Reading Room that was located in what is now the Great Court prior to the British Library splintering off and re-establishing itself at King's Cross in 1997. From 1850 to 1997, readers and scribes reigned in this space, their heads bowed over desks arranged in concentric circles like a congress of worshippers hidden in plain sight. We know some of their names – Karl Marx, Virginia Woolf, Marcus Garvey, Joseph Conrad, Bram Stoker, Muhammad Ali Jinnah, Agatha Christie, Vladimir Lenin, Arthur Rimbaud, Sylvia Pankhurst – and many other lesser known library-goers. Back in the first half of the 19th century, before the first iteration of the Reading Room, this space was an open-air courtyard, intended to be a garden, but it got so little in the way of light that nothing could be made to grow. Perhaps on account of the courtyard's infertile state, it got some use as an al fresco crematorium for "zoological rubbish". Neighbours complained bitterly of "the pungent odour of burning snakes" and other poorly embalmed, half-rotting carcasses thrown in a pyre by the keepers of the Natural History department.

*

"It must have been about three o'clock in the morning, and we're all settled down," said a member of the Permanent Nights who wishes to remain anonymous. We sat on the couches under the Great Court, just outside the BP lecture theatre, while the warder was on break. "The building's locked up, this whole area is secure." It had been a night like any other, until an alarm began to pulse and wail, triggered by a door handle turning in the disabled toilets on the east side of the Great Court, which had been cordoned off so that they wouldn't be used by staff and contractors overnight.

The alarm sent a team of Security guards running into the Great Court to enact a familiar set of protocols. They methodically swarmed the area – arriving from all directions, spreading out, doing a thorough check for intruders in adjacent toilets and galleries, and found no one.

A radio dispatch came in from the control-room operator who's been watching the centralised wall of CCTV screens almost every night for over 30 years. "He's called me up, so I've gone up there." The warder's voice rises in nervous anticipation, as if a secret was ripening on their lips. "Wasn't expecting what he had . . . There was massive balls of light and I mean, I'm not talking small orbs, I'm talking big bright lights, like someone got a torch."

The warder was awed by their movement – lowering and hovering in mid-air, achieving stillness at waist height for a couple of seconds before zipping off up the steps, or ascending vertically. The warder likened it to "an orb party". Telling me about the lights revived the sense of wonder felt by all who had been huddled around the CCTV monitors. The CCTV feed is in full colour and at a high resolution. The lights were "pure white" and they put on a show. These bright, levitating balls of light, chasing each other around the

Great Court in the early hours like children on a summer's day, had the warders spellbound.

"We actually went up there. I took my torch to shine it around and see what it was." They made their way to the top of the stairs, struck at first by how quiet it was, then they began to kick up dust, backlit by their torches, in an attempt to approximate the floating bits of luminescence that had enthralled them on the CCTV screens. Scouring the entrance to Gallery 35, seeking in vain a glimpse of the lights with their own eyes, they radioed down to the control room. "We can't see nothing . . ."

Control radioed back through static.

"They're all around you . . ."

"Did you feel anything?" I couldn't help but ask: if the warders couldn't see the lights with their eyes, perhaps they could feel their movement.

"That's the thing – it was nice and calm . . ." the night warder said, with a blend of relief and perplexity.

These lights appeared only on the CCTV feed. As we have seen, some spectres show up only in photographs. Others are seen or felt while going undetected by any sort of camera device or alarm. That such a blizzard of spirit activity should go undiscovered by every device apart from CCTV brings to mind quantum physics, where instruments attuned to a certain range of subatomic behaviour show the material world to be more animate than our senses are able to apprehend.

I then asked, as you're probably asking now, if anyone saved this footage. "They last about a month and then that's it, I'm afraid." I had known this would be the answer, because for a few years I worked the overnight shift in the "Security Room" myself at the Phillips

Collection, a museum of modern art in Washington DC. I'd watch the shadowy feeds of Monets and Rothkos, fighting to stave off sleep in a swivel chair. At the Phillips, if nothing noteworthy took place the tapes would be reused – recorded over. Now with digital media the footage auto-erases at monthly intervals so as not to overload museum servers with high-res footage of empty galleries. All of that aside, it would be a violation of one's responsibilities as museum security to share CCTV footage with outside parties, or to photograph the feeds. So as far as I know, no footage of the lights was retained by any of those who witnessed them.

The lights outside the Reading Room appeared on the CCTV every night from half-past two to four in the morning. Security stood by helpless, staring at the monitors. No less mesmerised by their dance, they got used to them, and over time they noticed small variations. Outside Room 35, there was a Tensabarrier stanchion, a silvery, waist-high post with a belt of extendable fabric, much like the ones used to delineate queues at airports, which had been set up to guide visitors into the Germany exhibition. On the CCTV screen, the barrier's strip of fabric was seen extended, as if it had been uncoiled by someone pulling it out, and it was flapping wildly in the wind. The warder held their arm out to the side as if it were the belt of fabric being whipped horizontal in a fierce gale. Once the warders acknowledged it, no sooner had they turned to each other and said a collective, "All right, then . . ." than it stopped.

This went on every night for the duration of the special exhibition, and then "Once Germany went, they went." After the "Germany: Memories of a Nation" exhibition was de-installed, the lights outside Gallery 35 weren't seen again. The warder repeated this point to make sure it didn't pass unnoticed – the lights came and went with the travelling exhibition.

I was so bowled over by this story that I hadn't got around to asking, what the hell was in this exhibition anyway?

"There was a gate in there, which I don't know whether it was the possible cause for it or not, but there was a gate from one of the concentration camps. That's what I think was the main trigger for it, it's the only thing. I know obviously objects hold . . . you get objects that hold energy, and you get objects that, people go with those objects. Nothing in that exhibition was anything that would have caused something like that. Yeah, there was pictures in there, there was art, there was objects like a rocking chair, et cetera."

The Mechanical Galleon makes a cameo in "Germany: Memories of a Nation", alongside the Gutenberg Bible, portraits of Martin Luther and Goethe, definitive works of Durer and Richter, Ernst Barlach's *Hovering Angel* sculpture, a Bauhaus cradle, beer tankards and astronomical compendiums, a Volkswagen Beetle and a replica of the Holy Roman Emperor's crown. The exhibition portrays the German nation as rising from the ashes of the Second World War, modern and industrious, a titan of contemporary design and engineering, rebuilding its image and reclaiming its past glories.

For the warder the gate was far and away the only material presence in the exhibition that bore such psychic weight: a gate to hell, a hell only recently and still not wholly extinguished.[1] Whatever suffering the gate had absorbed, whatever it had seen or heard, was present in the British Museum.

The gate had been taken from Buchenwald concentration camp, 8km (5 miles) outside of Weimar, where tens of thousands died and hundreds of thousands were held. *Jedem das Seine* is spelled out across its arc – "To each what is due", an axiom of Roman law and the title of a celebrated Bach cantata that debuted at Weimar.

Jedem das Seine frames the concentration camp as an apotheosis of Western law, asserting German cultural superiority while taking every opportunity to kick the prisoners in their ribs.

The trouble with the warder's theory is that the gate used in the exhibition was a replica. An exhibitions assistant confirmed via email that "the original is too fragile to travel", and that the use of a replica allowed them to restore the gate "to its original appearance". And so the museum's conservators applied subtle tweaks of the metalwork and a fresh layer of paint, resurrecting this gate to hell and returning it to its sinister youthful lustre. Whether a reproduction possesses an aura is a question already much debated – I will leave that to others. Still the fact remains that "Once Germany went, they went." We can't know for sure why. I will only add that when the warder said it felt "nice and calm" in the midst of the invisible lights, their voice intimated surprise at encountering a pleasant, almost healing presence.

What on earth do you do in a situation like this? I tried to put myself in the warder's shoes. What do you do when the museum's security is in your hands, something inexplicable takes place and it's your responsibility to figure it out?

The warder looked around the leather sofas outside the lecture theatres beneath the Great Court, a hideaway from the hordes overhead, as if doing a quick scan for the correct response. "If it was something like that, literally just balls of light, there's not much we can do!" Laughter broke out all around, dispelling the tension that had built up in their careful retelling.

As the gruff-voiced, long-time member of the Permanent Nights Steve Ginnerty once remarked, "We try not to make fools

of ourselves if we don't need to." This is why oral accounts are the substratum where knowledge of haunted museums tends to settle. Even the most senior members of staff shy away from filling out written reports of spirit activity, knowing that if they were to leave a paper trail, they might be thought of as unfit for their post. And so, the majority of these experiences go unvoiced: perhaps they tell their partners over the kitchen table, or former colleagues in the pub, but they know better than to share these stories in mixed company.

The episode of the lights dancing nightly for the CCTV feed occurred early on in that warder's tenure as one of the Permanent Nights. I was curious if it changed their understanding of the museum, and was surprised to find that the warder understood that their role as a caretaker of the collections – as the one who watches them as they sleep – extends to the non-corporeal caretakers that may come along with that artefact.

"At the end of the day, obviously we've got a vast amount of objects in this place from different places around the world. You know, I'm really not surprised if someone attached to that object was to come with it."

This was the first time I had heard "someone attached to the object" nonchalantly laid out as a variation of the idea that "objects hold energy". As in our earthly affairs, our attachments are near infinite in their malleability, and not always easy to discern – this "attached" someone could have crafted the object, or worshipped at its feet, or suffered in proximity to it.

The warder spoke in tones of hospitality, of welcoming a stranger who, through an accident of fate, took shelter in their workplace. "You couldn't blame them, to be quite honest. I'm happy to have them here."

CHAPTER 4

"ENDLESS BLOODY CORRIDORS" OF STONE TAPE

"Germany: Memories of a Nation" is just one example of the kind of special exhibitions featured at the British Museum, which are typically on view for a period of four months before they tour abroad. While admission to the museum's permanent collection is free of charge, visitors must approach the ticket desk in the Great Court and pay around £20 to gain entrance to the temporary exhibition; alternatively they can become members and donate to the museum on an annual basis.

The British Museum's funding comes from myriad sources; from 2022 to 2023 the government's Department for Culture, Media and Sport provided £47.8m in revenue and £20m in capital grant-in-aid,[1] in addition to funding raised through memberships, research grants, wealthy donors who lend their collections to the museum for safekeeping, corporations seeking tax write-offs and so on. The lion's share of the museum's resources is directed towards the production of "blockbuster" exhibitions, profit-driven endeavours that double as high-visibility promotional vehicles for corporate sponsors such as Citibank and British Petroleum. This financial model comes under criticism from archaeologists, advocates for cultural heritage and

those who study the illicit antiquities market. These specialists have repeatedly warned that the prioritisation of for-profit exhibitions over cataloguing the museum's long-neglected and always growing collections puts the British Museum on a collision course; these exhibitions are given precedence at potentially great cost to the museum's ability to safeguard its holdings.

The British Museum's public image is largely defined by its tone-deaf policy of ignoring repatriation requests or dismissing them out of hand, a position increasingly out of sync with the current direction of ethically minded museum practice, and moreover out of step with a globalised, multipolar world. In 2023 the revelation of the possibility of insider theft severely damaged the museum's standing and forced senior leadership to step down. The British Museum's focus on profit, inattention to research and unwillingness to adapt to a changing world leave many feeling agitated about its future.

The staff seated at the ticket desk still greet visitors with a smile, but morale is at an all-time low. Staff strikes over insufficient pay closed the British Museum repeatedly over the course of 2023, and there is much talk of jumping ship. As every effort is made to keep the front-facing areas of the museum spotless for the viewing public, in the Back-of-House disorder piles upon disorder, to be managed only when the problems teeter too high.

The British Museum has some 3,500 doors, and as we slip behind any one of the discreet egresses that lead from the public floor space into the Back-of-House, we find that a good portion of these doors bookend empty corridors. The Back-of-House is an unreflective hall of mirrors, and closed corridors are its stifling connective tissue. Moving through this area, we find corridors that lead to corridors.

No sooner do we hear the door close behind us than the person escorting us is holding the next one open. Each door has an inlaid window so that we can see what or who is on the other side. Most peer into yet another slim, cold and institutional white-walled corridor, with carpets worn thin.

"It's an old building, she moans and she groans," the old timers like to say as they lead the way. In the Back-of-House, the museum speaks in a private language, as if interrogating itself aloud. A couple of museum workers have identified themselves as adherents of the "Stone Tape Theory" – an idea first conceived in the late 19th century at Bloomsbury's own Centre for Psychical Research and later popularised by the Christmas ghost story, *The Stone Tape*, produced by the BBC in 1972. The Stone Tape Theory holds that not only objects, but buildings, in this case the British Museum's own architectural skeleton, operate as recording devices, absorbing the energetic impressions of the people, material heritage and events – including the deaths of staff and visitors – that linger on inside the museum.

These recordings, latent in the "stone tape" – the very fabric of the museum – play back at unknowable intervals, detected only in rare flashes of lucidity, or picked up accidentally, like a mysteriously intercepted radio signal. The voices in the stone tape are canned warnings from the past, delayed echoes of voices caught in the black hole, mundane and otherworldly, vivid and indecipherable. The operative metaphor is of audio playback, but these energetic impressions may also register visually or as physical force. Transmissions from the stone tape suggest that the shell of the British Museum is overburdened by its past lives and animated by the roaming, restive despair of its bygone workers.

Some neophyte warders speak into Dictaphones in an effort to

memorise the combinations of turns, stairwells, lifts and walkways required to arrive at a given gallery, office or storeroom. The winding, obstacle-laden corridors in the Back-of-House may be in part a result of piecemeal planning, of centuries of adaptive add-ons to the museum island, but they excel as defensive architecture, sure to slow the roll of any lone infiltrator, uninitiated museum worker or confused ghost.

On Christmas Day 2004, Danny Barwick, then a Security supervisor, was leading a patrol through the British Museum's circuitous Back-of-House. He and two other colleagues stopped off at the cold and vacant staff canteen to break for a cigarette and a glass of water before resuming the rounds. "Even on days when you're enjoying your turkey, we're here. Twenty-four-seven, three hundred sixty-five days a year." Born in Homerton, East London – my neighbourhood at the time of our interview – Barwick is tall, broad shouldered and alert, a welcoming presence and a steady hand, a sure comfort to his colleagues who had to work through the holidays.

He brought me to the empty canteen, which must have felt especially empty on that Christmas Day 12 years prior. It was after lunch when I visited, and the staff were winding down for the day. Tables were being sprayed and polished, and dishtowel-dried plates stacked. The sorting of cutlery punctuates the recording of our interview. Barwick offered me a seat on the tattered couch where he and his colleagues had cracked jokes and carried on, taking a moment to enjoy one another's company in the spirit of the holiday. "It's Christmas," Barwick related. "We don't want to be here, but we're gonna make the best of it, kind of thing . . ."

And then, while everyone else was engaged in Christmas chit-chat, Barwick had looked up at the double doors across the linoleum floor at the far end of the canteen. The same doors that he and his colleagues had just secured and whose inset windows allowed a view of the hallway. While the warders sat on the couch, a man passed by the windows in profile, moving swiftly through the hall from the lift lobby to the anteroom. Barwick was disturbed.

"I wasn't unduly worried, I was angry – that the patrol I was leading was suddenly now going wrong, because by no means should there be anybody behind us. So without thinking about what I was actually seeing, I got onto the control room and asked who was behind us." Control replied with a flat, "No one is behind you, Dan."

"I wasn't happy with that. I called control again." Returning to the impatience he felt at the patrol gone awry, Barwick slipped back into character, gripping his radio as if waiting for a satisfactory dispatch. "I said, 'It's Christmas. Don't wind me up. Who's behind us?' I got a reply that, 'No, Dan, you and yours are the only patrol out.'

"So I figure it must be someone with keys because I've just locked those two doors." Barwick had withdrawn his attention from the radio and got to his feet. "So, I've gone down there, lift lobby door is still locked, the other door is still locked. I'm still not happy." He checked the boardroom and the committee room, checked the toilets and locked up, with only one thing on his mind: "Where has he gone?"

"It's now starting to dawn on me that whoever this is, has not set off a single alarm." The entire museum is outfitted with hair-trigger infrared alarm systems. If there were even the faintest hint of movement, control would have radioed Barwick and not the other way around. "I'm starting to get a little suspicious about what's going on – am I being wound up? I'm not too sure."

By now, Barwick had put down his radio, and the tensity of recalling the chase had passed. "Then I had the thought, well, this guy's about my height, about six foot, he's a white male . . ." Decades spent working the museum floor shone in Barwick's photographic memory, his skill at latching on to details of a visitor's appearance before they melt away in the crowd. His description of the ghost he attempted to corral was remarkably precise, making its disappearance into thin air all the more vexing.

"You saw all that in passing?" I asked, impressed with the information Barwick had stored away from a sighting that lasted only seconds.

"Yeah, he's in his late forties, early fifties. He's got quite a beaky nose. He's got thinning hair. He's got a white shirt, and a black frock-coat over the top."

To show me in more detail what he was talking about, Barwick pushed through the double doors and led me into the anteroom, identifying the face of the intruder in a portrait that hung on the wall outside of the boardroom. A small plaque on the painting's gilded frame identified its subject as "Joseph Planta, Esq., F.R.S.,[†] Principal Librarian of the British Museum from 1799 until 1827." Planta is balding, with a beaky nose and a stiff jaw. He poses in front of a red velvet curtain with a book in hand, dressed in a white shirt and thick black coat befitting a chilly library. Barwick explained that the anteroom's walls are lined with paintings of "the top-job guys", who used to get dressed up in all their finery and have their portraits done. Through these portraits the museum's luminaries still have a presence at the boardroom meetings.

"The big personalities that worked here, you can imagine in a

† Fellow of the Royal Society

time before we enjoy the technology that we do now, how much of a driving force the director, or it would have been the chief librarian back then, would have been in order to galvanise all these people, to get them to do the things that needed to be done." In policing ghosts, who can be neither physically halted nor apprehended, identifying the intruder is probably the best one can hope for. Barwick grinned with a touch of pride as he gestured towards the portraits, "And they're all surrounding us now."

Why would Joseph Planta wander the Back-of-House? Was he lost, like so many others who couldn't find the door leading to the hereafter? Was there something he was looking to retrieve on Christmas Day when no one was around, or was there some business in the boardroom that he wanted to weigh in on, finding instead an empty table?

The southwest corner of the museum, the wing where Planta's ghost appeared, was built in the 1950s – over a hundred years after his passing. As Barwick explained, "The British Museum's always getting bits nailed on to it." The spirits who wander the Back-of-House may well be lost. Nothing is where it used to be. The old building that they once knew has been repurposed, it's devoid of old faces and full of unfamiliar corridors. In the Back-of-House, the time slip of the museum behaves differently. Every room was once another room, now home to its after-impressions. Here the museum's past lives amass worriedly, stalking the halls and breathing down the neck of the living.

The cast of characters who have populated the museum over the years is beyond all imagination. There was the time a cleaner was found living in one of the wooden cupboards – "He had it all set

up," one warder reminisced approvingly. There was a cat herder, a man whose sole duty was to look after the "little army" of felines who would roam the basement and lower levels, ensuring the gallery floor was free of mice. Antoni Jakubski, a Polish zoologist, was in the employ of the museum after surviving Auschwitz. Henry Hook, who fought against the Zulu Kingdom at Rorke's Drift in South Africa in 1879, became an "umbrella man" – collecting visitors' umbrellas at the museum entrance, after receiving the Victoria Cross and retiring from the military. The overlapping energetic footprints of the big, booming personalities and those who sought shelter in the museum's supply closets and veiled crevices are all counted as present. "All those little bits add up," Danny Barwick assured me. "All that energy, it's gotta go somewhere!"

In 2016, I visited an administrator who had, at one point, worked in a narrow, shared office which was once the director's bedroom.

The director of the British Museum has lived on site since the institution's inception, though this tradition has tapered off over recent decades. The most recently departed director, Hartwig Fischer, kept a residence at the museum. Neil MacGregor, who served from 2002 to 2015, did not. The convention of the director's residence is in continuity with the building's previous life as Montagu House, a private residence built for a 17th-century duke. For this reason, the British Museum's cleaning staff were called housemaids well into the 20th century, and the warders still refer to their overcrowded, jangling key rings as the "house keys" today. Back when coal was shovelled to power the museum and the Reading Room was lit by what little natural light the London skies afforded, long before telephone wires, couriers ran scraps of paper

from office to office, and the final word, issued from the director's residence, was received as law.

Sparsely furnished with three desks and a shelf of black plastic binders with wide spines marked "Trustees", "Finance" and "Seating plans" and a couple of office plants in need of watering, the director's bedroom's only distinguishing feature was a replica of the horse's head from the Parthenon, whose jaw hung over the top of the bookshelf.

The administrator I was visiting, who chose to remain anonymous, worked late nights when she first began, in an effort to get up to speed in her new role. While lost in her work she would frequently be brought back to her immediate surroundings by the sound of books falling from the shelf. She'd get up and inspect the bookshelf, looking for rodents that could have conceivably knocked something over, admitting with mild embarrassment that "mice have been known to inhabit this part of the building". Then she would go to check the bookshelf in the office on the other side of the wall, to make sure that nothing had fallen down.

"Nothing had ever fallen off the shelf," she said bluntly, while seated at her old desk. "I thought, 'Oh, maybe it's just me,' but a number of people that I've shared this office with over the years have said, 'There's something about that bookshelf that makes noises.'"

No mention was made of the replica equine head modelled from the Parthenon whose chin groove hangs over the edge of the bookshelf. It's one of many potentially cursed objects that inhabit the museum's offices with the ubiquity of paper clips and letter openers. The administrator, whose experience I defer to, felt this was all to do with the office being the former director's bedroom.

Outside the office is an exceedingly creaky corridor. "You cannot tiptoe down that corridor without someone knowing that you're

there, it's impossible." Numerous times she'd been working late and heard the sound of someone walking outside. Relieved to learn that she wasn't alone, she'd rise up out of her seat and poke her head out of the office, looking up and down the corridor. "There'll be nobody there, nothing there at all. There'll be nobody upstairs. Nobody downstairs." The doors at both ends of the corridor were closed, which didn't deter whoever it was from loudly pacing its achy floorboards.

Was it a former director sleepwalking in his old quarters? Was there something among the institutional records on the bookshelf calling out for inspection? Or was it simply a space that had seen so much life that it yawned out the director's old rhythms of domestic ritual, reading and pacing in agitated deliberation?

Near the director's-bedroom-turned-office, the director's former kitchen and dining room have been converted to meeting rooms, though they're still called the kitchen and dining room. Where archival photographs of the director's residence document richly patterned curtains and golden candelabras in what's now the staff meeting room, and even a piano in the corner of the office that the horse's head oversees, there are now barren office spaces. The shifting sands of the museum's many lives are not told in its floor plans. Many of the changes to the way the Back-of-House has functioned over the years have been improvised and unknown to central planning.

Pushing through the Back-of-House's southwestern corridors, we arrive at 1 and 1A Montague Street. These two linked Georgian buildings retained by the museum were once a family-run bank. Later on they became the first headquarters of the Football Association, and then offices where soldiers were billeted during

the Second World War, against the wishes of the British Museum's trustees, who feared that providing soldiers with board would make the museum a legitimate military target. Nevertheless, the old ballroom at the back was commissioned for training troops, as railings throughout the museum were removed, melted down and turned to armaments – shells and bombs, not to reappear as railings until the early 1960s.

After the war, 1 and 1A Montague Street became Storage for the museum's ceramics collection. When I conducted my very first interview there in 2016 with Jim Peters, collections manager of Pre-Historic and European collections, we sat at a heavy wooden table surrounded by oversized crates stacked two or three high and draped in archival blankets. Peters is a musician on the side, with thick black frames and longish hair.

"In the winter you have to go around and shut all the shutters on the windows, and if you go at the right time of day, you get the mounted police going past. In the evening it's dark, and you're closing the shutters and you hear the horse hooves outside, it's like suddenly you're a hundred years back. There have been several times when I've been in this building, and you hear a door go upstairs, and you think, 'Ah, someone else must be up here,' and you wander round and there is absolutely no one else in here, at all. But you've definitely heard something, and that's one of those moments you can't convince yourself it's just a creak."

Storage areas are furnished with heavy fire doors, kept locked at all times and, as we've seen in the Sutton Hoo gallery, opening them requires a key and a dedicated, full-body push; they bang and clunk unmistakably when they slam shut. Jim Peters is not alone in reporting that at 1 and 1A Montague Street, " 'There's been two or three times in this building, where I've heard a door and gone to

investigate thinking, 'I better not lock up 'cause there's someone else here,' and there's never been anyone here.'"

When I asked who he figured was making these noises, Peters introduced me to the Stone Tape Theory, though he wouldn't be the last museum worker to reference it.

"I very much buy into the Stone Tape Theory really. I was an archaeologist before I came here, so I spent a lot of time surrounded by old structures, messing around with old structures, and I firmly believe that they're able to absorb some sort of residual – whether it's a sound, whether it's a feeling, whatever it is. Maybe just because I work with sounds, I find it easy to believe that a sound can be absorbed into an object and can be trapped within it. For me sound is very important to the feel of a place, and the feel of a room. Even if you can't hear the sound, it's there, and it affects you. Once you realise it, and once you're able to accept it, I think you're more susceptible to picking it up.

"The British Museum is just . . . it's been here so long, so much has gone on in it, so many people have been through it, so many discussions have been had, so many objects have been brought in, it's absorbed so much."

Robert Smirke designed the British Museum's Back-of-House so that the offices, archives and study rooms of each department would be clustered around that department's gallery space. In the Clocks and Watches department, every curator is a trained clockmaker. A former Head of Clocks and Watches, his fingers smudged from handling oily gears, surrounded by grandfather clocks and astrolabes, used to swear that there was a ghost in the Botanical stairwell off Gallery 47.

It's called "Botanical" because, prior to the Natural History Museum opening a separate site in South Kensington in 1881, this stairwell was overflowing with Hans Sloane's collection of flora, crawling up the walls seeking sunlight, with manifold dense and snarled vines clinging to the stairwell's sinking banisters.

The ghost of a warder who hanged himself troubles the Botanical stairwell. This took place within living memory, so some still-active warders knew him, and have felt his presence and even seen him in the stairwell since he passed. They check the fire escape at the bottom of the stairwell every morning. The small set of steps leading down to the fire escape is steep, and several staff have reported feeling someone grab at their ankles or push them from behind as they descend. Whether due to the furious jostling of a ghost, or stairs that aren't quite fit for human feet, or both, quite a few accidents have taken place on these stairs, and staff avoid them if they can.

At the landing of another stairwell, a museum worker died of a cardiac arrest and lay for hours on the cold floor before being discovered. Due to the indignity of the warder lying alone, "because of the poor chap on the stairs", it henceforth became museum policy for the warders to patrol in pairs. I've heard tell of a staff member hanging themselves in a toilet stall, and another stringing themselves up in yet another stairwell. Another warder died of a heart attack in the building. "He was working too hard, and he didn't know he had a bad heart," Phil Heary said, eyes downcast as he tapped the table, remembering his friend. Before his passing, Phil said that his deceased colleague "saw a shadow on top of the North stairs, looking over at him. He looked up again, and it's gone. But he was a bit of a wind-up merchant, you know what I mean?" Most recently, someone passed in their sleep in the BP lecture theatre in

the middle of a talk. A quiet way to go, but a source of distress for the person in the next seat who heard their last breath.

The list goes on. Aside from a few instances which are well documented, or for which I was able to track down people with first-hand knowledge, many of these deaths are unverified, owing to the museum's concerns about the negative attention they might bring. There's a thick silence, a taboo around addressing deaths on site in a workplace already overfull with the contents of so many upset burial grounds; heaving with human remains, stolen tombs and funerary relics.

A pressing awareness of these passings is the reason that museum workers like Steve Ginnerty, a long-time member of the Permanent Nights, conceive of the museum's hauntedness as to do not primarily with artefacts, but with the museum's lost workers. "I could believe there are ghosts and spirits in this place . . . I think it's probably old former staff members, maybe public as well. We've had deaths on this site," he said knowingly.

The layeredness of these many histories stacked atop one another, or living in each other's shadows in stopgap storage rooms, creates a space where warders don't even speculate as to who they might have run into. With such a long directory of potential ghosts, and so many visitors and co-workers fallen and uncounted, the warders' lone imperative when things go astray is to *get out*.

"We was on another patrol, different part of the building. I can't take you to this one unfortunately, because it's in the Back-of House, in an area they call the Old Horse Stables." There was once stabling around the museum's West Wing, which was later converted to gallery space. The warder I was speaking to delineated its present-day

uses. "It's primarily an old gallery that no one ever uses anymore, still objects down there, and a bit of a staff area. So, I've gone up to turn the lights off. As I turn the lights off, it was like – you know when you get like a tingling sensation, like someone's right behind you?"

Her voice tensed as she sought to convey the feeling of being violated in a makeshift storage space. "It wasn't dark at the time. The lights were still on . . ." The room seemed to dim prematurely, before she managed to flick the light switch. "The only way I could perceive it was, someone had put their hand in and grabbed my spine and sent the biggest chill up my spine, my whole back literally went, like jelly legs and everything." The warder's tone sent a shudder running down my own spine. Still trying to make sense of what she had experienced, her first impulse was to play it off.

"I kind of ignored it, and said to my colleague, 'That was weird. You can unlock that in the morning. I refuse to go back there.'"

A proud Welshman, her patrol partner assured her, " Don't worry about it, it's fine . . ."

"He went back in the morning to unlock it, and I followed him. When we got back to the same area again, I got the same chills, but he actually had jelly legs as well, for no reason whatsoever . . . It completely put me off that whole area. It was that feeling of, 'I'll get up your back. I want you out my area', and for him to say that he felt his legs go like jelly . . . He doesn't take anything, none of this . . . But it even freaked him out, and we just went out of there as quick as you could say boo. We were gone. We were gone."

Pulling back from the depths of the Back-of-House, before re-entering the galleries, we enter the liminal space of the British Museum's departmental libraries and study rooms.

The Arched Room was built in 1842, an extension intended to address the museum's lack of shelf space in the face of an ongoing landslide of incoming books. By 1846, it couldn't fit another volume. Today the Arched Room is the Department of the Middle East's own departmental library and archive, as well as the repository for its reserve collection of over 130,000 cuneiform tablets. Located on the second floor, the Arched Room has alpine arched doorways, rickety spiral staircases and elevated walkways of a gridded metal, seamlessly integrated with the three-tiered bookcases. The overhead lights hang from chains riveted to the ceiling. The Arched Room is known to be haunted. A senior keeper reported a "troublesome ghost" sometimes seen by colleagues in the evenings. Others pointed out that the upper stacks in the Arched Room are on the other side of the wall from the Upper Egyptian "mummy gallery", a space synonymous with hauntings. Fiona Candlin gathered that the warders simply didn't like going down there because "there was felt to be something intangibly wrong in that place".

Internal to each department we find study rooms, which are only accessible to visitors who have been granted an appointment. Mini-libraries with tall ceilings, lined with glass encasements of rare manuscripts, replete with long wooden tables and archival reading stands set out for the viewing of rare books and paper ephemera, the study rooms act as the weigh station between the museum's public-facing realms and the abyss that is Storage. Something like a visiting room in a prison, researchers apply for an appointment to spend time with the artefacts under the watchful supervision of museum personnel in white archival gloves, turning pages or carefully rotating artefacts to appease the visitor's interest.

They try to weed out "unserious" visitors to the study rooms, but many slip through. One woman came in on a weekly basis to view a

Korean vase. She didn't inspect it as a curator or archaeologist would, but rather she was "fixating" on it, with a blend of disinterestedness and concentration that gave the outward appearance of meditation.

In the study rooms of the Middle East department, researchers often ask to see the Mesopotamian "Burney Relief" of Lilith, the goddess of the night. Formed in clay and dated from somewhere between 1800 and 1750 BC, she is depicted in a horned headdress, nude but for a necklace and bracelets, holding a rod in one hand and a ring in the other. Her wings are downturned, her bird-like feet settled on the backs of diminutive opossum-looking lions and flanked on each side by large owls. The Burney Relief left researchers from all over mesmerised, though one anonymous former curator was determined to steer clear of it. "It emanates huge power," she warned.

That curator contacted me by phone. Her warnings about the Burney Relief were dire, even though she'd managed to avoid ever touching it. "It's an object which I never came to hold. I didn't even want to be in the vicinity of it, wasn't happy going to the area where it was kept, as you walked down this particular locked-off area, the more you got towards the back, the stronger the presence was. It was quite overpowering. If I had to retrieve it for any reason, I'd get a colleague to go with me, to handle it, so I didn't have to."

Hundreds of thousands of artefacts passed through this curator's hands during her time at the British Museum. When I asked why she went to such lengths to avoid the Burney Relief in particular, she hesitated. "It wouldn't be my will to offend anyone, because some people might see it as more of a deity, or more of a goddess," whereas "some would say a demoness", but in her estimation this particular terracotta relief had a strong sense of "a demonic attachment", emitting an aura "of profound dread, an essence of evil. Just something your instinct told you, don't touch it."

The curator recalled a man who booked to see the Burney Relief in the study rooms of Western Asia, and was overcome, engrossed in lustful paralysis, "a kind of erotic adoration" that held the researcher in its spell for hours, making the typically unremarkable task of supervising the study room "disconcerting, and a bit unnerving".

The Prints and Drawings department boasts one of the more grandiose study rooms, with rows of vitrines and glass-encased scrolls lining the walls, and fitted tabletop lamps looming far overhead and running the length of the desk space. A museum worker once hanged themselves in a cupboard here. The dead air of archival storage took in a fresh corpse one morning, turning the study room into a mausoleum. A curator also hanged themselves in the turret near the East Gate, troubling the spiral staircase that leads from the East Road, an internal road on the museum grounds, up to Prints and Drawings. Those who work in the department say that, ever since these suicides, they have found items left in their workplace rearranged inexplicably, obstructing their workflow and creating disorder among the neat stacks of Rembrandts and Picassos. Security complain that when they enter Prints and Drawings after hours, papers fly through the air like bats that came in a window circling for a way out, while the unmanned door through which they entered flings shut, prompting calls for back-up.

One night a Security warder was making the rounds through the Back-of-House when a door just wouldn't open. He decided that something on the other side was blocking it and took a detour using the tiny padded lift that goes up through Prints and Drawings, not far from the cupboard where the hanged warder was found. The lift stuck and trembled, moved a bit, then stuck and trembled again.

It took five or six minutes to move just the one floor. As the lift shook, the warder's feeling of being obstructed intensified, until he shouted skyward at the ghosts, "Stop playing silly buggers!" When he was finally released from the lift and arrived at the other side of the door that had refused to open, it wasn't locked. There was nothing blocking it. It opened with ease. He attributed this to the "spirits of the place".

The Egyptian department's study rooms have long attracted practising occultists. "We got lots of people talking about how they were gods incarnate," recounted Emily Taylor, who worked in the department for 12 years and even wrote a dissertation about some of the uncategorisable artefacts on the department's shelves. On an autumn afternoon I sat outside the Duke of Wellington pub in Haggerston, East London, with Taylor, who now runs a frame shop in Hackney.

"One of the jobs that you had as a museum assistant was looking after people who came in to study objects. So academics, anyone, can make an appointment to go and see an object in the British Museum, you just have to know what you want to see."

One young woman came in and requested a piece of Ancient Egyptian jewellery, only to cradle it between her knees, clasped in her gloved hands, with eyes closed and head tilted back towards the ceiling for 30 minutes or more. The young woman's behaviour was mystifying, but this was not Taylor's first time dealing with unorthodox research requests. She reflected on her first day in the Egyptian department's study room.

"At the time that I started, there was a woman who was studying child mummies." Taylor held a pint glass between her hands,

recalling that on that morning the researcher was after a child who had been mummified during the period of Roman rule in Egypt. "So, my colleague at the time said, 'Oh, you can look after this woman. How do you feel about dead children?'" In a trial-by-fire job orientation, she retrieved the numbered Victorian box with its sliding glass lid, and realised that this mummified child had been unwrapped, and their bones unsheathed.

Taylor considered the child's journey. "They were Roman mummies that have been unwrapped at some point in their life, and I had to get them out for a woman to study." At the picnic tables outside the pub she recreated the pose of the mummified children, sliding into a horizontal L shape. "Hands by their side, their legs straight out in front of them, their heads straight up. As they had been wrapped up, I suppose. Really beautifully laid out, and then they had gold leaf on their faces and bodies. So you could see the squares of gold leaf, and their skin is completely ground, leathery, all the hairs intact, you know, eyelashes, all the hair's gone a kind of gingery colour."

Unaccustomed to handling, or even being near human remains, the children's presence shone in unexpected ways. Emily Taylor looked me directly in the eye, as if to underline the gravity of what she was about to say. "What really struck me at the time," she said, inhaling the autumn air, "was the *smell* of them, how *alive* they were."

CHAPTER 5

"SHE WATCHES THE DOOR"

Room 4 of the British Museum is the Egyptian Sculpture gallery, although it's more often spoken of as the Lower Egyptian gallery. Not in reference to Lower Egypt, the name given to the northernmost part of the country by the Greeks and Romans; it's rather that these gargantuan stone presences are too heavy to sit anywhere else but the ground floor. They survived impossible journeys across the sea, but upstairs is a step too far. Even during the Blitz, when the museum's collections were dispersed to adjacent tube stations, country homes and even a cave in Wales, many of these artefacts stayed in place and were simply covered by layers of sandbags.

Entering the Egyptian Sculpture gallery is humbling. The high ceilings and stone floors designate Room 4 as one of the more cathedral-like halls of the museum, yet it's so full of visages the size of boulders that it's a bit like being in the mountains. Just being in the room makes you feel smaller, stilled by the meter of geological time. Only instead of wind-carved rock formations there are pharaohs, priests and deities, standing, seated and kneeling – Horemheb, Amun-Ra, Amenhotep I, Amenemhat, Ankhrekhu, Wahibra and many others, protected by Kushite rams and red granite lions. Once the sun goes down and the house lights dim, the sculptures' shadows carry as much visual weight as the sculptural beings themselves.

"Younger Memnon", the monumental bust of Ramesses II, towers over the Lower Egyptian gallery. This immense likeness

of the third ruler of the 19th dynasty, reigning in 12th and 13th centuries BC, is the largest Egyptian sculpture in the museum. Younger Memnon's head, half of one arm and upper body weigh over 7 tonnes.

The Greeks call Ramesses II Ozymandias, and he was dubbed "Great Ancestor" by successive pharaohs. Weirdly enough, it was "The Great Belzoni", a circus strongman born Giovanni Battista Belzoni, who brought him into the museum. In 1815, Belzoni was recruited by Henry Salt, archaeologist and Consul General of Egypt, to assist in removing the colossus. Belzoni was an expert in hydraulics and, having lost his bid to modernise the Nile's irrigation networks, he took up Salt's proposal with enthusiasm. The removal of Ramesses was an engineering feat that had eluded the preceding French occupiers for years. They'd dynamited the enormous bust's base and left it in the sand. "I found it face upwards," Belzoni recalled with characteristic showmanship, "and apparently smiling at me, at the thought of being transported to England."[1] The strongman mobilised hundreds of Egyptians to shuttle the "Great Ancestor" on a sled over 1km (⅔ mile) of dry land, into the Nile and onward to England. The image of the circus strongman acting as an outsourced trafficker has the effect of transposing the circus onto the museum, bringing its inhabitants into ill repute, and recasting them as a band of travelling performers biding their time in an unfamiliar town.

Mounted on the wall of Room 4 is a list of Egyptian rulers carved in limestone, taken from the Temple of Ramesses II in Abydos. The names of each successive king are ordered in gridded hieroglyphs, the stone's weathered edges evoking an eroded landmass, a lost continent.

MODE IN WHICH THE YOUNG MEMNON'S HEAD NOW IN THE BRITISH MUSEUM WAS REMOVED BY G. BELZONI.

From *Plates Illustrative of the Researches and Operations of G. Belzoni in Egypt and Nubia*, 1822, John Murray, London.

The stone gods and rulers resident in the gallery are nearly all amputees. Heads torn from who knows where, upright figures with feet missing because the thieves were in a rush, or just weren't much concerned with feet. Yet they appear composed, undeterred and wholly present. These statues are unbroken in the same way that the part is reflective of the whole, in the same way that home is a place that you carry with you wherever you go. That they have been mishandled and have lost limbs is evident enough, but the deep time that they come from dwarfs that of the fresh-faced museum. They spread throughout the gallery in a far-flung huddle, plotting at a pitch unintelligible to human ears.

A large portion of the stone entities in the Lower Egyptian gallery, including the revelatory Rosetta Stone, came into the British Museum's possession after the Capitulation of Alexandria was agreed to. Signed in 1801, in the wake of France's defeat in Egypt at the hands of British and Ottoman forces, the memorandum allowed safe passage for the French fleeing Egypt on the condition that the British absorbed the antiquities that Napoleon Bonaparte's forces had looted since invading Egypt in 1798. With the Capitulation of Alexandria, cumulative tonnes of Egypt's material heritage, formed over eons, were divvied up like winnings in a whisky-fuelled card game. If the British establishment sobered up and renounced its colonial-era belligerence, then Bonaparte's abductees would no longer be in Room 4, but here they are. In each corner of the British Museum, the desires, crimes and imaginings of the colonial period are fossilized like insect parts in amber, like aftershocks from a world that has passed.

Wading through this indoor garden of ancient amputees, I notice a single rose being placed at the feet of the four Sekhmet figures who sit midway down the hall; the woman who left it

turns away. Security are unfazed, and continue their watch of the busy floor.

The British Museum is the unofficial centre of the Soho occult world. The Victorian-era Spiritualists of Bloomsbury, and those who still frequent its long-standing occult bookshops, have always looked inside the museum's gates for the evidentiary material from which their ideas descend. The Swedenborg Society, the Spiritual Institute, the Society for Psychical Research and the British National Association of Spiritualists all sprouted up nearby.

The methods and cosmologies of the Ancient Egyptians, Greeks and Romans, embodied in their tools, scripts and sculptures, are foundational to Western occult tradition, attracting regular pilgrimages by visitors who treat the exhibits not just as objects of study, but as sites of worship and opportunities to try to awaken the artefacts' supposedly dormant utility, to tempt them out of retirement and test the idea that museums categorically house the inactive, the decommissioned and the dead.

Despite the museum's public statements that their collections are open to all the world, given the cost of visiting London and the UK's restrictive border policies, the artefacts are much more likely to be accessed by tourists, the monied eccentrics found in Soho's after-hours bars, and day-tripping witches from outside the capital, than by their communities of origin. And so the British Museum has for centuries now been a site of experiments in the use of religious tools by the uninitiated and the home-schooled. These visitors seek to engage material heritage as a conduit, believing that if you approach for a dance, speaking and bowing in the right way, you'll be treated in turn like the devotees of yore. For these visitors the exhibition is

not something to be viewed, but a point of material connection that, if channelled properly, puts them into contact with anyone from the Egyptian stonemason who laboured over a sculpture's form to the god named in its chiselling and sanding.

Much of this devotional activity inevitably takes place within fantasies born of Britain's exploitation of Egypt, fuelling not only local occult enthusiasm, but popular interest too. Henry Moore, Britain's pre-eminent modernist sculptor, cited the Lower Egyptian gallery as a formative influence, and became a major donor for its remodelling in the 1970s.[2] Hitchcock's 1929 film *Blackmail* – the first UK-produced film featuring sound – contains a scene where the police pursue a suspected murderer through the Lower Egyptian gallery; it climaxes on the roof, when the accused crashes through the museum's glass-plated dome to his death in the Reading Room below.

In Room 4, I heard anecdotes of cold spells around certain plinths and stray Victorians: "There was a gentleman in a high hat, and a very long frock-coat, I thought it was a fancy dress to start with" – until they told him the galleries were closing and he vanished. Once I waded in a little deeper, the stories I heard from the Lower Egyptian gallery all tended to lead back to the four statues of Sekhmet, taken from the mortuary temple of Amenhotep III on the West Bank of the Nile at Thebes, or Luxor as it's called today.

Sekhmet's name means "She who is powerful". She is a solar deity in the Ancient Egyptian pantheon, a lioness, a daughter of the sun god Ra and an enforcer of his wrath. She could be invoked to spawn and to unleash plagues, and could equally be called upon for protection from disease, and to ease hardship. The British Museum is in possession of over 30 such Sekhmet statues, a succession of

modular gods, haloed by or holding chipped solar discs, belonging to a grouping of 730 similar figures – one seated and one standing for each day of the year. All of them were taken from the Karnak temple complex, where most were positioned adjacent to a sacred kidney-shaped lake inside the Karnak temple.

An earthquake in 27 BC created a fissure in one of the statues that sounded a wondrous tone when touched by the morning sun. In his 2nd-century *Guide to Greece*, the geographer Pausanias described the sound as "very like the twang of a broken lyre-string or a broken harp-string". By AD 199, a mere 20 years after Pausanias's death, the sound had been nullified in the course of restoration.

Hundreds of Sekhmets are now in the collections of the Vatican and the Metropolitan Museum of Art, the Louvre, the Royal Ontario Museum and many other colonial museums, but it is the British Museum that possesses the largest group of Sekhmet statues outside Egypt.

Lee Gerrard-Barlow, who leads tours on the magickal[†] practices of Ancient Egypt at the British Museum, said that in the summer of 2017, a woman in his tour group was surprised by a series of photographs she'd taken wherein rays "of very strong violet and green light" were pictured travelling horizontally through the pharaohs and Sekhmet, as if there were coloured spotlights being beamed onto them, but there was no such hued lighting in the hall at the time. "In the lap of Sekhmet, there was gold light, literally pools of gold in her lap."

[†] Aleister Crowley coined the spelling of "magick" with a "k" to differentiate occultist activity from stage magic.

Gerrard-Barlow said that these photographs could not easily be explained away as glares, reflections or other distortions of light.

Groups of mostly women, of unclear and perhaps mixed religious persuasion, routinely organise visits to Sekhmet in Room 4 – to perform worship, to pray and meditate in front of her likeness, and to leave offerings of roses, clementines and Ferrero Rocher chocolates at her feet. Perhaps as a result of Sekhmet's presence in Western museums, she has become one of the ever-ready gods adopted by New Age practitioners, many of whom understand her as a wellspring of power for assertive and independent women.

"Sekhmet, the giver of life, she gives life." Patsy Sorenti stood in front of the statues and, amid all the noise of the museum floor, tuned in and gave her psychic impressions.

"These are female statues and they're mothers, they give life and they ease the pain of childbirth. That seems to be very significant, childbirth. But they can't do it alone . . ."

Patsy began again, this time starting from the ground.

"I'm being drawn to their feet, there are offerings being made at their feet. Offerings were laid at the feet of the statues, by women who had given birth to live babies."

Patsy was referring not to recent offerings left in Room 4, but to the mode of worship observed in the Karnak temple thousands of years ago.

"These were offerings to say thank you. And there were flowers and food and fruit and so on, laid here."

As warders, visitors and others have observed, it's possible that deities in the gallery can initiate certain visitors in subtle ways by their mere presence. If we accept that these so-called objects have agency, then it may be that their presence compels visitors to reprise old rites in ways that aren't readily understood. Put another way, it's

possible that Sekhmet initiated this dance, unbeknown to those who approach her.

Fiona Candlin was working on another research project – this time on visitors touching museum displays – and was intrigued by these visitations to Sekhmet. She spoke to a warder who had asked one of the Sekhmet pilgrims what they were up to, and was kindly informed that they were channelling the energies of the goddess.

"We talked about that Sekhmet was known as 'she who mauls'," Candlin noted, through startled laughter. "She's really violent and bloodthirsty, and you would want to be careful around channelling any of Sekhmet's energies, it seems actually a singularly inappropriate sculpture, and goddess, to try and channel the forces of . . ." Sometimes home-schooling goes wrong. In occult practice there always lurks the distinct danger that people don't know what they're playing with.

When humankind ceased to worship Ra, he sent Sekhmet out in a cataclysmic shower of vengeance, imbibing tidal pools of blood that she let loose in a wanton slaughter of men, women and children. When Ra saw that she had nearly blotted humanity out, he fooled her with a cascade of pomegranate-dyed beer that gave the illusion of victory, satiating her bloodlust and allowing humanity to tarry a little longer. From the perspective of a warder, with one eye on health-and-safety protocols, offerings of gratitude for Sekhmet's mercy are far preferable to the channelling of a vengeful god on the gallery floor. A gallery is no place for gods, after all.

*

In January of 2023, I stepped out of the cold and wet of Bloomsbury's side streets and into the old storefront of Atlantis bookshop. Located on Museum Street, just a block or so from the British Museum, Atlantis is Bloomsbury's longest running, still extant peddler of print esoterica. With its thin and crammed shelves, it gives the impression of having been in business for ages, but not because it's dusty or overgrown. On the contrary, it's because its stock is so refined, denoting a well-used haunt that knows its clientele, with shelves dedicated to witchcraft, qabalah, alchemy, systems of practical magic, the folklore of Northern Europe and the deities of Ancient Egypt. Founded by Michael Houghton in 1922, Atlantis was a locus for occultists and writers who included Aleister Crowley, Dion Fortune, J R R Tolkien, W B Yeats and many others.

I'd stopped in hoping to chat with Geraldine Beskin, who runs Atlantis along with her daughter Bali. Beskin comfortably holds court at the desk by the front door, with her hair dyed a rosy colour and a ready smile. I'd stepped in to introduce myself before the pandemic began, and before I'd moved from London. I'd heard Beskin knew something about Sekhmet and I was keen to hear it in her words.

Chatting freely, she sketched a social history of the British Museum in the 1970s and '80s that I hadn't quite heard before: "I had a friend and he was just one of these weedy hippies, and his job was to get the index, and to write 'D' in the margins, which meant destroyed by enemy action during World War Two. And that was happening then, they were still very slowly going through."

I asked if it was true that back then access to the behind-the-scenes areas of the museum was more relaxed. Have you ever been to Storage? Did y'all hang out in the Back-of-House? "We used to

go through the stacks," she affirmed, "and just sort of smell things, and look at things, and play around and all the rest of it. Then there were various park benches for visitors to sit on. Except they always disappeared up onto the roof, which was terribly dangerous, I mean it was just a glass roof really with ladders across, but that's where the warders used to go, and smoke and have sex, and knock about. It was a very happy, different kind of a time then." The good old days, after the era when the warders were made up of retired police, ex-military or the trustees' discarded servants, and before the warders were sourced from temp agencies. They're lucky they got through those years without plunging through the shattered glass dome like the character in *Blackmail*. They could have ended up another ghost story.

According to Beskin, some decades ago curatorial staff decided on a whim to move the Sekhmets from their long-held position in Room 4, where they sit today. "Right, let's have a rearrange of the furniture," was how she characterised that particular piece of decision-making. But the staff on the gallery floor had misgivings; the warders found the very suggestion disconcerting. The four Sekhmets are situated near the centre of the Lower Egyptian gallery, their backs to the wall. To their left, they watch an entrance eclipsed by the Rosetta Stone and its attendant crowds, and to their right, a long hall of multifarious stone totems, all originating from Egypt.

"The warders who knew their galleries" – Beskin threw her hands up in exasperation – "they said, 'Don't! The girls, Sekhmet, like to be how they are.'"

The warders' protestations fell on deaf ears, but they steadily beat the drum, warning curatorial staff that Sekhmet should not

be moved. "They said that the girls were happy the way they were, not to move them. Of course, the person in authority said, 'I know better,' and so they rearranged them."

When the mason's assistants, the team responsible for moving heavy stone artefacts within the museum, shifted the quartet of Sekhmets one by one across the aisle of the Lower Egyptian gallery, the warders felt something unsettling taking hold. To any inexperienced onlooker, their dismay at Sekhmet's repositioning in the gallery might have seemed disproportionate. But they were convinced that something had gone wrong, and that it would soon spill over onto the gallery floor, where they paced anxiously and watched the doors that Sekhmet had once overseen. In the days that followed, a fist fight broke out between two visitors right in front of the relocated Sekhmets. "A physical one. You don't get fights!" Beskin proclaimed. The warders, who felt they were reaping the harvest of the curators' whims, had to pull the pugilists apart. The cause of the fight was unmemorable. You very seldom get a proper fight in the museum, this is the only one I've ever heard of, and the fact that it took place directly in front of Sekhmet caused the warders consternation. Since the curators had a rearrange of the furniture, in place of worshippers, approaching with flower in hand, praying under their breath, visitors were being knocked to the dull stone floor at Sekhmet's feet.

The warders waited helplessly for more misfortune to be visited upon Room 4. Within a few days another visitor slipped squarely within Sekhmet's line of sight and broke an arm. The warders who had warned that moving the Sekhmets would upset them could only watch the surface calm of the room slip away in painfully slow motion.

After this disorder was unleashed, the warders restated their message to curatorial staff: "Move them back, and everything will be all right." Beskin said it again with pointed emphasis on the final syllables of each phrase: "Move them *back*, and everything will be *all right.*"

The Sekhmets were returned to their original position, and the rush of violence abated. The Lower Egyptian gallery became calm once more.

When I asked Beskin how the warders knew that Sekhmet should remain in position, she said simply, "People know their stuff, basically, like anybody who works there knows not to use that lift, and so on. They knew!" Again, the warders' knowledge of the artefacts' behaviour outflanked that of the higher-ups. For once, they were vindicated.

Why would Sekhmet object to being moved? What was it about this initiative to "rearrange the furniture" that called up such resistance?

When Patsy and Ricky Sorenti visited the Lower Egyptian gallery, Patsy cut to the question of the Sekhmets' placement unprompted, years before I had even heard Geraldine Beskin's story. "These statues, they should stay here. They should not be moved from this area. They are protectors. They oversee where their countrymen are." Then, more slowly, "They're the guardians, watching the doors, facing the door. These should be left here, not moved at all, left in the gallery where they can see who comes in."

After being uprooted from the Karnak temple where hundreds of Sekhmets dwelled together for millennia, these Sekhmets were then shoved aboard a ship, and left to sway over the uncertain depths. Having now managed to forge some semblance of community with

the other sculptures in Room 4, an already dislocated protectress was apparently unwilling to be uprooted for a second time, or to let her "countrymen" out of her sight.

Here there is no suggestion of a "spirit attached to the object". The warders recognise Sekhmet as not merely the subject of the sculptures, but an active presence in the gallery. The statues *are* Sekhmet, and the warders know better than to mess about with her. An eager defender, Sekhmet would not allow her back to be turned on her countrymen. They survived the journey from the Karnak temple to Room 4 of the British Museum, but, unless they're going home, any further is a step too far.

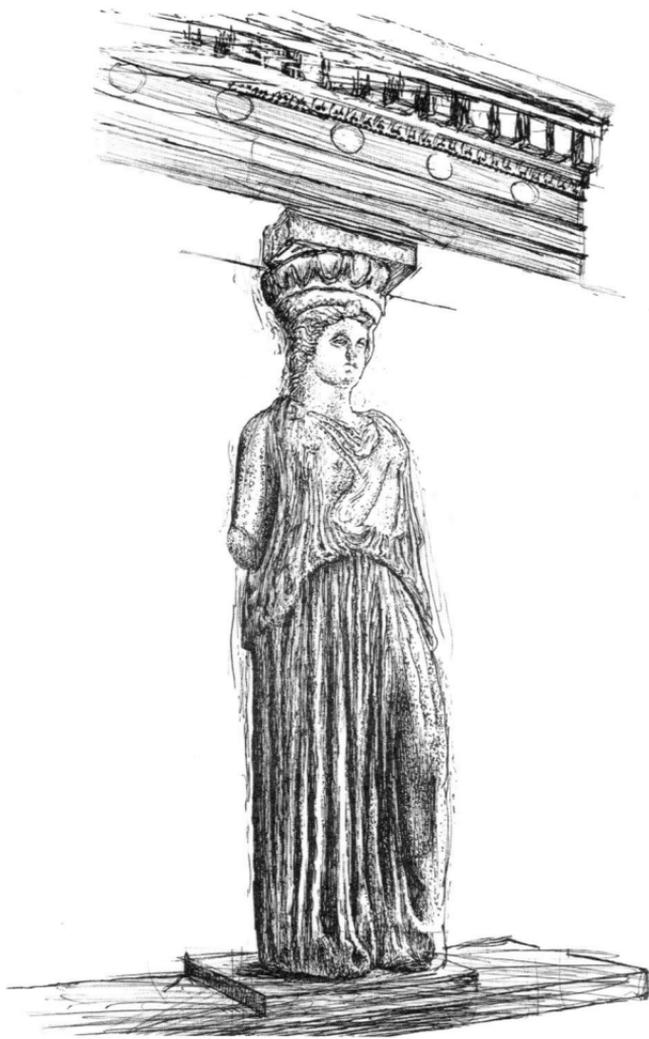

SONGS OF A MURKY PRISON

As we leave the Egyptian Sculpture gallery, we pass through Room 8, which is signposted "Assyria – Nimrud" and come upon the regal lamassu from Nimrud, an ancient city near present-day Mosul in northern Iraq. A lamassu is a bearded and winged lion-centaur, a majestic bulwark extending out from a wall of gypsum. This one was integrated into the fortifications of the royal palace of Ashurnasirpal II in the 9th century BC, to protect the king from demonic forces. The devilry of the likewise bearded Liberal MP, archaeologist and travel writer Austen Henry Layard must have caught the palace's protector off guard, when Layard removed the lamassu in 1845. Layard's travelogues *Nineveh and Its Remains* and *The Monuments of Nineveh* sold in great volume, successfully monetising the author's self-mythologising exploits of trafficked antiquities.

Warders tend to rush past the lamassu in the Assyrian gallery. Some of them have complained of a cold spell surrounding the lamassu like a chilly forcefield. They're careful to point out that this chill isn't caused by vents or drafts from any doorway. One warder said she's heard the sound of scratching coming from its many big-knuckled feet, which she attributes to a rudimentary game etched into its base by Roman soldiers thousands of years ago.[1] In the warder's estimation, the marks match the sound, and so the needling of idle soldiers scrapes on. The activation of this agitated

sound reminds the night-roving warder that now it's the lamassu idling in a strange land.

We pass through the roundabout of Room 23, swirl round a spiral of schoolchildren who always seem to get waylaid at the sight of the crouching sculpture of Lely Venus at the gallery's centre, and enter Gallery 17, where the Nereid Monument stands – a lofty sculpted tomb from Lycia, present-day Anatolia in Turkey, built around 380 BC.

Visitors often stop mid-stride when entering Gallery 17, not in appreciation of the magnificent stonework, which can't be beheld at a distance, but at the jarring realisation that a fully reconstructed tomb is sat stooping at the far end of the room, cut off from earth and sky. A burial vessel is customarily planted deep in the soil to join in communion with others who have passed on, its exposed dome an unimpeded point of intercession with the heavens. Grave-robbing nominally refers to the contents of the grave, but here we are presented with an entire mausoleum scalped from its hilltop home by Charles Fellows, a British archaeologist, and broken down into sections to be reassembled inside a museological monument to British Empire.

In the evening, the Nereid Monument is often used as a setting for concerts. String quartets pull their bows, holding notes in a controlled shiver on the museum floor in front of rows of seated guests. The concert-goers' heads tilt up towards the softly lit, ancient and expectant tomb where three headless statues in sinuous robes halt mid-sway, in a pose they've held for nearly 3,000 years.

The Nereid Monument is the tomb of Arbinas who, in the 5th century BC, ruled Western Lycia on behalf of the Persian Empire. The Lycians were a seafaring people, living within the Athenian maritime empire, and so accordingly Arbinas's tomb is

in the style of a Greek temple decorated with sculpted sea nymphs –
nereids or eliyānas as they were known locally – with windblown
hair like weathervanes cutting through choppy waters and guiding
sailors ashore. Arbinas's tomb was also built in keeping with
Zoroastrian principles favoured in Iran, constituted of thick stone,
elevated on plinths and containing solitary, windowless chambers.[2]

Several warders, unbeknown to one another, confirmed that
in the early hours music emanates from the dome of the Nereid
Monument. These curious tones sound to the passing guard "like
Ancient Egyptian music", evoking a time when migration and
musical exchange between Greeks, Turks and Egyptians was fluid.
The warders offer no explanation for this phenomenon. In the
same way that these floorboards creak and that door is fussy, the
dome releases music from time to time, like a chimney billowing
smoke when the frost hits. Only unlike the floorboards or a
chimney, the warders were stunned and soothed by the tones issuing
forth from the dome.

"DL", who came into the museum as a contract surveyor, emailed
me photographs he had taken in the course of his work, of bright
blue orbs hovering around the Nereid Monument's dome – where
the music comes from and where no lights are mounted, much less
blue spheres soaring free. Alongside these images, he submitted
a photograph of a lone orb among the pieces of the Parthenon
monument in Room 18.

Behind the Nereid Monument in Room 19, a gallery whose entrance
is obscured by Arbinas's tomb and which is often closed without
warning, we find the Lost Caryatid. A caryatid is an architectural
support, a column in the form of a woman's body. A lonesome

presence, this caryatid is counted as lost as she lives in perpetual estrangement from her five sisters who together held the canopy of the Porch of the Maidens at the Erechtheion (or Erechtheum) temple in Athens.

In 2018, I met Emelie Ieremia in Tromsø, in the north of Norway, far from the clamorous crowds of Bloomsbury. I led a two-week workshop on storytelling and documentary at the university there, where I presented an early sampling of my findings from the British Museum. Afterwards, Emilie came forward. Born in Stockholm of Greek descent, with jet-black hair, glasses and a reserved yet playful manner, she contributed a story that has long circulated within her family. We sat in a soundproof side room used for recording, and I got my mic set up.

"When I was a child, my grandmother, she told me this story about the Lost Caryatid, it was removed by Lord Elgin, the ambassador of Britain." Emilie sat upright in the studio chair, careful not to misrepresent what her grandmother had said. "She told me that apart from taking the marbles from the Parthenon temple, he also took one column pillar from the external temple on the northern side of the Acropolis mountain in Athens. And it was this female figure, a statue, that's what a caryatid is, acting as a pillar. He wanted to use this pillar as a decoration for his mansion in Scotland. But it's back and forth why he did it, and if he did it because he wanted to save the cultural heritage from the Ottomans that were occupying the city at that time. And I guess that's also the case for the British Museum today, that's why they're saving it, or not giving it back to the Greek state."

I thought that was generous of her.

"That's what they say," I chuckled, "but what did your grandmother tell you?"

"She told me that when they had removed her, the staff could hear her crying in the coffin the whole way."

I couldn't help but notice how Emelie identified the caryatid as "her", and used "coffin" as the most natural, self-evident designation for the crate that they put her in. Neither term merited any further explication. The idea that the Parthenon sculptures are incarnations, more alive than life-like, has a long pedigree. The Greek historian Plutarch wrote in 75 A D that the works of the Periclean age – which would include the Lost Caryatid and her sisters – possess a quality "which keeps their beauty untouched by time, as if they had perpetual breath of life, and an unageing soul mingled in their composition".[3] As I imagined the Lost Caryatid's cries arising from her coffin, bewildering imperial deckhands in the belly of a ship bowed by the sheer tonnage of the fragments of the Parthenon, Emelie carried on, carefully rethreading her grandmother's words.

"About the left caryatids. There are six of them, and the left ones, it's also said that they were crying for their lost sister at night."

The sisters' anguished polyphony ringing out through the Athenian hills is present in historical accounts:

When the Caryatid was removed from the Erechtheum
the whole town filled with the doleful sighs and lamentations
as the remaining Caryatids mourned their "ravished sister."[4]

Wailing also barraged Greek labourers who were in cahoots with Elgin's men.

It was also said that some Greeks, who were conveying a
chest of Lord Elgin's marbles to the Piraeus, suddenly threw
it down and could not be prevailed upon to touch it for some

time, protesting that they could hear the enchanted spirit within the sculpture "crying out and groaning for his fellow spirits . . ."[5]

Thomas Bruce, the seventh Earl of Elgin, born in Broomhall House in Fife, Scotland, was appointed Ambassador to the Ottoman Empire in 1798, with a limited remit to employ artists to draw and make casts of the Acropolis in Athens. By 1812, he'd shipped out over 120 tonnes of marbles in an act of industrial-scale theft that haunts the United Kingdom to this day, at the level of international trade deals, UNESCO declarations and official complaints to the UN's International Court of Justice. Elgin's misadventures in Athens read like a slapstick sequence of tragic farce, a walking refutation of the notion that the British should be entrusted with others' material heritage.

The Parthenon is a temple erected in the 5th century BC, dedicated to the goddess Athena, the protectress of Athens, at the Acropolis – an ancient citadel on a rocky mountain above the Greek capital. It is widely considered the crowning achievement of Greek classical art and architecture, and is equally revered for the values it embodies – the genesis of Western democracy, and the storied history of Athens and its attendant gods.

In order to "save" the sculptures that had stood for millennia from vandalism, theft and occasional rain, Elgin stole half of the Parthenon. Marble saws cleaved limbs and torsos in two, and friezes were violently removed and shattered under the reckless force of his men. Elgin's eyes were evidently bigger than his stomach, or his greed in excess of his nautical know-how, as his ship the *Mentor* sank off the island of Kythira, leaving a substantial portion of the Parthenon sculptures on the seafloor for over two years. Many more

fragments of the monument were stashed at the port of Piraeus as royal warships and private freighters ferried them to London. Elgin was taken as a prisoner of war in France and returned home facing tremendous debt, exacerbated by a costly divorce, forcing him to sell his spoils to the British government.

While Lord Byron ridiculed Elgin in verse, a parliamentary select committee was formed in 1816 to debate whether the government should purchase the "marbles". A quizzical letter submitted by prominent banker Hugh Hamersley read, "It was to be regretted that the government had not restrained this act of spoliation; but, as it had been committed, we should exert ourselves to wipe off the stain, and not place in the museum a monument to our disgrace."[6] One committee member issued a warning that "If ambassadors were encouraged to make these speculations, many might return in the character of merchants." The politician Sir John Newport argued, "The Honourable Lord has taken advantage of the most unjustifiable means and has committed the most flagrant pillages. It was, it seems, fatal that a representative of our country loots those objects that the Turks and other barbarians had considered sacred."[7]

In parliamentary debate, the British political class positioned themselves as reluctant saviours of the relics of Western classicism, rescuing cultural heritage from the occupying Turks and from the modern-day Greeks who had regressed into peasants, unfit heirs to their own heritage. Newport duly added that the government's pay-out to Elgin would "sanction acts of public robbery". All of these arguments volleyed back and forth in Parliament only had the effect of bringing the price down. The government agreed to pay Elgin £35,000, only half of what he spent out of his own pocket in removal, shipping and lavish gifts to Ottoman officials.

Elgin's dreams of making a fortune from the butchering of the Parthenon evaporated, spelling his ruin.

Elgin died in Paris, hiding out from creditors. Whether from syphilis or some more obscure affliction, he was disfigured by a deteriorative disease and lived the latter part of his life without a nose, an affliction more common to statues than men, and a curious fate for a man whose legacy is the dismemberment and exiling of mighty beings of stone and marble.

In the 1930s, the notoriously unscrupulous art dealer Joseph Duveen spent a hundred thousand pounds to construct a wing bearing his name to house the Parthenon sculptures at the British Museum and, in 1937, he commissioned a team of masons to "remove discoloration" from the stones. The masons took up wire brushes and copper chisels and scrubbed off the skin, the polished outer layer that protects marble from having pores, being dirtied by the particles in the air and losing its shine. Duveen insisted the sculptures should be more white,[8] deforming them irreparably.

The Duveen gallery opened to the public in 1939 and was obliterated in the Blitz in 1941. It had been emptied beforehand, and none of the sculptures were damaged in the bombardment, but any claim that the museum is a safe repository for the world's treasures would have to be measured against other sites that haven't suffered a devastating aerial assault within living memory. Duveen's insistence that the Parthenon sculptures be scrubbed white with wire brushes is also testament to their being better off in their home country, where people know them well enough to give them proper care.

*

In August 2023, news broke that Peter Higgs, a senior curator in the British Museum's Greek and Roman department, had been dismissed from his post in connection with the discovery that thousands of antiquities worth an estimated tens of millions of pounds were missing from the museum. A police investigation was launched, precipitating the resignation of director Hartwig Fischer and deputy director Jonathan Williams, both of whom had been alerted that items from the Museum's collection were being sold on eBay years before these sales were made public and had failed to take appropriate action. Higgs's son protested his father's innocence, and, to date, police have not announced any charges.

When all else fails, especially in cases like the dismemberment of the Parthenon, where it's plain to see that its collections were wrongly acquired, the British Museum has always claimed to have world-class facilities where the safeguarding of material heritage is absolute. With this news, the museum's oft-repeated claims of superior standards of guardianship were proven manifestly false. The very thought that the curator responsible for the artefacts from the Parthenon collections might have anything to do with selling stolen antiquities on eBay dealt a staggering blow to the museum's reputation, throwing the institution into a full-scale crisis of legitimacy.

I spoke by phone with Lydia Koniordou, an accomplished actor who served as Greek Minister of Culture under the Tsipras government in the late 2010s. Koniordou is a passionate advocate of Greek cultural heritage and has argued for the reunification of the Parthenon at the highest levels of government. From her home

in Athens, she sought to reframe the problem of the Parthenon sculptures at the British Museum.

"We contemporary Greeks, we understand that ancient heritage is part of a world heritage that we must take care of, in the name of humanity, not just the Greeks." Koniordou rejected the framing of repatriation as insufficient. "We speak of reunification, not repatriation, right? We're not talking from a nationalistic point of view. It's not a nationalistic pride. It's a matter of identity. For the Greeks, ever since they've known themselves, they have lived among these monuments. Even though they wouldn't understand, if they were not educated, their specific importance, they felt it. So we need to work very, very hard in order to protect this heritage and also make it alive. Because it is alive." For clarity's sake, she reiterated, "We are asking for the reunification of a destroyed entity, which is this monument."

Prior to the public disclosure that items were missing from the Greek and Roman department, the British Museum, led by Tory politician and architect-of-austerity-turned-chairman of the museum's Board of Trustees George Osborne, was discussing a "cultural partnership" with Greece. Outlining the terms of this partnership, Osborne proposed the return of the Parthenon sculptures to Greece as a loan.

In a position consistent with that of the current Greek government and each prior administration, Koniordou rejected the suggestion outright.

"The Greek people will not accept the partial return of the monument, and of the sculpture. We cannot accept it as a loan, or a long-term loan, because that means that we accept that this is owned by the British Museum." In a similar vein, in 2022, when the Vatican returned three of the Parthenon sculptures to an archbishop of the

Greek Orthodox Church, it did so as a "donation", sidestepping the legal implications of a "return" at the state level.

The Greek government has never recognised the British Museum's ownership of the Parthenon sculptures, and in light of the news of possible thefts, its stewardship has once again been shown to be grievously lacking. As Koniordou put it, "We saw now, with all these thousands of pieces. . ." Koniordou pointed to the unfolding scandal in the Greek and Roman department. "It's negligence. The Greek artefacts are much better kept in Greece."

She reached for an analogy to underscore the absurdity of the situation:

Would it be possible to imagine Guernica being cut – and one horse given to one museum, and two horses to another, and one fist here and there? This is outrageous. This is an act of barbarism. What has been done to this monument, it's an act of barbarism, a trauma being done against global heritage, and this trauma must be healed. It has to be reunited for the sake of the decency of the human race; otherwise we are barbarians.

Nobody wants a great country like the UK to be humiliated or to do something against their will. They must do it out of generosity.

Koniordou recalled her message as a visiting official:

This is what I told them, that this is a great moment for you to show your generosity to humanity, and how important you think that culture is for people and not just, you know, power.

This is a big moment for you to show your generosity, and to do something which is right.

I believe that there will be a moment when diplomatically Britain will gain by returning the sculptures, by doing a gesture of greater meaning, which will bring you back some kind of profit in another way, and not necessarily some of the treasures of the Greek National Museum.

I have a feeling that this time is coming closer.

Today the display of the Parthenon sculptures at the British Museum is marred by the eyesore of their prolonged exile. Once a millstone around Elgin's neck, at the British Museum they brand the United Kingdom as an unrepentant kleptocracy.

The infamous British Museum Act of 1963 forbids deaccession of the museum's holdings in the absence of a further Act of Parliament. In other words, the museum is barred from getting rid of artefacts without Parliament's express approval in the form of a new law. And so, for the past 60 years, Westminster and the British Museum's Board of Trustees have engaged in a Chinese finger-trap model of manufactured legal limbo, where Parliament insists that repatriation is a matter for the trustees to decide, while the trustees maintain that repatriating material heritage requires an Act of Parliament, both parties feigning powerlessness in an unstated agreement to uphold a rancid status quo, with the near-religious refusal to part with stolen material heritage at its core.

In the soundproof studio above the Arctic Circle, sensing that our interview was nearing its end, I asked Emilie a closing question.

"When your grandmother told you the story of the caryatids, what did you think of it?"

"I believed in it. It's something very important for her, and our family in a way. I mean it's, I guess these events are part of our history and identity. You just accept the stories as a child. Later on, it's another story."

"So what do you think of it now?" I enquired.

Emilie paused in deliberation and then, in a mysterious tone of quiet defiance, said, "I think this story is there for a reason."

The reason for the story is an inextinguishable knowledge of home. Elgin divided the six sisters from the Erechtheion temple into left and lost – the Lost Caryatid crying out for her sisters who stayed, and the caryatids left behind crying out for the sister they lost. While the British Museum treats them as objects whose ownership can be established by a trail of receipts and memos (though the Ottoman-issued firman which Elgin claimed gave him permission to remove the sculptures has not been found to exist), Greece recognises no such claims. The sculptures are subjects just like us, with an inalienable right to return home.

The museum's disgraced former director Hartwig Fischer once said that the removal of the Parthenon marbles was a "creative act".[9] Lydia Koniordou summed up the caryatid's removal in more stark terms: "She was abducted and taken to a museum as a trophy." While ruling out their return, British Prime Minister Rishi Sunak spoke in 2023 of the "Elgin marbles" as a "huge asset", outing himself as the former hedge funder that he is. Meanwhile, Prokopis Pavlopoulos, the former President of Greece, has called the British Museum a "murky prison"[10] over its obstinate refusal to let the Parthenon sculptures return home.

This is the chasm of misunderstanding that has to be bridged – between museums that retain objects and communities that are actively missing subjects. The British Museum, and the British government which legislates its dealings, are worried about losing collections and tourism revenue, and about potential liability – they are concerned that any "return" could be understood as an implicit admission of cultural heritage crimes. Meanwhile, those with ears to hear the caryatids' spectral cries can no longer countenance these so-called marbles with "unageing soul mingled in their composition"[11] being kept in bondage, in departments where artefacts are disappearing, as the price of the British reluctance to atone.

A lone child, about seven years old, in fresh trainers and thick glasses, skips through the tangle of airless Greek sculpture galleries that lead to the Cracherode room. The child speeds up, giving voice to the flight impulse felt by the rest of us, fleeing the dead air in one of the museum's most stagnant public quarters, which is often closed on account of a leaky roof. The natural light of the Great Court seeps into the room and orients us again towards the museum's round atrium. The skipping child dissolves in the sun, dissipating like a figure in an overexposed photograph.

CHAPTER 7

HOUSE OF SPIRITS
IN THE BASEMENT

From the Cracherode room, we drift into Room 24, which is supported by the Wellcome Trust, a foundation for health research. Born in 1853 to missionaries in frontier-era Wisconsin, Henry Wellcome was a pharmaceutical magnate and an archaeologist with a keen interest in medical artefacts, a selection of which are now spread about Room 24.

As we enter the room, the Hoa Hakananai'a, a Moai or ancestor figure, stands at 2.5m (8ft) tall and weighs in at 4 tonnes. With its broad brow, narrow shoulders and attentive posture, it's instantly recognisable as a basalt statue from Rapa Nui (Easter Island). Hoa Hakananai'a translates roughly to "the lost, stolen or hidden friend". From photographs, we know that it belongs planted in its native soil where the ancestors lay, the sun lighting its forehead and belly, with a protective eye cast toward the lowlands. Instead, it faces the wall above the doorway to the Great Court, and a warder seated on a stool by the door checking their watch, their attention worn from the steady flood of schoolchildren who rush in and then stutter-step in the doorway as they find themselves in the stolen friend's gaze.

In 2018, Rapa Nui governor Tarita Alarcón Rapu wore a traditional white feather crown and vest and pleaded to a gathering of journalists and photographers assembled on the British Museum's

front steps.[1] On behalf of her travel-weary delegation, she expressed their singular desire to retrieve their stolen friend. "We all came here, but we are just the body," she told the reporters through tears. "England people have our soul." Reporters scribbled in silence at the bottom of the museum's steps, unaccustomed to taking stock of the whereabouts of souls.

The Hoa Hakananai'a was stolen from Orongo, a village of the Rapa Nui people, in 1868 by Richard Powell, a captain of the Royal Navy. Powell presented it as a gift to Queen Victoria, who then donated it to the British Museum in 1869. The museum lists the stranded ancestor as a gift of the Queen, in a museological sleight of hand that obscures Powell's original theft, and uses the monarch's infallible name to launder stolen property.

The Ma'u Henna community on Rapa Nui, with support from the mainland Chilean government, has offered to produce an exact replica for the British Museum in a proposed swap for their stolen ancestor. They have offered to put their own ancient stone-carving knowledge to use, with the aid of the latest technological tools through a partnership with the Bishop Museum in Hawaii. The British Museum hardly acknowledged the offer. Its spokespeople restated the usual talking points about how admission to the museum is free of charge, and how millions of people see the stolen friend each year, nearly all of whom are rank strangers.

The Hoa Hakananai'a watches over the entrance to the African gallery below. To enter this gallery you must descend two small sets of stairs leading to a set of glass double doors beneath Room 24. The African gallery's underground location is often criticised as being hidden away or put low – "Africa in the basement" is a

familiar formulation – while others are more generous in assessing the gallery's place as foundational. Leaving aside the distinction between "Saharan" and "Sub-Saharan" Africa in the Western imaginary, which results in Egypt and Sudan constituting a separate department, prior to the turn of the millennium there was no African gallery at the British Museum. It is only with the millennial expansion that included the construction of the Great Court that the Department of Africa, Oceania and the Americas joined the main site at Bloomsbury.

The African collection's place within the British Museum is a point of sensitivity because the full extent of Britain's violent underdevelopment of Africa[2] has yet to be reckoned with. A less than prominent positioning, paired with untold numbers of artefacts languishing in Storage, is understood by many as a continued policy of hoarding African resources, in this case invaluable cultural and spiritual resources with cosmological underpinnings and uses scarcely understood outside of their communities of origin.

The gallery is awash in low, warm lighting. It's more of a "white cube" type of space than most of the British Museum's galleries, perhaps because it's underground, or because the works on display are a mixture of contemporary African art and traditional relics – that is to say, things designed to be seen in exhibition spaces and others not meant for the average visitor's eyes. The atmosphere is accordingly a little uneasy. There is the head of an Ife king so lifelike he appears to be sleeping with his eyes open. There's a vitrine of extraordinary floating hats, helmets and headgear from across the continent. Highly stylised swords and knives, intricately carved ivory salt-cellars, wood-sculpted and caned chairs, examples of textiles and ritual masks, sit alongside contemporary works of painting and sculpture. Some ask you to look upon them, others watch you.

Many of the stories in this gallery centre on an Nkisi from the Congo, which people in the museum call Kozo. This Nkisi appears as a tailless, two-headed wooden dog with zagging incisors, whose back is bristling with nails and fin-like rusty blades protruding in all directions, with wiry fragments and chunks of bone mixed in. Its catalogue number, "1905 5-25 6", is painted directly on its cheek in white. Its feet are like those of a table, with nubby indentations denoting toes. The clanging of its making is almost audible. A stone cylinder is lodged atop its back, its surface is that of an altar that's seen plenty of use, with still more winding blades reaching up from its vertebrae like prickly sprouts breaking soil in spring. Some visitors are drawn to the Nkisi. I'm more often moved to look away.

I met a Storage assistant for a pint in the Stag's Head, an old East End boozer across from the British Museum's storage facility in Orsman Road, Haggerston. It was early in the evening and the sweet smell of spilled ale was in the air. A large portion of the African Department's storage is over the road at Franks' House, a three-storey brick-build on Regent's Canal neighboured by newly converted luxury flats and council estates. Before I pressed record on my portable mic, the Storage worker specified that they wanted to speak anonymously on account of the strict code of silence observed in their department.

I brought up the fact that the Nkisi described above is classed by the museum as a "fetish object" and asked how they understand the use of that term. The Storage worker confessed that, "What the museum calls 'fetishes', that's a word for 'thing that we don't know enough about to describe'."

These so-called fetish objects are sometimes imbued with poison to repel the uninitiated, and consequently British Museum Storage workers and conservators do on occasion fall ill.

"I know people who have opened something up, and it's had a burst abrus seed [†] in it, and they've had to go to A&E . . . You have to put a hazmask on, because a lot of those poisons are still real. A lot of these religious, 'fetish objects', as they're called, make me feel sick."

It is not just the still-active toxins that cause the Storage assistant's stomach to turn, but the caustic mixture of dodgy acquisition and palpably sacred function: "I find there to be something uniquely horrifying about clearly spiritual objects that were created with care and held a lot of power, and you don't know how they were collected." What little we do know can be enough to induce queasiness, they confessed over the clamour growing in the pub. In addition to unequal barter and theft, the museum acquired many artefacts through organisations that sought to rid Africans of their religion. "Many of them were given up by people who converted to Christianity. That's how a lot of them came into the museum – donated by the Missionary Society from converts in West Africa. As an act of showing that you've joined the church, you would give up your relics."

While making the rounds, back before warders started patrolling in pairs, one of the Permanent Nights had slowly come to understand the Nkisi in Room 25 as a "a powerful object". Late one night, for

† *Abrus* sp., a pan-tropical climbing plant whose red and black seeds have numerous decorative, ritual and practical uses, but which also contain the deadly toxin abrin.

reasons unknown, he stood in front of the two-headed dog, raised his finger and pointed directly at it. And at that very moment, as if on cue, all of the alarms in the gallery resoundingly went off – "It really freaked him out." The blaring throb of the activated alarm bouncing off the subterrestrial gallery's walls only served to confirm his suspicions of the Nkisi's strength.

The warder went home and, still trying to make sense of the encounter, he told his brother about it. A couple of days later, the brother came in to have a look for himself. The two men went down to Room 25, where the warder once again pointed at Kozo. All the alarms went off for a second time, this time during visiting hours, with a gallery full of visitors and with the warder's brother standing by as a witness forewarned. Now they were both freaked out, and duly converted to a belief in the Nkisi's power.

In Bakongolese tradition,[†] in the able hands of a trained spiritual practitioner known as an Nganga, a Nkisi mediates between the living and the dead. This inter-dimensional mediation is prompted by the Nganga, who performs invocations while driving blades into its back. Like the Nganga, the warder did something that caused Kozo to act. The gesture of pointing his finger might even be understood as a formal echo of the Nganga lodging a pointed iron into the Nkisi's spine, thus triggering the alarm system.[3]

Over and again, we see the infrastructure of Security – alarms, CCTV, gates and doors – flipped and turned against museum staff, inverting the roles of host and captive that structure the museum, as if to say, "It is *you* who are in *my* space, and your security, not mine, which is in question."

[†] The British Museum's online registry lists its origin as "Bakongo (?)"

When I asked how the warder understood this Nkisi's power, he told me simply: "It just was. It just was powerful."

There are persistent reports of cleaners who don't like to clean near the Nkisi. While some find themselves inexplicably drawn towards it, those who are compelled to dust it prefer to keep a respectful distance.

At the opposite end of Room 25, there is a wall of Benin Bronzes suspended in a grid formation, their shadows distending across the sterile white backdrop as if reaching out for a world they were culled from.

The kingdom of Benin dates from around the 12th century A D and is located in what is now southern Nigeria (not to be confused with the contemporary nation-state of Benin). Benin's rulers, whose arrival oral accounts trace back to many centuries before, are said to have come down from the sky, their royal lineage being of the divine. The kingdom was by all accounts extraordinary, the length of Benin City's walls exceeding those of the Great Wall of China, and it had some of the world's first streetlights, powered by palm oil.[4]

Benin, whose people are known as the Edo or the Bini, is famed for its workers' guilds, where craftsmen lived and worked together, with over 40 guilds organised to serve the Oba, or king. The Edo are especially renowned as metalworkers. Europeans were stupefied by Benin's lost-wax casting techniques, which were far more advanced than the contemporaneous methods of medieval Europe. The Benin Bronzes are, in fact, made of brass, with elements of ivory and wood also present. Among the Edo, brass was understood to repel evil,[5] and its use was reserved for the royal court. Each time an event of note took place, the king commissioned metalworkers to record it.

The Bronzes are therefore the foundational stories of the kingdom, a record of divine rule and an embodiment of its continuity, more so than any written text or oral tradition.

The British looted thousands of Benin Bronzes in 1897, in a "punitive" raid conducted in the era of British colonial consolidation of West Africa. The word "punitive" in this context refers mostly to Benin's unwillingness to submit to economic subjugation imposed by British authorities. Benin traded with European merchants from the 15th century on, beginning with the Portuguese. By the 1860s the British were hell-bent on monopolising Benin's palm oil and rubber trade. In response, the Oba sought to cease all trade with the British, but the British weren't having it and tried for three decades, through various means of diplomatic gift-giving and duplicitous agreements, to gain control of the kingdom's resources. In 1897, a small British delegation, headed by James Phillips, the acting Consul General of the Niger Coast Protectorate forces, showed up unannounced to meet with Oba Ovonramwen, and was turned away because the Oba was engaged in a religious ceremony. The British knew that Ovonramwen was in ritual isolation during the annual Ague festival, and Phillips's men were warned, but attempted to force their way in, to provoke a pretext for a broader attack. The British delegation was driven out by Edo warriors. Several of Phillips's men were killed, along with hundreds of African carriers who accompanied them.

The British then mobilised over 1,200 soldiers led by Vice Admiral Sir Harry Lawson. Backed by ten naval warships and equipped with Maxim machine guns, they launched an all-out assault on the city, to finally wrest control of Benin by force.

It took ten days of heavy fighting to breach the kingdom's borders, but once British forces were in, they set fire to civilian homes, to places of worship and royal palaces, firing then-experimental exploding bullets on civilians,[6] and looting residences of note. British forces kept no record of the number who died in this assault, but the indiscriminate torching of the city means that the figure was probably in the tens of thousands.

Having caught wind of reports of looting in Benin in the *Standard* newspaper on 16 March 1897, Charles Hercules Read, curator and keeper of British and Mediaeval Antiquities and Ethnography at the British Museum, wrote to the museum's director, Sir Edward Maunde Thompson, the very next day to recommend that the museum acquire the spoils.

> I saw in the papers yesterday a telegram from Lagos announcing the return of the Hon. G. W. Neville from Benin, and stating that Mr Neville brought to Lagos specimens of antique ivory, bronze, and other native ornaments. I think it would be desirable to ascertain from the proper quarter whether these articles, and perhaps many other similar things, that have been discovered by our officers in Benin, could not be secured for the British Museum. So far as my department of the Museum is concerned, I should be quite prepared to recommend the Trustees to pay a fair price for any such objects.

Read ended his letter by expressing his desire for a more streamlined approach for bringing such plunder into the museum:

> I wish it could be made known to our officers and men who go on such expeditions as this so fortunately ended, that the national Museum is anxious to acquire the native "curiosities" that so often fall into their hands.[7]

Today the British Museum holds over 900 Benin Bronzes, the largest concentration held in any Western institution.

Back in the 1970s, most of the African collections were kept at Orsman Road – all but the Benin collections and certain African textiles, which were held at the Museum of Mankind, a satellite facility of the British Museum, located at 6 Burlington Gardens in Mayfair, now part of the Royal Academy. Between 1970 and 1997, the Museum of Mankind held and exhibited the "ethnographic" collections and was home to the museum's anthropology library. The "ethnographic" collections consisted of material from Africa, Oceania, the Americas and certain "tribal" collections of Europe and Asia. Burlington Gardens was treated as a secondary site of miscellanea that wasn't earmarked for the main Bloomsbury site.

The Museum of Mankind closed in 1997 and is scarcely spoken of these days, if only on account of its unfashionable name, which calls up the heavily racialised, freak-show aspect of ethnographic museums, where the "savagery" of other peoples and the right to rule over those depicted as savages is at every turn affirmed in the service of sustaining empire.

Nii Kwate Owoo's 1970 film *You Hide Me* is an extraordinary

glimpse into the African department's storage at the Museum of Mankind. Shot entirely within the confines of the museum's restricted-access vaults of African holdings, the film shows the young Ghanaian filmmaker and a companion (Margaret Ekua Prah, who currently serves as Ghana's High Commissioner to Zambia) marvelling at the ancestral treasures enfolded in suffocating plastic bags, stuffed into crates and placed on unending tiers of metal shelving. In place of daily offerings of libations, food and prayers, archival practice – regulating temperature and humidity, and restricting exposure to life-giving forces such as sunlight and human touch – is the standard of care that museums are qualified to offer.

In a searching voice-over, Kwate Owoo considers the significance of so much African heritage being hidden in the British Museum, and other colonial and ethnographic museums of its ilk.

First, they destroy a civilisation and condemn it as primitive and non-human, then they rehabilitate certain parts of it as examples of high civilisation. They refuse to understand African civilisation, then they present themselves as the experts on the subject and decide which are the masterpieces of African art, which is now becoming a very profitable business in Europe and America.

You Hide Me leaves us with the impression of Storage as a place of neglect, of institutionally enforced separation and profound loneliness. Kwate Owoo's foray into museum storage is not unlike a prison visit with long-lost relatives. The film ends with an imperative: "We the people of Africa, and of African descent, demand that our works of art, which embodies our history, our civilisation, our

religion and culture, should immediately and unconditionally be returned to us."[8]

I got in touch with Chris Spring through my friend Satch Hoyt, an artist and musician. When we met in Berlin in early 2022, Satch was negotiating to get into the British Museum's collection of African instruments, so that they can be played again.[9]

Chris Spring is an artist himself, a painter who worked his way up from the lowly position of assistant to a librarian at the Museum of Mankind in the 1970s to becoming a curator of the British Museum's African collections, a post he held from 1987 to 2017. During that time, Spring made a concerted effort to commission new works by contemporary African artists, to move away from the colonial grounding of so much of the museum's African collection. I met him for coffee in the Members' Room cafe in January 2023. Short, with greying curly hair, glasses and a slightly wild look in his eyes, he laid his scarf across the back of his chair and, over the ringing of cutlery, he recounted the one episode that came to mind when he heard that I was collecting ghost stories.

"I was still making coffee for the librarian, so I was probably wheeling books along," Spring remembered. For a couple of weeks in the 1970s, in an underground corridor only accessible to staff at the Museum of Mankind, construction was underway. A ramp was being built at the entrance to the storage space that held the Benin Bronzes, so that they could be carted in and out using a trolley, rather than being lugged up and down the unforgiving stairs. For weeks the shrill sound of drilling filled the basement, unsettling the subterranean storerooms and

throttling the corridors with a sporadic pall of concrete dust particles.

"When they were doing this drilling, when they packed up working in the evening," Spring recalled, sifting through the memories of the basement corridor, all those years ago, "I'd come out and I'd just see these figures by this ramp." The surprise still resonant in his voice, he set the scene. "It was a long, long corridor, from one end of the museum to the other in the basement. I was at one end of it, and they were at the other end. I thought to start with it was just my mate Royston." But when he called out to Royston and there was no response, he started to reconsider, and began a slow march towards them. "Then I thought they were the guys working on the ramp." He hastened his stride as the riddle of the figures grew in complexity. He second-guessed the worker hypothesis – "I thought it was odd that they seemed to be kind of stationary – they were not working on anything."

Two figures stood tall, one on either side of the entrance to the storeroom where the Benin collections were held. "As if they were standing guard, like one of those people in front of Buckingham Palace or something." Spring called out to them. They stood motionless and unresponsive, and then, "As soon as I boldly started walking toward them, they just disappeared . . ."

Spring's observation that these figures were reminiscent of royal guards, unmoved and unyielding in silent defence, reminds us that Benin too is a kingdom. When British forces attacked Benin City and looted the Bronzes, the Kingdom of Benin was overwhelmed by British firepower. The city burned uncontrollably for days. Did these two figures perish in the fire? Or were they guards of an ancestral register, ever present but rarely seen, asserting their presence as the

drilling – the breaking up of earth on their doorstep – stirred up memories of the consuming squall of industrial warfare?

"I saw them a couple of times while that ramp was being built," Spring remarked, noting that the figures' presence in the Burlington Gardens basement wasn't a one-off. "They were making that ramp for about two or three weeks maximum. As soon as they made the ramp and concreted it over, I didn't see them again. It was just during that drilling."

Having ruled out Royston, the day-to-day museum staff and short-term contractors, Spring is unequivocal in naming what he saw. "That's the only kind of spirit manifestation that I can remember." He naturally relates the guards standing at attention to the section of Storage that they appeared to be guarding – the Benin Bronzes. "They're works of great spiritual significance and power, historically and still. Even though the colonial authorities may have taken away military power and political systems, they still have enormous power."

In 1996 Prince Edun Akenzwa wrote directly to Queen Elizabeth, his royal counterpart, requesting the return of Benin's looted heritage:

These objects not only contain the history of my people but also are used in our ceremonies as part of our cultural and religious beliefs. Your Majesty may be aware that our ceremonies, dating back hundreds of years, have not been written down as indeed have some of Yours, but have been recorded faithfully and accurately in the Bronze plaques. For example, at the time of my coronation as Oba, because

my father, the previous Oba, had ruled for almost 50 years, a certain part of the ceremonies had been forgotten and it was necessary for the plaques to be consulted in order to ascertain the precise adornments to be worn and the exact ceremony to be performed. Fortunately, we had the relevant Bronzes in Benin at that time and we were able to conduct the ceremonies in our traditional manner. There are many other ceremonies for which we need to scrutinise the Bronzes, but are unable to do so because of their removal. This has caused my people tremendous grief and remains a bone of contention for my people.[10]

Akenzwa makes plain that the return of the stolen Bronzes is self-evidently the right course of action, and that such a gesture would be a step towards repairing relations between the two kingdoms, as the "return of the Bronzes and Ivories would also demonstrate that injustices perpetrated against African peoples are also being addressed".[11]

At the time of this writing nearly 30 years later, this appeal from one sovereign ruler to another has yet to produce its desired result. When presented with formal repatriation requests, the British Museum has responded with the risible excuse that these brass relics that survived British firebombing and looting by its soldiers are "too fragile to travel".[12]

In an online promotional video entitled *British Museum Youth Collective presents: Quizzing the British Museum's Director*, former director Hartwig Fischer is seen chatting informally in videoconference with a handful of aspiring young museum

professionals. When presented with the ubiquitous memes about decolonising the British Museum that feature jpegs of empty galleries, Fischer responds evasively, like a ghost crab skittering sideways, and tells a curious anecdote:

"I had once the visit of the Ooni of Ife, the spiritual head of the Yoruba." Ife was a neighbouring kingdom to Benin. The Ooni, its traditional ruler, was paying a visit to his kingdom's material heritage. "He called the museum a house of spirits," Fischer recalled with delight, "and said that while he was there, he could communicate with the spirits of all times, and from all regions of the world."[13] From the bend of his knowing smile, Fischer seemed to enjoy the privilege of hanging out with a noted spiritual leader, and to feel pride in possessing an array of ancestral songbirds that he's unable to hear.

If not only the Ooni of Ife, but night-roving warders and budding curators glimpse the power and presence of these cultural entities, it is easy to see how they speak more freely, and are heard more readily at home, among kin.

If the African gallery is foundational to the British Museum and not buried underfoot as some contend, then there is undoubtedly unrest at the foundation of this "house of spirits". Centuries of violence and forced labour, of enslavement, of political interference and pillaged resources, all rationalised through the dehumanising illogic of assumed racial superiority, have sought to rob colonised Africans of interiority and community, of independent thought and action, of religious life and even afterlife. The removal of these ancestral artefacts serves a two-fold function – Indigenous knowledge can prove a source of resistance to colonisation.

The sooner a people are separated from their gods, so the coloniser imagines, the sooner they can be put to work on the plantation, in the mines or as merchants and foot soldiers in other colonies. That these ancestral presences can furnish museums, de-toothed as artworks that evidence extinct, once-great worlds, also serves the function of siphoning off knowledge to Western metropoles and enriching their tourist economies.

You don't have to crook your head to the side and squint, you don't need a spirit level to see what's crooked at the foundation of this "house of spirits". Its cornerstones stolen, its centrepieces all dislocated, built on dangerously lopsided power relations, heedless to protestations that they are not exhibiting objects but withholding ancestors, the museum is founded on unsound structural principles.

A consensus has crystallised even among the most inertia-ridden museums in the West that the Benin Bronzes are not "contested objects" in any meaningful sense, but rather incontestably looted heritage gained through catastrophic violence. Bronzes held by major museums in the United States, France, Germany and even regional museums in the UK are returning to Nigeria. The British Museum is conspicuous in its covetous isolation, fearful of sliding down the slippery slope of deaccession and unravelling empire, a fear that's fundamentally about the loss of power. It would do better to fear the misappropriated powers it scarcely understands that rumble alarm systems, poison conservators and repel cleaners, singing out to kings and standing guard against curators, roiling the depths of the museum's subterranean storerooms and exhibition spaces. Even a house of spirits must rest on a solid foundation, for in a house of spirits the winds that threaten its integrity won't blow from the east or the west, but up from a draft originating in the basement.

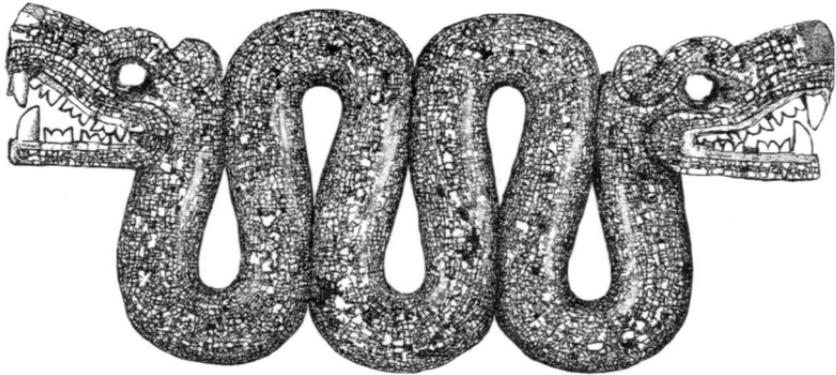

CHAPTER 8

THE ENCLOSING
SERPENT ROOM

As we come up for air, ascending the stairs from the African gallery and entering the Hoa Hakananai'a's field of vision once again, we're confronted by a crystal skull in a slim, raised vitrine. Originally introduced to the antiquities market as a relic of Aztec origin, it is now thought to be a fake, carved from Brazilian crystal in Europe in the 19th century.

When the crystal skull was on display at the Museum of Mankind, it was draped over with a black cloth every night, to keep the vitrine from accumulating dust. According to Chris Spring, the warders told him many times, "I saw that levitating again last night." The cloth would hover several feet above the glass case it had been resting on, at a height that ruled out static electricity or a basement breeze.

Spring reasoned that even though the crystal skull is a well-established fake, that doesn't mean that it isn't authentically cursed.

"You could argue that the fact that it was a European imitation of ancient Aztec sculpture, it could be the Aztec gods coming back and saying, 'Look, I'm gonna move you. I'm gonna scare the pants off these warders!'" And so the question of the troubled replica takes on further iterations, with demand in the antiquities market

making way for forgeries and tampering with the manufacture of the sacred.

Eventually it was decided that perhaps putting the black cloth over the crystal skull was "a bit like a parrot in a cage, perhaps a bit disrespectful" and the practice was brought to an end.

On our way to the Mexico gallery, we visit Room 26 – "North America" or the J P Morgan Chase Gallery of North America. With glass doors opening on to larger galleries at either end, Room 26 is a moderately sized hall that's sometimes used as a shortcut – that is, when it hasn't been closed without warning. Certain of the galleries – most frequently the African, North American and Greek galleries are unceremoniously shut when the museum is short-staffed.

I haven't yet heard any stories of unquiet artefacts in the North America gallery. I stop momentarily to pay respect to the litany of glass-encased detainees, spanning the Plains to the Arctic – arrowheads similar to the ones I'd come across as a child, stone-carved tobacco pipes shaped like birds, slitted Inuit sun visors that read as futuristic prototypes for sunglasses, harpoons and ladles, beaded moccasins and tomahawks adorned with feathers and fur, and a caribou-skin shaman's drum from the Inuit community of Igloolik Island.

A placard claims, "This exhibition introduces indigenous people and aboriginal cultures from North America, focusing on initial European contact and colonisation", but it doesn't say much more. Thinking of the many unexhibitable horrors of first contact, my mind is drawn back to Thomas Harriot, the astronomer, astrologer and mathematician who was enlisted by Sir Walter Raleigh to

navigate the seas to help found the first British colony in North America in 1585. Harriot was something of a polymath – he founded the "English school" of algebra, learned to speak Algonquin and made the first detailed mappings of the moon. In 1588, he wrote that, in the "new world", death shadowed the British colonisers at every turn.

> There was no towne where wee had any subtile devise practised against us, we leaving it unpunished or not revenged (because we sought be all meanes possible to win them by gentlenesse) but within a few dayes after our departure from everie such towne, the people began to die very fast, and many in short space; in some Townes about twentie, in some fourtie, in some sixtie, & in one six score, which in trueth was very manie in respect of their numbers.

Smallpox was ravaging the Indigenous population. For the afflicted this was a catastrophe for which there was no precedent in living memory or oral tradition. That the colonists were unaffected by the plague was a dire mystery, and a source of agonised speculation.

> The disease also was so strange, that they neither knew what it was, nor how to cure it; the like by report of the oldest men in the countrey never happened before, time out of minde [. . .] Insomuch that when some of the inhabitants which were our friends & especially the Wiroans Wingina had observed such effects in foure or five towns to follow their wicked practises, they were perswaded that it was the worke of our God though our meanes, and that wee by him

might kil and slaie whom wee would without weapons and not come neere them.

This marvelous accident in all the countrie wrought so strange opinions of us, that some people could not tel whether to thinke us gods or men, and the rather because that all the space of their sicknesse, there was no man of ours knowne to die, or that was specially sicke: they noted also that we had no women among us, neither that we did care for any of theirs.

Some therefore were of the opinion that wee were not borne of women, and therefore not mortall, but that wee were men of an old generation many yeeres past then risen again to immortalitie.

According to Harriot, some Native Americans foresaw the continued arrival of European settlers, backed by warring spirits:

Some would likewise seeme to prophesie that there were more of our generation yet to come, to kill theirs and take their places [. . .] Those that were immediatly to come after us they imagined to be in the aire, yet invisible & without bodies, & that they by our intreaty & for the love of us did make the people to die in that sort as they did by shooting invisible bullets into them.

The view that the smallpox epidemic was the work of the Englishmen's god was later propagated by John Archdale, the British colonial Governor of North and South Carolina. In a cruel and vainglorious account published in 1707, Archdale portrays the slaughter engendered by smallpox as divine intervention, to keep

the English from dirtying their hands any further in a genocidal campaign that was already well underway.

> I shall give you some farther Eminent Remark hereupon, and especially in the first settlement of Carolina, where the Hand of God was eminently seen in thinning the Indians, to make room for the English. [. . .] it at times pleased Almighty God to send unusual Sicknesses among them, as the Smallpox, to lessen their Numbers; so that the English, in Comparison to the Spaniard, have but little Indian Blood to answer for.[1]

Swept up in a pilgrim's genocidal fantasy, Archdale can hardly contain his excitement at thoughts of pestilence. Within the confused and hubristic theology of imperialism, Archdale liked to imagine angels from other far-off lands, swooping in to assist the British in their colonial enterprise.

> Now the *English* at first settling in such small Numbers, there seemed a Necessity of thinning the barbarous *Indian* Nations; Since our Cruelty is not the Instrument thereof, it pleases God to send, as I may say, an *Assyrian* Angel to do it himself. Yet will I not totally excuse the *English*, as being wholly clear of the Blood of the *Indians* in some Respects, which I at present pass over.[2]

This momentary "passing over" of colonial-era crimes is ongoing. After the Indigenous population of Virginia and the Carolinas was decimated by smallpox, the British colonists began kidnapping Indigenous women and children to replace the labour of Indigenous men who were enslaved and wiped out by disease. These raids fuelled

the discontent that led to the Tuscarora War of 1711, in which strained relations between European settlers and the Tuscarora people boiled over, leading to all-out conflict. Following that war, the Tuscarora fled north and the British began to import increasing numbers of enslaved Africans, which leads us to the Akan drum, also present behind glass in Room 26.

The Akan drum was obtained through one of Hans Sloane's contacts in Virginia, a Mr Clerk, around 1730. Sloane catalogued it as an "Indian drum made of a hollowed tree carv'd the top being brac'd wt. peggs & thongs wt. the bottom hollow", even writing "a drum from Virginia" directly on its playing surface.[3] For a long time, no one inside the British Museum questioned this provenance, but then in 1906 a curator recognised the drum as being from West Africa, and about seven decades later museum forensics confirmed this to be so. The body of the drum, with its worn geometric carvings, is of *Cordia africana*, an African evergreen tree. The six wooden pegs that fix its head in place are of *Baphia nitida*, a hardwood found on the central West African coast. The head was refitted with a deer hide in Virginia.

Enslaved people were not allowed personal belongings. They were treated as property – not eligible for the ownership thereof. Some speculate that the Akan drum was brought on board a slave ship to keep the bodies of the enslaved in working order – to bring them up from the hold for a taste of sun and fresh air, to keep their muscles in operation, so that they wouldn't succumb to the high mortality rates of the Middle Passage (the deadly journey endured by millions of enslaved Africans who were trafficked across the Atlantic) and to ensure that they would arrive on the other shore able-bodied and fit for sale.

Whatever its precise path may have been, the Akan drum

survived the Middle Passage and was a witness to many who did not. It is a material remnant of the British slave trade, and its presence in the British Museum's North American gallery is an echo of the many Africans who escaped enslavement and were taken in by Native Americans in impassably dense swamps and forests, in a joint effort to live free of the ever-encroaching, war-hungry British colonialists.

The Mexico gallery in Room 27, or the Serpent Room, as it's sometimes called, is a cavernous, diagonally domed stone room with sloping corners. This gallery was purpose-built and ever since its construction was completed, workers have complained that they don't like to go inside, especially after dark.

A slanted and triangular stone island rises from the floor, hoisting Huaxtec and Aztec figures atop a modernist armature that coyly abstracts the architecture of the temples the figures were removed from. In their open-mouthed and wide-eyed pose, the members of the silent statuary chorus appear stunned and forlorn.

The displays here are weighted towards the gory and sensational. Prominent, spot-lit placement is given to an 8th-century limestone lintel from the Mayan city of Chiapas; it depicts Itzaamnaj B'ahlam, ruler of the city of Yaxchilan, guiding a thorn-studded rope through his wife's tongue in a blood-letting ceremony that produced a transcendent spell. Then there's a 14th-century Aztec calendar carved and polished from a single human bone. A black backdrop activates the bioluminescent turquoise and oyster-shell mosaics that decorate an Aztec sacrificial knife from the 15th century; there's also a modified human skull whose exposed nasal cavity is lined

with bright red thorny oyster shell. The skull's polished pyrite eyes beam, inlaid in a gleaming white conch shell, in contrast to a rigid and unadorned jaw with a full set of teeth.

The Mexico gallery opened to the public in 1992. On a Friday evening, just after the public had cleared out, a BBC production unit was filming a segment about the inauguration of the new gallery. I spoke to someone who was on set that evening, whom I met through a journalist friend. The producer, described by the person in attendance as "an exceedingly rational Englishman", was choreographing a shot with a curator of the Mexico collections. The curator was an American, who was praised as a knowledgeable and effective speaker, with "a real Harrison Ford thing going on" – a reference to the actor's role as Indiana Jones, a character who lent sex appeal and Nazi-vanquishing righteousness to popular representations of archaeology.

With the cameras rolling and boom mics tilting overhead, the curator directed everyone's attention to an Aztec artefact – a double-headed serpent, coiled symmetrically as if poised to strike from both ends, made (like the knife and skull mentioned earlier) of a mosaic of turquoise and red thorny oyster shells. This 15th- or early 16th-century relic is thought to have been worn across the chest of a priest during ceremonial rites, which may have included human or animal sacrifices. Snakes were sacred in Aztec culture, as they invoked the plumed serpent-god Quetzalcoatl and themes associated with him, such as death, rebirth and communication between worlds.

The curator looked into the camera lens and asked the viewers at home to think about the significance of the serpent. Just as this

pregnant pause was initiated, as the first syllables of a prepared scholarly account left his lips, he noticed that the room was beginning to warm. At first he thought that maybe the air con had gone off. The cameraman hit pause while the curator exited frame to fiddle with the thermostat. The curator made a joke to paper over the nervousness in the room, before muttering that the cleaners never have liked to work in the Mexico gallery after dark.

It was getting hotter still as the minutes wore on. The curator took to checking whether the heating was on. A member of the crew tried to quietly manage the temperature by letting some cool air in. They went to crack open the door to the stairwell and found that it wouldn't budge. These are glass doors, and the Mexico gallery is small, so they couldn't have been locked in without the crew registering a warder at the door. And besides, who would want to lock them in?

"We were mildly alarmed," the bystander on set recalled, maintaining the appearance of cool as the numbers on the thermostat rose.

The heat took an increasingly claustrophobic turn. The room rapidly lost dimension as the air was alloyed with panic. The Mexico gallery seemed to have broken out in a fever, as if to flush the film crew out while denying them an exit. It was as if someone, someone in the gallery, wanted them to know what it felt like to be trapped inside. The curator's anxiety was rising visibly, like a waterline consuming a sinking ship.

"By now it was very hot. The producer was rattled. We were unnerved. We thought we were going to be roasted alive in an oven."

I'd heard tell of staff stuck in lifts, or having doors slam shut behind them, but nothing so terrifying as this. Next the lights went out. At this stage, mired in powerlessness, the curator gave up

projecting a controlled calm: no one could see him anymore anyway. With unmasked fear, he found a new, more resolute voice. "We've got to get out of here," he told the crew, then radioed for help. In the still-escalating heat, he explained that there were sacred presences in the room that had caused the change of atmosphere. As they waited for the warder to arrive, to unlatch the lock and dissolve this fever dream with cool outside air, the curator fixed his attention on the serpent. He seemed to be asking the crew to be respectful, though no one knew what precisely he meant. The time for authoritative pronouncements about the serpent had passed.

It took ages for the warder to arrive, and even this delay felt odd – like an extension of the effort to keep them stuck, and to draw out the unpleasantness of the heat. Eventually someone came, and at long last turned the key and let them out. When the crew left the room and entered the corridor, they passed through an invisible wall of heat, beyond which it was cool. One of them stepped back in the gallery to see if it was still hot inside, or if they'd imagined the whole thing, and felt no pronounced heat at all; it seemed to have returned to room temperature without any cooling-off period.

A couple of cleaners welcomed the BBC crew as they filed out. One cleaner said, "There are people who don't like going in there," sympathetically, as if she wasn't one of those people. The cleaners didn't suspect the serpent, but some of the small clay figurines stored behind glass towards the back of the gallery, as the potential source of the heat. This menagerie of figurines are from Jalisco, Tlatilco and the Gulf Coast, and have been variously formed over the past 4,000 years. Some are toys, others were plucked from graves, where they acted as tiny ancestral guides who assist the deceased in finding their way in the afterlife. It's possible that the museum is experienced as

a wrong turn and that the guides are lost, because these figurines often confound the cleaners by moving when no one's around.

Tensions eased as the curator and film crew's lungs took in the stairwell's cool air, giving way to spasms of laughter. "I thought it was hilariously funny, and the curator slightly reprimanded me, on the grounds that, 'These are not just objects.'"

Within days of hearing this story, while its contours were fresh in my mind and had yet to settle, I came back to the Mexico gallery with Andy Chaplin. Andy is a psychic medium whom I met through my walking tours at the museum. He has a shaved head and wears a round shungite pendant which hangs down over his t-shirt; there is a quiet curiosity about him that I instantly appreciated, and a brightness in the eyes that's common to psychics – he looks as if he sees things that others might not. Andy knows Patsy Sorenti well; they sometimes work together. In the context of the museum, Patsy's approach was more mediumistic – she would chat playfully with the spirits attached to the artefacts, whereas Andy seemed to key in psychically to the material conditions the artefacts had once known, which formed them energetically.

I decided not to brief Andy about the Mexico gallery in order to get an unbiased reading from him. Without any knowledge of the night that the room overheated, he spoke up. He had a burgeoning sensation.

"Smell. I get a smell connected with this room."

Not the olfactory sense that ties his nostrils to Room 27, but a psychic smell, related to but not immediately present in the Mexico gallery. The form of clairvoyance related to smell is called

clairosmesis, the gift of smelling in deep time. Interested in where this aroma might lead us, I asked him, "What kind of smell?"

"Burning. Smoke. Burning. It doesn't feel like cigarettes or a pipe. This feels like wood. It feels like this smoke, it could be connected to a village that was set on fire."

I listened to see if he picked up anything that might coincide with the television crew's experience.

"Have any of the cleaners complained of shortness of breath?"

Andy wasn't asking so much as arriving at an outline of what had transpired in Room 27. I kept quiet. "It's almost like I want to clean the floors or wax the floors, but as I'm doing it, I'm getting shortness of breath, and I have to get out of the room to recover my breath."

"This smoke," he continued, "it could be connected to a village that was set on fire. I got this mental image of a village being burned, and villagers being killed or the village being completely levelled. It's like being a European." Andy was working to position his sensations. "I'm invading these places, and I'm kind of nabbing these items, and I'm setting fire to things, and hushing up the locals, because the locals are not happy that these are being brought over here. This is their treasure, and the Europeans are nabbing it, basically. I feel like it was a brutal era."

In 1521, Hernán Cortés and an army of Spanish conquistadors and Indigenous allies besieged and laid waste to the capital city of Tenochtitlan, now Mexico City. It was perhaps the decisive battle in the fall of the Aztec Empire. Cortés ordered houses to be burned en masse, as a central, freely deployed weapon of Spanish imperial strategy.[4] Not only a scorched earth military strategy of

expropriating territory and resources, this mass torching was a policy of religious violence, as temples and shrines were actively targeted and supplanted by Christian iconography.

Bernal Díaz del Castillo's first-hand account of the conquest of Tenochtitlan, written in 1558, offers the following example:

> Pedro de Alvarado ordered one [company], under the command of Gutierrez de Badajoz, to ascend the hundred and fourteen steps of the cue of Huichilobos [a temple at Tlatelolco, dedicated to Huītzilōpōchtli, an Aztec deity of the sun and of war, and the patron god of Tenochtitlan]. As we advanced the enemy bands kept close to us, and we were in great peril of our lives. Nevertheless we climbed to the top, set the shrines on fire, burnt the idols, and planted our banners there; after we had fired the shrines we fought on the ground until nightfall.[5]

The burning of shrines and temples was also a strategy of Aztec imperial warfare, prior to Spanish colonisation, as attested to in its pre-conquest codices: the given symbol for a city-state subdued is a glyph of a burning temple with its thatched roof overturned and smoke pouring upwards.[6]

This story suggests that the method of an artefact's removal is inscribed within it, like a memory that can be transmitted and lived again. Who doesn't remember the day that they left home? It was the Spanish who burned the villages, their horsemen's hooves flogging the night while juggling reins, spears, swords and torches, but it's the British Museum that now inherits the traumatic spell of homes and

shrines devoured in mass arson, an earthen hellfire sparing only the gods formed of precious metal.

Andy read further down the temporal line. "A lot of these objects might have gone other places before coming here. I get the feeling the British were clamouring to get as much as possible." When the serpent was purchased in 1894 for £100 from an Italian aristocrat acting as a go-between for an unnamed seller, the British Museum showed no concern for its provenance, only for negotiating a lower price.[7] The museum's hunger for acquisitions easily overrides any pretence of ethical concern, such that when shortness of breath occurs, or the heat rises, leaving employees perspiring as if a bone is caught in their throat, one wonders why such restless relics were ever swallowed whole to begin with.[8]

"There's a double annoyance going on, with the spirits attached to these, and maybe the gods, the entities attached to these." Andy had arrived at a two-point list of concerns. "Number one is that the artefacts have been taken away from their home and brought here. The second thing, I get the word 'broken', so some of these objects might have been broken during the transportation process, and there's annoyance that some of them might have been stuck back together, or repaired in some way. They're not happy that some of them have been broken."

Here we encounter an often-overlooked aspect of museum practice. Preservation is all the time spoken of as a force of unqualified good – but what if disintegration is preferable to being reconstructed by an outsider? What if the artefacts in question are intended to have a short life, and that life is now being artificially prolonged against tradition, against the wishes of the community of origin? While museums harbour human remains, denying them burial, artefacts too are disallowed a natural death.

After Andy had aired his psychic intimations of the Mexico gallery, I filled him in on the evening that the gallery overheated, ensnaring the horrified television crew. He laughed and returned to an earlier point he'd begun about the protective character of the serpent. "What I get with that double-headed thing, and the connection with the gods, it really is a case of if it likes you or not. For some reason it didn't like the BBC reporters coming in. The heat was to get rid of them. It was to get them out."

CHAPTER 9

THE ENLIGHTENMENT GALLERY'S FALSE DOOR

The certitude that everything has been written negates us or turns us into phantoms. I know of districts in which the young men prostrate themselves before books and kiss their pages in a barbarous manner, but they do not know how to decipher a single letter. Epidemics, heretical conflicts, peregrinations which inevitably degenerate into banditry, have decimated the population. I believe I have mentioned suicides, more and more frequent with the years.

Jorge Luis Borges, *The Library of Babel*[1]

Room 1 of the British Museum is known as the Enlightenment gallery, or alternatively the King's Library. As the official name suggests, the gallery is meant to celebrate and reflect on the Age of Enlightenment, which saw great gains in Western Europe in the realms of science, philosophy, politics and economics at a steep cost to much of the rest of the world. "King's Library" is a holdover from the British Library days, when this gallery was designed as a repository for King George III's collection of 625,250 volumes and 19,000 unbound tracts, donated by his son George IV in 1828.[2] Lined floor to 9m (30ft) tall ceiling with antiquarian books, with floors of inlaid oak and mahogany, and George IV's royal cipher

festooned across the vault of the ceiling, Room 1 is the den of an immense hoarder. It *looks* like a king's library, a cross between a bank vault and a turbo-charged posh sitting room.

The Enlightenment gallery runs nearly the length of the building's east side, leaning heavily into the "cabinet of curios" origin of museums, where stockpiling was a form of décor that boasted of overseas contacts and briskly accumulated knowledge and capital. On the upper level, vertiginous stacks are interspersed with windows, slits of filtered sunlight that pierce the library's stuffy air in measured intervals, an architectonic articulation of enlightenment; the expansive, illuminating ideal of the library, a heaven-like place where light floods in, where it becomes possible to know what has been concealed or left unelaborated. If permitted, you could easily spend several lifetimes poring over the volumes in this room, or be buried under an avalanche of books if a shelf decided to buckle.

Below is a sea of things behind glass, organised in such perplexing juxtapositions as to fool your senses into believing that space and time have collapsed, and that damn near everything is here in this one room. There are Chinese candlestick holders, German drinking horns, Babylonian arrowheads, battle armour from Sumatra, plentiful Greek pottery, a Mesopotamian board game of fired clay and an enormous severed toe made of marble; rings, coins, Javanese gongs, cowrie shells and Māori clubs in whalebone, basalt and wood. Asian deities are reduced to decorative elements – the Hindu gods Lakṣmī and Varuna, porcelain Guanyins from China's Qing Dynasty and Sri Lankan Buddhas in bronze and gold. The dead are present, too – mummified jackals and cats from Roman-ruled Egypt, along with canopic jars, and cinerary urns of human cremation from Colchester. A terrifying "mermaid" from Japan's

Edo period also lies on the shelf, a chimera of dried and sewn-together fish parts, with fangs and claws drawn as if it were fighting for its life.

As if to answer the unvoiced question of how the hell all this stuff got here, busts of the British Museum's patriarchs are spaced throughout the gallery, alongside representations of the likes of Hercules and Zeus. A terracotta bust of Hans Sloane in a flowing wig is accompanied by a placard identifying him as a slaver, declaring the museum's core collection as having been financed by enslaved labour. There are likenesses of the museum's architect Robert Smirke, and Charles Townley, the collector of Greek and Egyptian antiquities. There is also one of Sir Joseph Banks, who advocated for colonisation of Australia and accompanied Captain James Cook from 1768 to 1771, on his first voyage to Brazil, Tahiti, New Zealand and Australia.

In a glass case just a stone's throw away from Banks's bust is the Gweagal shield – a narrow, leaf-shaped shield 100cm (3ft) tall, carved from red mangrove and bark with two bullet holes shot clean through it. The shield has long been thought of as the first material point of contact between First Nations people of Australia and British colonists. In Cook's diary entry for 29 April 1770, he tells of firing a musket at two men on the shore of Kamay, now known as Botany Bay, and taking the shield after they fled.

I thout that they beckon'd to us to come a shore but in this we were mistaken for as soon as we put the boat in they again came to oppose us upon which I fired a musket between the two which had no other effect than to make them retire back where bundles of thier darts lay and one of them took up a stone and threw at us which caused my fireing a second

Musquet load with small shott and altho' some of the shott struck the man yet it had no other effect than to make him lay hold of a Shield or target to defend himself emmediatly after this we landed which we had no sooner done than they throw'd two darts at us this obliged me to fire a third shott soon after which they both made off . . .[3]

Thus the shield symbolises not only the first instance of contact, but the violence and dispossession that followed, engulfing an entire continent. After a repatriation campaign was launched in 2015 by Rodney Kelly, a Dharawal and Yuin man and descendant of a Gweagal warrior shot by Captain Cook, the British Museum launched an inquiry into its provenance. This reassessment has raised some doubt as to whether it is the shield from Cook's incursion, but as one of the earliest extant shields from the eastern coast of Australia, it remains an artefact of deep cultural significance for First Nations people. The campaigners' calls for the shield's return continue.

Cook's belongings are also on display in a free-standing glass case in the Enlightenment gallery, returned to Britain after he was killed in 1779 while attempting to kidnap the Hawaiian monarch Kalaniʻōpuʻu.

Staff readily cite the Enlightenment gallery as one of the most haunted spaces in the museum, but when pressed for specifics, details usually come back thin. There are lights that flicker capriciously in response to the presence of warders on patrol, and an Edwardian woman who is seen walking the gallery when the

moon is full, but the King's Library is in the end remembered as a backdrop of suicides.

Henry Symons served as assistant keeper in the museum's Printed Books department for nearly a quarter of a century. A quiet figure, known for growing roses on his allotment, he was found with his head resting in a pool of blood on the surface of his desk in the Cracherode room on the morning of 22 September 1922. He had a single gunshot wound to his right temple. When his superior was called to the scene and saw Symons's lifeless body, the first thought he uttered aloud was, "Did he damage the book bindings?"[4]

"They weren't worried about the dead member of staff! They were worried about their books!" exclaimed former Visitor Services supervisor Danny Barwick, all too familiar with the sometimes callous neglect shown to the British Museum's understaff. The bindings were spared, but the bullet that ended Symons's life did nick a bookshelf after exiting his skull.

It's long been a part of museum lore that the warders were once made up of ex-servicemen, and later ex-police, and that the ex-military especially continued to carry their service revolvers on patrol. Henry Symons was too old to enlist when the First World War broke out, but he did manage to borrow a pistol from a shell-shocked ex-soldier colleague.

Symons appears to have taken his life over a failed marriage. He wed a young Frenchwoman whom he'd met on holiday and, despite dexterity with French language library materials, it turned out that neither was fluent in the other's tongue, and the relationship quickly fell apart. Symons's heavy heart is undisguised in his final letter to his sister: "It is useless to go into more details. She says she cannot

live with me and I cannot go on in the face of this obstinacy. The evil is much more deep than you have been able to discover."[5]

Symons's death is not associated with any ill-gotten artefact but with the cascading presence of the library – the King's Library in particular. Symons was a librarian and, especially back when the British Library was at Bloomsbury, books were everywhere inextricable from the architecture – piled on reading desks, packed into wheeled carts, gripped by couriers sprinting past and wedged into the museum's endoskeleton of all-pervasive varnished shelving. A librarian who spent decades in the museum was a fixture, a live cog in the museum's innermost machinery. It's easy to get lost in the museum, to be pulled under in its deep time. If, as the French-Algerian philosopher Jacques Derrida says, "the structure of the archive is spectral",[6] the librarian or archivist is surely at risk of becoming a spectre. The museum worker is already among the dead, awash in a numbing, ceaseless sea of stuff, fatigued from the confusion of navigating the museum's disjointed realities. Henry Symons never made it out.

Symons's passing is one of the few deaths on site that is well documented,[†] and so his story becomes a vessel for others who passed in the building unacknowledged; staff claim to feel his presence not just in the King's Library, but in the stairwells, offices and galleries that branch off from it.

† Symons's death was covered in the newspapers of the day, however this name faded from memory until the publication of an obscure pamphlet in 1984 (see Endnote 5 for this chapter, page 229).

By October 2020, I'd left London for good and was hiding out for a few months in Treignac, a rural, semi-mountainous village in the interior forests of southern France, before joining my girlfriend in Germany. I was staying in a half-converted sewing-machine parts factory, which is haunted by its former workers from surrounding villages and children who were given up for adoption back when the building was a poorhouse centuries before. I was dealing with ghosts on ghosts, and winter was setting in. It was at this time that I had a lengthy phone conversation with a former curator back in London. They requested anonymity in telling the following story, because even though the incident took place decades ago, they questioned whether it was too soon for it to be made public. I sat in the chill of the factory, captivated as I heard the fullest account yet of an event of which for years I'd only had glimpses and reverberations.

The curator recalled that once, while chatting with a colleague who served as an administrator in another department, the colleague spoke of a Sunday evening in the 1980s when he was working alone in the King's Library, well after closing time. Immersed in his desktop landscape of scattered paperwork, he all of a sudden felt a jolt of awareness that he was not alone.

"Oh! Gosh!" The words flew from his mouth. "You gave me a fright!"

The administrator hadn't heard anyone approach the desk, and was unnerved that he'd become so lost in his work that he'd forfeited his senses. He recognised the newcomer as a warder, not because he knew his face or his name, but because he wore a warder's uniform. The warder was tall with an unsteady stance, making it all the more confounding that he could arrive in front of the desk without a sound. The warder addressed the administrator without

preamble in a deep, raspy tone, as if it had been ages since he opened his mouth to speak.

"Aren't you scared of working on your own in here?"

The administrator didn't see any reason why he should be afraid. He didn't pay the question any mind, aside from thinking it was an odd way to open a conversation. He'd stayed after closing time precisely so that he wouldn't be disturbed, but it would have seemed rude to say so, so he went on shuffling his papers and replied, "No, no. It doesn't worry me at all. Not at all."

He stole a quick glance at the warder and noticed that his costume was a bit off. He couldn't quite put his finger on it, but it differed from the standard-issue uniform. He then looked the warder in the face. "His hair was dark. He looked pallid, he looked so, so pale. Really unwell." Something wasn't right about this warder.

The security warder spoke again, reprising the prodding, quizzical tone of his opening remark. "Well, you know about the guy who, who was found. Who killed himself over there . . ." He pointed to a bookshelf that doubles as a hidden door, like you see in the movies. It hinges outwards from an unbroken row of leather-bound, gilded spines. Behind that spine-laden door is an entry point into the museum's Back-of-House labyrinth of hidden stairwells. Visitors are routinely surprised when they see the clandestine door swing open. The administrator knew about the trick door, he used it all the time, but he hadn't an inkling that someone had died there. He took a deep swallow.

"Yeah, over there," the warder said, driving his point home. "The staircase behind there."

The administrator went weak. "Oh, my goodness" was all he could muster. This was the first he'd heard of it. "Wow. No . . ."

The administrator faced his desk, but only for a second,

attempting to make sense of what the warder was saying. As he raised his head, he heard a single footstep. In that split second, he thought that the warder was turning away to continue on his rounds, but when he looked up the man was gone. The Enlightenment gallery is 90m (300ft) long, about 12m (40ft) wide, and they were bang in the middle of it.

"He couldn't have gone anywhere," the curator told me over the phone, with a quiver in his voice. "If he'd walked in either direction it would have taken three minutes that way, or three minutes the other way, and if he'd have turned and gone through the door, he'd have had his keys out, walked across the gallery, turned the keys. He literally just vanished into thin air."

The curator I was speaking to on the phone said that a week after hearing this story, he was having lunch in the staff canteen with some old timers from the Conservation department. The curator was still digesting the tale of the vanished warder and, in between forkfuls of salad, he decided to retell it. As he did so, the conservator seated across the table gave him a pained look.

"I can't believe I picked him of all people," the curator told me, flabbergasted. The curator stopped mid-sentence and asked, "Are you okay?"

"That was my mate," said the conservator.

"What, who was your mate?" The curator couldn't understand what the conservator meant.

"My mate hanged himself in that staircase. He was a gallery warder." The conservator was in shock, and sick with grief.

"Oh my God, I'm so sorry." The curator's voice trailed off, regretting having brought the incident up. Up until then, there had been no suggestion that the pallid warder in the outdated uniform was the one who had hanged himself in the stairwell behind the

trick door. They went over the details of the warder's appearance bit by bit.

"That's right, thin moustache."

The conservator nodded sombrely.

"Very tall. Dark hair. Pale. Deep voice."

"Yeah," he confirmed. "That was him, that was my mate."

The conservator was nearly in tears, recounting the last sighting of his friend. "He had a meeting that he was worried about. He was really, really, really stressed," and after a few days time, "Nobody had seen him."

He hanged himself on a Friday and wasn't found until the following Monday. "He had been hanging there in the stairwell for about three days." They agreed that there had to be more troubling him than just the prospect of the meeting. As Patsy Sorenti had explained to me, "People don't commit suicide for one reason." By the time the weight of the warder's burden was known, his body had been discovered.

Decades on, warders still avoid that stairwell. Some old timers who knew the hanged man claimed to have seen him there after his death. Others felt his presence. Somehow, even though I was hundreds of miles away at the old factory in France, the image of the dead warder chilled me to the bone. The distinct feeling of dread carried in the curator's quivering voice, the conservator's spasm of grief, a weekend spent suspended from a rope in the stairwell, it was too much to bear, especially with the multi-spectral factory workers and orphans milling about while I was trying to get to sleep.

At the northern end of the Enlightenment gallery, near the Mexico gallery and the East stairs, is a vitrine dedicated to the artefacts

of John Dee, the 16th-century mystic and scientist who served as Queen Elizabeth's court astrologer. These include a crystal ball you could hold in the palm of your hand, and a scrying mirror or "shew-stone", a polished piece of obsidian of smoky depth that Hernán Cortés's conquistadors pilfered from Mexico; it had once been used by Aztec priests and later by Dee to contact spirits and conjure visions. Dee advised Queen Elizabeth in favour of the expansion of naval powers and even coined the term "British Empire" – probably the most powerful spell that he ever cast.

"Someone's up there, sitting in a chair reading."

Patsy Sorenti stood at the vitrine. I was fishing for a reading of Dee's paraphernalia but Patsy's attention was pulled overhead. She motioned with a nod to the upper stacks 4.5m (15ft) above the oak floor where we stood, where brass railings fence in a wall-bound walkway and glass-fronted bookcases that reach to the ceiling.

"There are two ghosts here. Absolutely two ghosts here," Patsy said in a gentle, matter-of-fact tone. "One is a hanged man, hanged himself in the 1950s or '60s. Also there's someone up there, who sits there reading a book. I think this is someone connected with the museum who died a long time ago, who died and refused to, who's just come back to read. There's someone who reads, like a bookworm, but it's up there, away from everybody else here. You have to go upstairs. Lots of things happen on that railing up there."

I asked Patsy to tell me more about the man who reads.

"This man's been seen in the day as well as in the evening. He hangs around. He's not that old. He's not young. Forty-odd." Henry Symons had just turned 50 when he passed. "A very learned man. He looked after the books."

She paused.

"They're waiting here."

CHAPTER 10

MIXING THE SPIRITS UP

"There was a time when the cleaners refused to clean the cases in the mummy gallery because the mummies would move," said Jim Peters, thinking back to the early 2000s, when he first started working at the museum. "They refused. They genuinely believed that the mummies were moving, and refused to go in there."

Rooms 61–65 are spoken of as the Upper Egyptian or the mummy galleries or, on occasion, the Egyptian mummy galleries. I have never in my life heard anyone refer to them by the names given on museum signage: Egyptian Life and Death in 61, Egyptian Death and Afterlife in 62 and 63, or Sudan, Egypt and Nubia in 65. People do sometimes refer to the Egyptian and Sudanese galleries in acknowledgement of the 4,000-year-old Sudanese person whose bones are splayed in a glassed-in sandbox at the entrance to Room 65. However they are designated, the Upper Egyptian and Sudanese galleries are identified with the overpowering presence of human remains.

These galleries are full of amulets and sculpture, daggers, ancient cradles and hieroglyphs, but I could never focus on them because I'm not accustomed to spending time with corpses. I don't know how to study a piece of pottery with a dead person lying exposed nearby. That seems like a weird thing to ask of anyone, especially the droves

of schoolchildren who are brought to the museum like livestock to a feed trough. The stories found in these galleries are testament to the taboo of the exposed corpse, which persists despite Western museums' efforts to naturalise their display through centuries of exhibiting bodies – both exhumed and unburied – so brazenly.

What to make of the cleaners' collective refusal to enter the Egyptian and Sudanese galleries? The cleaning staff seemed to stage a strike on the basis that they had agreed to clean the vitrines, but being complicit in the bald transgression of exhibiting the dead became too much once the dead began to stir. Or was it the human remains that went on strike, and the cleaners who joined them? Imagine playing dead for centuries, tourists feeding on the sight of your bare bones day in and day out and, even when it's quiet, the cleaners and security guards are still keeping an eye on you. Word got around about the cleaners' strike and a meeting of the broader British Museum staff was scheduled to address the disquietude.

"The fact that the cleaners said they'd seen their wrappings rippling," Jim Peters parroted whatever spokesperson the museum trotted out to calm everyone down, " 'Oh, that was just the cleaners *over-cleaning* the cases! They'd caused a build-up of static because the cases hadn't been open for a while, so it built up the static charge in the air, and it meant things seemed to be moving, but they weren't really.' Everyone just went, 'Thanks for explaining that. We can go back to work now.' "

Peters was unconvinced. "You know, you'd have to be quite close, and they'd have to be quite light fabrics," he reasoned, drawing on decades of experience handling collections, "and you'd have to be really aggressively over-cleaning . . . I never really bought that.

So, the museum had to do something about it, and get different people in. That was the resolution." I took Peters's line about getting different people in to mean that new cleaners were hired on the understanding that when you clean the cases with mummified human remains in them, the bandages move. If you want the job, that's what it is. Take it or leave it.

The story of how these mummified Egyptian and Sudanese human remains ended up in the British Museum is the subject of myriad historical volumes. For our present purposes it could be said to begin with Isma'il Pasha, who ruled as Khedive of Egypt from 1863 to 1879, with the backing of the Ottoman Empire. Pasha attended the Exposition Universelle in Paris in 1867, when Egypt's cotton industry was seeing a surge in demand as the Civil War in the United States ended with the defeat of the Confederacy, disrupting Europe's supply of cheap cotton. European banks were keen to provide loans to Egypt which would allow them to profit from its booming cotton trade and to play a role in the redevelopment of its economy. And so Pasha left Paris with financial support to 'modernise' Egypt: to upgrade its infrastructure by digging irrigation canals, thereby increasing agricultural acreage, laying railways and building schools and bridges. The Suez Canal, a boon to Europe as it became the shortest maritime trade route to Asia, was the crowning feature of this development project.

The entirety of the British Empire hung upon control of the Suez Canal; as long as the British controlled the Suez, what was left of the empire held. Though not formally a colony, Egypt's indispensability to the British Empire set the stage for mythologies

of buried dynasties, of monarchs who once ruled the land and whose influence, imagined or deadly serious, worked against British interests.

The terms of the loan agreement were predatory, leading the Egyptian state to default on its repayments. European shareholders – primarily French and British banks – took control of Egypt's economy, imposing severe taxation, frequently collected through torture, to recoup their investment. This led to widespread rebellions that were suppressed by British forces. The lopsided Battle of Tel-El-Kebir in 1882 saw thousands of Egyptians massacred and marked the beginning of British military occupation. The British reconquered Sudan in 1898 at the Battle of Omdurman, described by one soldier as "more like a butcher's killing house than anything else", with an estimated 16,000 Sudanese dead and 48 British losses.[1] Both countries would remain under British occupation until the Suez Crisis in 1956, when the Egyptian revolution headed by President Gamal Nasser shook off British control in Egypt, and independence was granted to Sudan.

The period of British occupation not only saw unrelenting taxation and military rule; Egypt was also turned into a playground for Europeans with outlandish and perverse orientalist fantasies. A culture of smuggling material heritage for sport ensued. In Victorian England, "mummy brown" was a popular pigment, made from ground-down mummified remains imported from Egypt, mixed with white pitch and myrrh, and producing a colour somewhere between raw and burnt umber. Powdered mummified human remains were also present in mumia, a medicine used for treating wounds. By the 19th century, mummy unwrappings had become fashionable social occasions. Presided over by figures such as Thomas Pettigrew, a founder of both the Royal College of Surgeons

and the British Archaeological Association, audiences assembled in private parlours, lecture halls and even back rooms of the British Museum, awaiting a glimpse of the grave goods that might be found tucked into the bandages holding these ancient beings together. The audience's fantasy of being party to archaeological discovery often went unsatisfied, and instead they watched the archaeologist or mere parlour host labour for hours – sawing, sweating, dodging clouds of timeworn bone dust, and failing to gain entry.

"There's a place off of Gallery 61 called Budge's and Gadge's workshop," Danny Barwick told me, "and a lot of the unwrapping occurred in that room." The English Egyptologist Wallis Budge was made keeper of the Egyptian and Assyrian antiquities at the British Museum in 1894 after a decade in the department. He was also the finder of much of the Egyptian department's ill-gotten acquisitions. Budge's surreptitious and underhanded tactics of acquisition are legendary, and he was later knighted, after a long career of larceny in service of the Crown.

It's crucial to note that human remains were often collected to bolster farcical notions of race science; that is, millions of people worldwide have been pulled from their graves or denied burial in order to prove the supposed superiority of Europeans. During this period, Western anthropologists engaged in a preposterous debate on the racial origin of Ancient Egyptians, who were widely recognised as an advanced people, and yet indisputably African. This posed a problem for the reigning architects of race theory, who sought to reconcile white supremacy with their admiration for Ancient Egypt. In 1889, Wallis Budge unwrapped a corpse at University College London, declaring at the conclusion of

the programme that the Ancient Egyptians were not, in fact, "Negroes".[2]

The legacy of this unholy extraction of the dead shows up in bizarre forms of public engagement with the Upper Egyptian and Sudanese galleries. A visitor who called himself "the Gold-Faced Prince", in a likely reference to the mummies whose faces are covered in gold leaf, was banned from the museum for repeatedly turning up and "giving the guards a hard time", by forcefully announcing himself as the rightful heir to every Ancient Egyptian artefact on Earth. After his banishment he sent in a series of elaborate dossiers that are still held on a shelf of unfileable miscellanea in the Egyptian department.

"There was a gentleman," one warder told me, "who left a bag full of dead birds, as you do, in the mummy galleries, in Gallery 63. Now what was that in aid of, some sort of sacrifice for an Egyptian god? I don't know." Unattended bags are treated as a pressing security concern, but this bag of fowl is far from the most off-putting offering that's been left in the gallery.

Emily Taylor, a former museum assistant in the Egyptian and Sudanese department, told me over a pint that, "There were things that were found in the galleries, like actual Egyptian amulets and stuff that people would leave, and say this has given me terrible luck . . ." A mummified hand, brittle, unguarded and alone, was left in the gallery during her time at the museum. Like abandoning a baby on a doorstep, leaving a mummified human hand in an empty gallery, with nothing more than a note attached, forecloses any possibility of rejection or return. The note read something along the lines of "This was found among my grandfather's things after he passed, it's brought me such misfortune that I've got to get rid of it."

These orphaned body parts and amulets are evidence that although the Victorian-era trend of collecting mummified human remains and assorted paraphernalia from Ancient Egypt has died out as a popular pastime for well-to-do Europeans, the descendants of those who amassed them are still dealing with the repercussions of their forefathers' pursuits several generations on.

In Room 64 we find the so-called Gebelein Man, excavated by Wallis Budge in 1896 in Naga el-Gherira, about 40km (25 miles) south of Luxor, and dated to the pre-dynastic period, circa 3400 BC. Before Gebelein Man, a pre-dynastic set of human remains had never been uncovered in such a complete and unblemished state. Budge stealthily smuggled Gebelein Man out of Egypt and into the British Museum, where staff still informally refer to him as "Ginger" on account of a surviving tuft of red hair. Though these days that nickname is absent from the museum's public-facing statements, as it's not in keeping with its official policy on human remains.

In a gallery otherwise filled with brightly lit ceramic vases on tiered glass shelving, Gebelein Man is dimly lit. It is as if he is being granted some privacy, an acknowledgement that harsh lighting might be inappropriate for the dead. However, this pronounced lull in lighting functions as a sort of reverse spotlight. Crowds are drawn to this brief cessation of brightness, which reads as a rest from afar, but when you make your way across the shiny hardwood floors and approach the vitrine you find yourself circling around someone several thousand years dead, curled up in a near-foetal position, knees tucked in toward their breastplate. It's thought that Gebelein Man was killed by a knife to the back,[3] and mummified naturally by the dry desert sands. I've seen many recoil from the

dimmed centre of Room 64, slowly backing away, wondering what sort of educational value they could possibly extract from laying eyes on someone who died such an apparently anguished death.

Roger Luckhurst is a writer and professor at Birkbeck University who spent 2009 and 2010 scouring the British Museum's archives researching curses associated with mummified human remains and earning a reputation as a foremost scholarly authority on the phenomenon of the "mummy curse". I was introduced to him through Fiona Candlin, and we met between meetings in his office at Birkbeck on an August afternoon in 2018. Luckhurst spoke of the difficulty of pinning down Budge's movements as well as his beliefs, in part because Budge always covered his tracks: "Wallis Budge, who was the keeper at the time . . . did burn quite a lot of his archive because he stole so much, and was quite careful about it."

Though Tutankhamun's tomb would not be breached until 1922, the idea of the "mummy curse" was gaining currency decades before. For men like Wallis Budge, shaped by a culture of deeply ingrained imperial disdain, the idea that mummified human remains could unleash a curse on antiquities traffickers was if anything alluring, a sweetener that enlivened the gentleman's sport of grave-robbing, adding an air of otherworldly danger that differentiated antiquities smuggling from the humdrum duties of day-to-day colonial violence.

On a busy afternoon in the Upper Egyptian gallery, I stood in the midst of the packed museum floor and spoke to an elder member of Visitor Services staff, who has since retired. She said that one day the exhibitions team was swapping out Gebelein Man from a glass display case in Room 64 and that she quite absent-mindedly sat on

a coffin-crate as they were moving the body, as if it were any low-lying box scattered about the gallery floor, and not a vessel reserved for someone who died a violent death thousands of years ago. One of her colleagues was quick to warn her, "You might not want to do that. He may not appreciate it. Careful." Realising her mistake, the warder sprang to her feet and turned towards Gebelein Man. Everyone says that when you spend time with human remains, you very quickly come to regard them as people, and so she jumped up and started nervously cracking jokes: "Look at you, you've still got plenty of hair after all these years, don't you look great!"

It happened that on this particular night the warder's husband and daughter were out of town, which left her and her son alone in their home. In the middle of the night, at about three in the morning, she felt someone tugging at her duvet, at the foot of the bed. The duvet dropped to the floor, waking her out of her rest and leaving her body cold and exposed. As she came to consciousness she saw a shadowy figure flee the room. Remembering that she was home alone with her son, she thought that this figure could only be her son winding her up. She went to his room and knew with a mother's surety that he was sleeping soundly.

When the warder came home from work the next day, she saw a poster of Krishna newly affixed to her son's bedroom door. She sought an explanation, what brought about this newfound devoutness? "What is this?" she asked. "You're a teenage boy. You should have a poster of Samantha Fox on your bedroom door. Why Krishna?" His eyes cast down, and in a low mumble he admitted, "Mum, last night, in the middle of the night, I was sleeping and I felt something tugging on my duvet, and it fell off the bed."

She didn't need to hear another word. Her son had put the poster of Krishna up as a means of protection against the same intrusion

that she had experienced. And she had suspected it was him! As soon as her son told her this, her thoughts returned to Room 64, to the moment she sat on that coffin, and she knew: "Something followed me home."

In the warder's telling, there's no suggestion that this incursion was the result of a curse, but an outcome borne of accidentally transgressing the sanctity of human remains, as if to say, "If you violate my space, remember I can do the same to you."

It was not uncommon for relics thought to wield a curse – which had already brought about the untimely death, disfigurement and bankruptcy of those who scavenged them, and in some cases their accomplices and kin – to be donated to the British Museum. In the museum it was believed that the curses had mostly subsided, that they found a measure of peace in joining an esteemed body of ancestors, or that the curse had run its course after inflicting generations of harm.

"Mansell were the official photographers for British Museum who were on Oxford Street, and lots of the Unlucky Mummy stories are to do with photographers," Roger Luckhurst told me. The Unlucky Mummy is a reference to the "mummy board" or inner coffin lid that once enveloped a priestess of Amen-Ra dated from 950 BC and found at Thebes. This mummy board is the subject of a constellation of capricious rumours as well as verified incidents of death and misfortune, each attributed to its removal from Egypt.

The most mythologised coordinate in this knotted web of curse narratives happens to be the most easily debunked – the persistent notion that this mummy board was onboard the *Titanic* and may have caused it to sink. But the mummy board is not among the

scurrying bottom-dwellers of the Atlantic sea floor; it's on display in Room 62. It was donated to the British Museum in 1889 on behalf of Arthur Wheeler. Little is known about Wheeler, other than that he and Douglas Murray were part of a party of five Englishmen who bought the mummy board on a trip to Egypt in the 1860s. Murray was a familiar presence in the aristocratic and bohemian spheres that so often found overlap in Bloomsbury. Shortly after he procured the mummy board, his hand was blown off in a freak accident involving an exploding pistol, and Wheeler lost his fortune almost immediately and died within a year. Two unnamed members of their party are also said to have died following the sale. Journalist Bertram Fletcher Robinson wrote a detailed account of the curse of the unlucky mummy for the *Daily Express* in 1904 and died suddenly less than three years later, at the age of 36, of enteric fever. His death is often attributed to the thorough retelling of the curse, so I'll tread lightly and stick to the photographic postscripts that relate to the unlucky mummy's afterlife in the British Museum.

One account from the 1890s tells of a junior photographer at Mansell who had a pointedly unpleasant, disabling night after photographing the mummy board.

> Upon the way home in the train, he injured by some unaccountable accident his thumb, and hurt it so badly that he was unable to use the right hand for a long time. When he reached home he found that one of his children had fallen through a glass frame and was suffering from severe shock.[4]

Founded in 1862, the Ghost Club was a secret fraternal order with an abiding interest in the supernatural; it met regularly in London and is still active today. Wallis Budge was a member, as

were prominent literary figures such as Charles Dickens, Arthur Conan Doyle, Algernon Blackwood and W B Yeats. Air Chief Marshal Lord Dowding of the Royal Air Force, psychologist Arthur Koestler, Julian Huxley, the first director of UNESCO and president of the British Eugenics Society, and Charles Babbage, the mathematician and inventor credited with the concept of a digital programmable computer, are but a further sampling of the Ghost Club's membership. There was a sense in the late Victorian era that there was power to be harnessed in coming to terms with the underlying reality of the non-physical world, power that could be used by physicists, spiritualists and military leaders alike.

In the minutes of a meeting of the Ghost Club from 1900, we find Douglas Murray's account of the arrival of the mummy board at the BM.

The mummy case was eventually sent to the British Museum, and with the object of having the cartouche deciphered, a photograph was taken in the presence of A.W.F.'s sister. She asked the photographer whether he had ever found anything photographed upon the plate which had not been visible to the naked eye. He scoffed at the idea, but a few minutes after being in the dark room, he returned and pointed out the semblance of a human form, which appeared in the photograph, but was not visible on the mummy case. The photograph was sent to the gentleman who had promised to decipher it, and was returned by him a fortnight later. A few days afterwards he went down to his country house and shot himself. The man who carried the cartouche to the photographer died a few weeks afterwards of brain fever, and the photographer himself died within two years.[5]

At the far end of Room 65, near the entrance at the top of the East stairs, a 2nd-century sandstone relief from the funerary chapel of Kushite Queen Shanakdakhete takes up almost the entire wall. The battered and radiant relief shows Shanakdakhete enthroned with her son at her back, both protected by a winged Isis, with rows of tiny figures extending palm branches and looking reverently towards the Queen.

An anonymous warder told me that some years ago, a little boy was sitting alone on one of the two benches in front of the relief of Shanakdakhete when he was photographed by his parents in a quotidian museum snapshot. You can imagine the pose – a child with his head in his hand in a melodramatic rendering of boredom, like Rodin's *The Thinker*, but tired, waiting for his parents to get done with whatever they're doing, so they can go to dinner or back to the hotel room after a long, tiresome day of touristic overstimulation. The parents took two photographs of their child only seconds apart. In the first, according to a warder stationed nearby, "There was, what you could only describe as a black mass" rising up out of the floor, "right next to where their son was", threatening to overtake the child. The warder arched their shoulders and gestured with their hands above their head like a wave on the verge of breaking, about to take the child under in its black swell.

"When they took another photo, it had gone." The photograph taken only a second later was identical, only with no black mass. Once again, the parents take the camera to the first person they see in uniform and ask incredulously, "What is this?" The warder is invariably speechless, withholding a longer, more worrisome list of questions behind a courteous smile.

*

In the same gallery, Room 65, another boy was this time the one snapping pictures. "This little boy, I say little boy, he must have been about 14 or 15, took a photograph of an artefact in one of the cases," recalled Stuart Westerby. As the child was reviewing the shot, something unusual appeared in the digital camera's display screen, and again he showed it to the Visitor Services staff. "He came up to my colleagues and said, 'Is this normal?'" Stuart's eyebrows raised as he took a deep breath.

"It appeared as clear as anything – it was a wrapped, mummified Mexican baby in mid-air." Stuart was astonished, even in recalling the photograph. The infant was bundled tightly in a patterned textile that the warders immediately recognised from the Mexico gallery downstairs. They stood shoulder to shoulder around the camera, trying to make sense of it. "We said, well, that was very strange 'cause it's an Egyptian gallery . . ."

Among the guards there was a silent consensus that things often go awry in the Upper Egyptian gallery, where the warders are every day besieged by the occasionally unruly dead, but they were all trying to get their head around how a Mexican mummy could be pictured there. How does that make any sense? Again they were asked to speculate on ghosts' behaviour to assuage visitors' nerves.

"I said to my colleagues after that the Mexican gallery in 27 is immediately below us here in 65. So, God knows." Stuart felt that somehow this spectral newborn had floated up through the floor or trailed the family up the East stairs, from the Mexican gallery into the Upper Egyptian gallery. While this photographic image confounded the warders, it was apparently not unprecedented for the boy who had taken it.

"The young lad's parents, they said it happens quite often to him, he photographs things – quite normal things – and afterwards,

every now and again, something odd appears like that." While some possess the facility of clairvoyance, clairosmesis or clairaudience, there are others, such as the young boy mentioned here, who are given to picking up spectral presences on photographic devices.

In September 2017, I sat in a cafe inside King's Cross tube station, having coffee with Phil Heary and basking in his fond reminiscences of his days at the museum.

"I love the place," he says warmly. He claims Princess Diana once asked him what he was up to on the evening of her visit. She was going clubbing, and looked back at him mystified when he told her he had to work. "I remember George Bush and his bodyguards come in," in the early 2000s, around the time of the invasion of Iraq. "And so we had to close the museum for him. He looked like John Wayne. I mean, he was, he was John Wayne, wasn't he, really?"

These brushes with high-profile figures from the world of the living are good for a laugh, but they aren't necessarily the most memorable experiences he had inside the museum. By his own telling, Phil Heary never once came across a ghost until he worked at the British Museum, where he had several revelatory experiences, all in the Upper Egyptian galleries.

"The mummies. The mummies. In the Upper Egyptian galleries, yeah, in 61 and 62." In Room 61 we find the deconstructed tomb chapel of Nebamun, a scribe from Thebes of the 13th century BC. Room 62 – "Egyptian Death and Afterlife: Mummies" – is an emporium of sarcophagi, wrapped bodies and grave goods. A mummified cat stands upright on the second tier of a glass shelf, watching as you pass through the doorway from 61.

Phil remembered, "I've been up there in the past where you've heard

a door slam, windows creaking, and everything's secure, but you think, 'Oh, it's just an old building. So you think nothing of it . . .'" On other nights it became impossible to find refuge in easy explanations, to chalk it up to the groaning of an old building. Something was wrong up there, and, whatever it was, it shook Phil to the core.

"One of my first experiences was when I went up to the Egyptian mummy gallery in the middle of the night, just to check it out, to see if things were all right. I opened the gallery up, and it was absolutely freezing. It was so cold, it was unbelievable, you know what I mean? I could not believe it. This was a summer's evening and you can see the breath coming out my mouth, and I couldn't see, why is it like this? It was like walking into a freezer. Why is it like this? Why is it so cold? It was no real rhyme or reason for it, you know? And it had this sort of smell – I couldn't describe it. My stomach turned over. There was an eerie feel about it. The feel about the gallery was, you want to get out. It was scary. So I phoned up Security. I said I think something's gone wrong up here. And they come up, and it was gone. When they went up, it was gone."

When Phil said his stomach turned it chimed with my own experience of the Upper Egyptian gallery. I always ended my walking tours there, and always left with a raw feeling in the pit of my stomach, like a stomach ache brought on by stress, only it would come simply from walking into the gallery, without any obvious external stressors. Like Phil, my unsettled stomach also made me want to get the hell out – to escape not just the Upper Egyptian gallery, but the building. Patsy Sorenti told me that this feeling was on account of a servant woman who was drugged and drowned in order to be ritually interred with her monarch.

According to Patsy, the woman didn't want to die. She was young, and still had plenty of living to do. "I feel dizzy, and I feel weak, and I feel sick – she does, and she projects it onto living people now." Patsy even posited that the servant woman was the black mass who had appeared in the photograph in Gallery 65. She was responsible for watching the children during her earthly life and is still drawn to them now.

Phil Heary experienced a resurgence of this hostile change in atmosphere in the Upper Egyptian galleries years later, when he was sent up ahead of then-Prince Charles and Hosni Mubarak, the former President of Egypt, to make sure everything was secure. He felt that something was terribly wrong in the gallery, but rather than make a fool of himself ("You don't want to be the guy, 'Oh he's a bit loopy', you know what I mean?"), he shrugged it off and gave them the go-ahead.

I asked Phil if he had a theory, or any particular thought as to why he'd had these experiences specifically in the Upper Egyptian galleries. "It's strange, isn't it? I suppose that the history, the history of Egypt, especially with the Tutankhamun thing, you know about the curse of this, the curse of that, you know. I haven't really got a theory, because I don't believe that I could put my finger on it." Phil's conscience was clearly unsettled by his encounters in the Upper Egyptian galleries. What had he been asked to do that caused such upset? "Is it right? Is it wrong? I don't know. Is it my imagination?" Phil asked aloud, then corrected himself. "It wasn't my imagination. It happened.

"I'm a great believer that, wherever you're buried, you should stay there. It's sacrilege to bring anybody up, but because the mummies are such a great pull, they bring the people in, because of Egypt with

its hieroglyphics, and its tomb paintings and what have you, you know what I mean?"

In the tempest of restlessness let loose in the Upper Egyptian gallery, Phil found himself treading uncertain ground even as he stood in the middle of the museum's hardwood floors. He wrestled with distinguishing popular myths of Ancient Egypt from his own pre-existing beliefs and lived reality. He was humbled by his experience, even if he was rattled. Staring at the dregs at the bottom of the cafe's cheap porcelain coffee cup, he arrived at the need to respect the sanctity of the dead.

"A lot of the mummies should be back in their graves. They shouldn't be in the museum." Phil spoke firmly, without raising his voice or hardening his tone, with a candour found only in former employees, who no longer feel the need to defend the institutional line. "I'm talking about, around the world, you know? That's why now, if you go to Egypt, Tutankhamun's back in his tomb in the Valley of the Kings. They're all back in the tombs now, because they realise now that you're, you're mixing the spirits up. Because there's something out there . . . There's more than just life, there's something else besides life, you know what I mean? I think there's restless souls up there. I know, I've watched a lot of horror films and that, but I've always believed that. I've always believed that."

"You're mixing the spirits up" is concise in its double meaning. Desecrating carefully dressed graves is a dire confusion. Even Neanderthals buried their dead. When the dead are disturbed, it creates confusion in the land. For many, death is spoken of as a return home. If one's body is exiled in death, that going home is woefully complicated.

At what point does a person become unworthy of a dignified rest in death? The taboo of displaying the dead is waived by colonial and ethnographic museums in cases where the person died so long ago that they're supposed to have passed an unspecified statute of limitations, or if the person is racialised or otherwise exoticised in such a way that the projected audience wouldn't think them deserving of dignity while alive. To claim that you enjoy respectful relations with formerly colonised nations while harbouring and exhibiting their ancestral remains betrays a confused, corrupted ethics. The dehumanising forces of colonisation and occupation do not spare even the dead.

If I told you, dear reader, that I have a single human corpse stashed away in my basement, you'd probably think I was a psychopath, and rightfully so. If I told you that I have a dozen skeletons I dug up myself to wow guests, there's a strong chance I'd be writing this from a jail cell. We are all too well acquainted with the fact that crimes of magnitude are more likely to evade corrective measures. Still, it beggars belief that, by its own count, the British Museum holds over 6,000 "sets" of human remains.

According to a publicly available listing,[6] a "set" could denote anything from "skeletal remains of 14 individuals" from Egypt to a "group of 3 human teeth" from Belize. The "sets" include Ecuadorian shrunken heads, Fijian needles carved from human bone, Tibetan thigh-bone trumpets, and drumsticks fashioned from human leg bones taken from the Ashanti kingdom in present-day Ghana, but many entries read simply "Head", "Hand", "Skull", "Finger bone", "Knuckle bone", "Penis" or "Fragments of burnt bone".

People from former British colonies and protectorates, and lands

that were once subject to British occupation, administration and meddling, are over-represented in the British Museum's obscene, incomplete spreadsheet of skeletal remains and body parts – the dead from India, Ireland, Iraq, Iran, Oman, Jordan, Nigeria, Uganda, Ethiopia, Borneo, Vanuatu, New Zealand, Australia, Papua New Guinea, North America and China join scores of Egyptian remains, mixed up with people from Germany, France, Latvia, Norway, Mexico, Chile, Peru, Turkey, Turkmenistan and Greece. This list has just over one thousand entries, and many are missing details, with the fields of date, provenance and country marked as "UNCERTAIN". This list has not been publicly updated in 13 years, which is to say there are at least 5,000 "sets" of human remains for which no information is available.

A page of the British Museum's website devoted to a statement on human remains is headed by a scene from the Egyptian *Book of the Dead*, a traditional book of spells, incantations and illustrations on papyrus scrolls, placed in coffins to guide the deceased through a series of obstacles, gods and unfamiliar states of being, as they journey through the afterlife. Scrolling down the page, past the British Museum's logo, you read the statement:

> This important collection is a unique record of the varied ways different societies have conceived of death and disposed of the remains of the dead.
>
> Their display and study provide one of the most direct and insightful sources of information on past lives, human biology, different cultural approaches to death, burial practices and belief systems, including ideas about the afterlife.[7]

While all of that may be true in some measure, this is a pedagogy borne of grave-robbing. Whatever the British Museum can tell us about the burial practices of other cultures, the more striking thing is the curious cultural practice of denying burial to others and exhibiting them, or stowing them away. The museum's collection of human remains evidences a culture of gathering the dead as loot, in furtherance of war and other extractive colonial-era industries, of treating the dead as objects of study and fuel for race craft, and as curiosities to be catalogued in showrooms and cellars.

This is a condition endemic to the museums of Western Europe and North America. Are the dead really held captive for research purposes, or is it out of ignorance? Are they restricted from going home as a matter of imperial pride, or out of a paralysing sense of shame? Are they stranded as a result of apathy, or an active and sustained refusal to acknowledge the humanity of others? I ask these questions well aware that these binaries do not hold; the museum is all mixed up.

An examination of the Upper Egyptian gallery's spectral disquiet leads us inescapably not into the underworld as traversed by Ancient Egyptian gods and ancestors, but into the basement, the multi-storey netherworld underlying the British Museum. At the building's foundation is a congregation of unearthed dead, pulled from across the planet, which more than two million visitors per year unknowingly stomp and stroll over. With 99 per cent of the museum's holdings hidden underfoot, what we experience as the floor of the museum is the ceiling for the overwhelming majority of its inhabitants. The exhibition spaces serve as the fleeting exception, window-dressing for the museum's core function – Storage, the domain of the disappeared.

CHAPTER 11

STORAGE: THE DOMAIN OF THE DISAPPEARED

The British Museum's principal storage space is located directly under the main building. Once we breach the Earth's surface, the "seemingly endless bloody corridors" that connect the Back-of-House turn into a tangled, sprawling root system of underground tunnels. These tunnels and their tributaries are of stone brick, with minimal patches of plaster. Modular fluorescent tube lighting hangs down over the main arteries, mirrored by a dull lustre on the worn linoleum floor. Once you step off the footpath and into a store, provided you have the required security clearance, the stores are worlds unto themselves. Closed worlds.

Though more sparsely populated with workers than the rest of the museum, some of the storerooms have conservation areas situated within them, with work benches and tacked-on spotlights. Porters push trolleys through the tunnels, ferrying exhibition materials from department to department. The conservation workspaces open into larger areas where prototypes of exhibition displays are developed and the dimensions of custom cabinets are modified. On the surfaces of these tables, sleepy-eyed, long-dormant relics are handled anew, alongside fresh arrivals flown in from partner institutions.

I've never once heard of an intruder in Storage, but I have

heard of a couple of museum workers being accidentally locked in storerooms, including "a really old-school, posh Egyptologist too polite to pull the fire alarm and let people know he was trapped". He was found in a "mummy store", alive but in a bad state after three days of hesitating to pull the cord. The nightmare prospect of being locked in a storeroom, a variation on being buried alive, is the dominant mode of being for the millions of presences resident down here. Storage is the subsumed body of the proverbial iceberg, a host organism teeming with entities extramundane and unregistered.

In this netherworld, thousands of items, including quantities of human and animal remains, are held as though in purgatory. Concealed and neglected, most with no chance of ever being put on display, the artefacts stored here are barred from rest, return, visitors and sunlight. In human time, many of them have already served several consecutive life sentences imprisoned here; though for those presences that are thousands of years old, this is a mere interlude, and is perhaps little different from having been underground for a millennium or two. I've never been to Storage; it's a forbidden zone. Even among museum workers it is a place characterised by rumour more than experience. And the rumours are legion.

During the first interview I conducted with Jim Peters in August 2016, I was still so green that, not knowing yet where to take the investigation, I asked for his advice on where I might find fruitful lines of questioning when talking to his colleagues. His response was immediate and exact: "Storage."

He disclosed rumours of a fully reconstructed Ethiopian monastery hidden in the basement, where it's shut year-round in one of the many airless, windowless vaults below the building.

"There was some sort of local civil war going on and the monastery was being pulled to pieces and the monks fled and they set up elsewhere, and they're still an order. But the British Museum kind of rescued a lot of the relics and altarpieces, and the fabric of the building and they put it here. They built it in a basement here, and it's shut all year. No one ever goes in.

"It's open for one day a year when the monks come over from Ethiopia and they venerate all the relics, and they worship – but no one knows, they go in, the door gets shut, they do their thing, they come out, and off they go. It's perfect Dan Brown material, isn't it?" Peters quipped, referring to the bestselling author of conspiratorial thrillers. "That story, everyone knows. That story – no one knows if it's true or not."

I was struck by the way that Peters, a Collections Manager, spoke of Storage as if its depths were unknowable. He told me that a fragment of the Ark of the Covenant – the sacred chest built (in Abrahamic traditions) according to God's instruction, tailor-made for the two stone tablets on which the Ten Commandments were engraved – is said to be contained within this much-mythologised subterranean abbey. Peters's tone conveyed that this was in all likelihood an embellishment, but since the monastery is kept beyond public reach, neither its existence nor any details of its contents can be verified.

"I can believe that," he allowed of the secret monastery, "'cause we've got relics in our department that people come over and venerate." Peters disclosed that a Croatian religious order visits the museum once a year to venerate two pendants held sacred by adherents of St Demetrius, the patron saint of Thessaloniki and of warfare, agriculture, peasants and shepherds. They pray, sing and kiss the Perspex box containing the relics, but they're not allowed to touch them.

With the question of strict veracity set aside, Peters rattled off the monastery story as though everyone in the museum knew it, like a yarn that has been long spun at Christmas parties, or at the Museum Tavern at the end of a long day's work. It's an extraordinary idea: that somewhere below the museum, there is a complete, functioning, holy building, locked all year round, containing a fragment of the Ark of the Covenant. A building inside a building always has a touch of the uncanny to it. As I sat listening to him, the story brought to mind visions of a completely hidden world, a series of sacred networks and relationships: warders with rings of jangling keys to unseal the locks, and ghost-like mobile cloisters of visiting priests who disappear into clandestine temples and into the night, all underneath the distant sound of tourists' hooves stampeding overhead.

I don't know if there's a fully reconstructed Ethiopian monastery in the basement, perhaps no one knows for sure. What is known is that hundreds of relics of great significance to the Ethiopian Orthodox Christian Church were delivered to the British Museum in the wake of the Battle of Maqdala in 1868.

The purpose of the attack at Maqdala was not to rescue any church put at risk by civil conflict, but to free around 40 British prisoners. Emperor Tewodros II had taken British diplomats and missionaries hostage in a badly miscalculated effort to get Queen Victoria's attention and gain her support against his enemies. Maqdala was Tewodros's mountain stronghold in the Ethiopian highlands. Once its summit was breached by tens of thousands of British personnel, firing rockets and Snider rifles, mowing down hundreds of men holding spears, shields and rickety, archaic

firearms, Tewodros shot himself rather than end up in the hands of the invading army. British troops tore scraps of clothes off his still-warm body for souvenirs, the bloody strips of fabric being the most prized.[1]

Richard Rivington Holmes joined the military procession to Maqdala in his official capacity as assistant in the Department of Manuscripts at the British Museum. At the time, biblical archaeology was prioritised in building the museum's collections, and Ethiopia's geographic isolation and undisturbed, continuous practice of ancient Christian rites meant that many rare and well-cared-for artefacts, especially illuminated manuscripts, would be present at Maqdala. The British Museum supplied Holmes with a substantial line of credit for the procurement of valuables. The custom at the time was for an auction to be held among the assembled party of senior officers, engineers, journalists, photographers and in this case museum personnel, with the soldiers who had looted the auctioned items splitting the proceeds evenly.

The auction that took place after Maqdala went on for two days, such was the volume of loot the soldiers had amassed. Gold chalices, shields with pelts of lion's mane hanging proudly from them, necklaces, ankle jewellery and umbrella ornaments, psalters and censers, sabres, ceremonial crosses and hundreds of irreplaceable illuminated manuscripts were auctioned while the fires that had erupted during the battle raged in the background and thousands fled.

Richard Holmes acquired hundreds of artefacts on the British Museum's behalf. This is a moment of particular shame for the museum as the appearance of remove, which allows for the plausible denial of complicity in acts of looting, was not observed. Holmes rode along with the military invasion and negotiated the sale of

several relics as they were being looted. He even made a drawing of the deceased Emperor's floating head from observation, titling it "King Theodore, after Death". Holmes kept the Kwer'ata Re'esu icon, a treasured painting of Christ in a crown of thorns, for himself, a fact that came to light only when his wife sold it through Christie's auction house after his passing in 1911.

The focus of the priests' much-rumoured secret visits to the British Museum basement is likely to be a set of ten tabots held in Storage. A tabot is a holy tablet which is kept covered at all times and can only be viewed by Ethiopian Orthodox priests, a sacred presence closely associated with the Ark of the Covenant and the Ten Commandments. A tabot's presence consecrates a church, and it is to be kept in the Eucharist, at the heart of the church. Like the online entries for human remains in the museum's collections, the tabots are registered without image, out of regard for their sacred status. Yet instead of anchoring and activating houses of worship, the British Museum tabots are in the basement, in the moaning belly of a colonial museum.

The museum acknowledges that it holds these sacred tabots, and has agreed that no one will enter the space where they're stored, nor touch or even lay eyes on them. Yet while it has sworn not to touch the tabots, neither will the museum relinquish them from its stony grip. Its possession of the tabots is evidence to the contrary of its stated mission as an educational institution. Why withhold material heritage that it's sworn not to access? By what authority? In cases such as this, we see the underbelly of the museum's rhetoric of accessibility, its naked determination to maintain control of others' holiest relics, at a cost of great deprivation to the communities of origin. Recent reports have floated the British Museum's offer of

returning the tabots to Ethiopia as a loan. "You can't loan God to a church," said Frezer Haile, a former diplomat at the Ethiopian Embassy in London.[2]

An anonymous worker provided a startlingly abrupt account of the unknown contents of Storage, though this one wasn't a matter of rumour.

"There's a store – a coffin store that no one knows about. It's got three stone coffins in it."

My eyebrows raised and I paused my breath. It hadn't occurred to me that there might be unknown coffin stores. The Storage worker went on to describe the storeroom, cramped and absent from museum accession records:

"There's no light in the store, it's just pretty much the size of the coffins. You open the door and then you stand in the doorway – that's the space. No lights. Three stone coffins, all with their bodies in. All of the heads are missing on the bodies. No one knows anything about them – how they got here, where they came from, how old they are. They're just here."

That was it. The worker moved on to talk about more routine matters, as if this beheaded trio were not all that remarkable within the scope of the museum's unknown holdings.

Why are they there? Perhaps more pertinently, why are they still there? Who are they? No doubt they are unsorted overflow from the museum's early days when acquisitions came in by the thousands. Are they long forgotten, lost in the darkness below the building before the electricity was even put in? Held in a chilly, lightless catacomb, headless and nameless, they are akin to a grisly

foundation sacrifice, like the small animals killed and interred in the walls of buildings during construction, as a way of bringing good luck and warding off evil. How many more human bodies are secreted within the museum in this way? It's a story to chill the blood, one that makes the place seem less a museum, more a temple to older, more implacable gods, its pillars resting on human bones, the brightly lit hum of modern activity powered by three decapitated batteries, sequestered deep within the building's fabric.

"The mortuary for the BM, there's been a couple of areas used." I first heard about the morgue from Danny Barwick. We were in the middle of discussing where soldiers were billeted in the Second World War when he told me that the morgue was once located in an underground passageway. "There's an area we call the morgue passage where a lot of the mummies were kept, and it literally was a morgue, it was full of dead people, that's why we called it the morgue." In time, the morgue graduated from a basement passage to having its own designated room in the basement, where few dare to tread.

"The morgue is where all the bodies are kept, that are in the museum's collection, because it's a cold room," one warder told me. "They're on big, wheeled shelves. It looks very clinical and everything, but it's just all dead bodies, so some people don't like walking through there. Some of the Security guards don't like patrolling that. They run from one end to the other." Although warders report a blanket feeling of discomfort enveloping the morgue, there is a dearth of folklore around it, perhaps because the staff who are compelled to visit only do flying stops.

"I'm no great sprinter," one former Storage worker joked, "but I used to do a decent impersonation of Carl Lewis."

Rumours about the contents of Storage abound, in large part because access is so restricted. In Phil Heary's 29 years at the museum, he'd never gained admittance: "I've been told that the worst is if you go downstairs," Phil spoke with an air of formless worry. "Down in the vaults, where they keep the other artefacts from Egypt." Phil intimated that many unexhibitable entities are confined underground on account of their size. "There's a lot of stuff they don't show, they can't show, you know? Because the museum ain't that big for what they've got."

Stuart Westerby is an old colleague and mate of Phil's. He echoed his friend's point in a later conversation when I asked him if it were true that many of the objects in Storage will never see the light of day. We were talking over a drink in the Boot, an old Irish pub in the backstreets of Bloomsbury. Stuart confirmed that even staff who know the museum inside out have often never set foot in the basement.

"Funny you should say that." Stuart greeted this query as a welcome bit of serendipity, as only the day before a former warder now working in Egyptian Storage had shown him a startling photograph. "There are mummified animals. There's a very small baby crocodile, but I've heard these stories that they have a large one." His friend had shown him pictures to confirm that there is indeed a large, mummified crocodile stuck in the basement. "It's, what did he say it was? 20 foot long? Mummified crocodile. Egyptian! It was massive . . . I said to him 'The head, it looks modern!' But he said, 'No, all the bandages have rotted.'"

The Nile crocodile can grow to be 5.5m (18ft) long, though thousands of years ago their scale was closer to that of their dinosaur antecedents. In later periods of Ancient Egypt, particularly the Ptolemaic and Roman times, it was not unusual for Nile crocodiles to be mummified in temples devoted to the god Sobek, who was often depicted as having the head of a crocodile. In 2015, a mummified crocodile from 550–650 BC was exhibited at the British Museum, though, according to Stuart Westerby, a larger one – too large for the galleries – lurks below.

I asked Stuart whether it had ever been on display.

"Never. They will never put that on display. There's no room for it. It's massive. They've got no room for this bastard. Its head is bigger than this." Stuart stretched his arms as widely as he could in the packed pub, announcing that the size of the long-dead crocodile's head exceeded his own wingspan.

Curious to hear about the others held in Storage, I gave Stuart another prompt that Phil had shared with me: is it true that there's a mummified woman who they'll never put on display?

"Yeah, it's too haunting. It's female . . . Not that Ginger, not Gebelein Man," he clarified. "She's standing up, and they never put that on display because of children. It's too frightening for kids." I thought back to old folks who frightened me as a child, because they were brash, animated or odd-looking in ways that I wasn't yet accustomed to, and wondered what it would be like to spend the afterlife hidden away, kept apart from the world for fear that you might scare the children. Stuart returned again to the mummified woman's subterranean neighbour, the crocodile.

"Maybe it should go to somewhere like the Natural History Museum. I was really surprised at how well preserved it was." We laughed over the roar of the pub, knowing full well that if this

Ancient Egyptian crocodile is too big for the British Museum, the Natural History Museum would probably pass on it too. And so the crocodile is trapped in the basement, indefinitely. Stuart trailed off, as if wondering what else could be down there. "I hear all these things, but I've never been to their Storage rooms. I've never been. I'd love to go."

This curiosity regarding Storage by those otherwise familiar with the minutiae of museum life stayed with me; it seems to be a measure of the depth of the museum's secrets. Even those who have dedicated the better part of their lives to serving the institution, including people in senior positions, don't know what it holds.

Storage operates as a set of fiefdoms. A collections manager like Jim Peters knows roughly the contents of their own department – though even some of that, as we have seen, might remain inexplicable – but what they know of other departments is largely a matter of conjecture. Storage assistants, curators and museum assistants have some access, but again only within a given department, and on a need-to-know basis. The sheer volume of material heritage, including human and animal corpses, present in Storage is such that, even with access, it would be impossible to get to know its contents comprehensively. Even the Security personnel who patrol every corridor of the museum only pass along the periphery of Storage and, from what I gather, they are reluctant to go any further in than they have to.

In one storied corner of the building's basement, we find a restricted access brick store that was once favoured by spectres. It's a dank

and chilly room, filled with Mesopotamian clay bricks bearing cuneiform inscriptions – hundreds of them – spanning the dynastic eras. For decades, the brick store was in a state of abject disarray, and it was felt to be a place of disharmony.

In the late 1990s, a cuneiform specialist named Christopher Walker decided that the state of the brick store was disgraceful and that it had to be sorted out. A museum assistant was recruited to help with the task; notably, this young woman self-identified as being psychic. As she later told colleagues, she felt an aura of cold air when she got near the brick store, and would go no further, convinced that there was "a presence" there.

Her colleagues joked with her and tried to demonstrate that it was safe, but she wouldn't hear of it. "She wouldn't go in this brick store for love nor money," one recalled, surprised by her unswerving conviction. "Because she said there was something in there."

A few years later, a staff Christmas party was thrown in the Syrian sculpture room downstairs. Christmas parties are regarded by some as an opportunity to close out the year with their close friends and by others as a chore. For the latter, free booze helps to facilitate a lengthy appearance. Most years, everyone can be counted on to hang around until 10pm, when the night shift begins. Only on the occasion of this particular Christmas party, "far before the drink had run out, which is of course the telling matter, a high proportion of the staff were no longer to be seen". The revellers who remained thought little of it, and finished the catering and alcohol before staggering off into the cold night air.

All the while, a handpicked group of people had splintered off from the designated Christmas festivities and held a seance in order to find out who was in the brick store. It was claimed by those in

attendance that the ghost in the brick store was a former curator, who had died leaving behind a backlog of material that had never been registered.

Each curator I spoke with at the British Museum knows all too well the nagging feeling that comes along with a backlog of un-accessioned items. As one put it, it's considered the highest crime "if you have material in the collection which hasn't got numbers on it", but some find that the backlog they've inherited upon taking the job is insurmountable. While this shame is familiar to all curators, most know it only in passing, and few die with the matter left unresolved. According to those present at the seance, this curator died with an uncomfortable margin of uncatalogued material, and was therefore troubled and unable to leave the brick store.

The seance was conducted by a man called Greene. Once he succeeded in summoning the curator, and pinpointing the wellspring of their discontent, someone currently working in the same department as the departed stepped forward, declaring to the ghost that the cataloguing of these items had been completed. "It's been dealt with. Go on to your eternal rest." With that assurance given, the attendees of the seance left the museum, into the biting cold of night, each to their own terrestrial places of rest.

A consensus formed among everyone present at the seance in the brick store: they had managed to establish contact with the ghost, the ghost was a former curator, the ghost was stuck on account of a backlog of un-registered artefacts, and by reassuring the former curator that everything had been catalogued, the matter was resolved. The curator was free from the chilly stagnancy of their cell in the cuneiform brick store. Those assembled were amused and astounded at what transpired and the fact that they all agreed on the above points.

There are a few who stayed behind, unaware that their earthly life had come to an end, still watching the clock on the wall, waiting for their shift to finish. There are those for whom after hours and the afterlife run together: they circle round, in an interminable late night at the museum, where work seems to be neverending. The fallout from recent suspected thefts adds another dimension to the story of the seance at the brick store – what if the curator was stuck not just because of the items "that haven't got numbers on them", but because they saw the institution to which they had devoted their life slowly sinking under the weight of the unnumbered items that it had stockpiled indiscriminately for centuries, and which now threatened to overtake its orderly façade. Perhaps from beyond the grave the curator could see that this carelessness would be the museum's undoing – that the artefacts "that haven't got numbers on them" add up.

I did end up attending the British Museum's staff Christmas party in 2019 as a guest. Cartoonish pools of white felt approximating snow covered the floor of the Great Court, foregrounding Neolithic stones of speckled grey foam. Disco lights splashed the artefacts as a cover band churned out the hits. The only tune I recall specifically is Dolly Parton's "9 to 5", which got a rousing response on the dance floor. I felt like the guest of honour when I saw the "Early Americas Menu" complete with "North Carolina Buttermilk Fried Chicken" and "Cherokee Corn Fritters". My great-grandmother's fried chicken sets an impossibly high standard – in her day, chicken was fried in bacon grease, and it was a delicacy, not yet associated with fast food. The fritters weren't half bad, though I can't say how Cherokeean they were.

I staggered home, and wondered as I drifted off to sleep whether there had been a seance held in the basement below, hoping only that if so, everyone found their way safely home.

The curator in the brick store is not the only member of staff to dutifully carry on with their work in the museum well into the afterlife. The following story was told by Sam Moonshadow who worked as a curator at the British Museum for 23 years across three different departments, and who is herself endowed with great psychic sensitivity. Moonshadow told of one widely reported ex-colleague: "Many years ago, there was a man with a green baize apron who was frequently seen in one of the archival basements."

Moonshadow said she often felt that she was being touched very lightly, and then caught a glimpse of him. She'd descend into the basement, passing through a room full of scribes busy working at old-fashioned architectural drafting tables. "And out of the corner of your eye, you'd catch a glimpse of this guy with this green apron. Obviously he still thought he was working there."

The basement is a closed chamber. It receives neither the foot traffic nor the chatter of the public, no fresh air and no sunlight. There is no indication of night or day. Perhaps, in such a space, old presences can linger for decades or centuries; in an underground city of closed circuits and dead ends, a spirit might find itself stuck in a storeroom-shaped loop.

That said, the basement is not necessarily a quiet or neglected space, as Moonshadow pointed out: "I think the basement had so much life, had so much going on over the years. You know, the under-members of staff, the scribes, the stonemasons, the servants,

trainees . . ." Stretching back to the days of Montagu House, when the museum was the home of a wealthy family, "There must have been servants bringing up coal, you know, working in the basement . . ."

Just then, as she was immersed in contemplation of the basement's many lives, Moonshadow was brought back to an incident relayed to her by a member of Overnight Security decades ago. This warder was patrolling the basements alone, using a torch to light his way, scanning the shadowy catacombs as he went.

"There was a sort of gated area that was locked, and he swung the torch light round, you know, literally just to check, to make sure – yeah, that's fine, that's fine . . . Nothing there." Moonshadow said that usually, once the warder had confirmed that everything was as it should be and that the gate was locked, he'd be on his way.

"He swung the torch around, and he said it was as if there was someone on the other side, desperately, desperately trying to get out, and rattling, and rattling, and *rattling* the cage." He could clearly see the gate in a riotous shaking fit, and could just as clearly gauge that there was no one standing behind it. "This guy was a big guy." Moonshadow wanted me to understand that he wasn't the type to get spooked at the sight of his own shadow. "He legged it. He was *absolutely petrified*."

There is a lot to hear in the telling of these stories. That is, in how they're told. As the warder begins strolling down the concrete corridor, the gate is a gate. Once it's rattled by the unseen presence, it's referred to as a cage. In a telling linguistic slip, a gate keeps others out, whereas a cage keeps the caged in. In its desperate shaking, the gate signalled that it was a cage. The warder didn't understand the rattling as the work of a trespasser, which he would've been prepared to deal with, but an invisible captive, whose rattling didn't warrant further looking into, only blind horror.

Who could have been rattling the gate? The possibilities are incalculable. The basement gates act as a cage to untold multitudes. Storage at the British Museum is neither a home, nor a place of rest for many of the relics and human bodies entombed therein; perhaps it should be seen more like a holding cell, an imperial-era detention centre still processing and imprisoning millions of ancient beings and lost gods who desperately want out. Desperate rattling is a probable rhythm down there; the tremors of an unfreedom felt in the afterlife.

At the pub one evening I sat with an anonymous former Storage worker. I was particularly interested in their experience of handling human remains: my interlocutor dealt with them on a daily basis, and I wanted to know more about the intimacy that develops from being in close proximity to physical remains of the dead, the familiarity that results from handling them, and returning them to their holding position on the shelves. We discussed methods of mummification, and the conventions of preserving and ornamenting mummies in Ancient Egypt, but as a counterpoint to the mummies, with their carefully furnished ritual burials, my interlocutor noted, "we also had to deal with . . . not-so-pretty human remains. When they excavated Sudan, they just ran off with anything they could find."

After my companion had been several years on the job, there was a flood in Storage. Leaks are common enough. The River Fleet runs through the basement, channelled through two robust, industrial-strength steel pipes. The Fleet corridor boxes in the river-carrying pipes that cut through the basement and the warders check it for

leaks when on the rounds. Other, lesser water pipes are a regular cause for concern.

The flood was in a section of the basement where all the boxes of human remains from Sudan were stored. A small team was sent in to salvage them. Old, dusty boxes of thin, bowed cardboard, split at the corners and tied up with parched strings, already falling to bits, had been worked into a pulp of floodwater, disintegrated human bone, dust and dirt.

Viewing this incident through the lens of the British Museum's official literature on human remains – which is as thick as a phone book and essentially asks us to understand them not as objects, but as people, people who can teach us – what would these Sudanese people tell us about the flood they endured in the museum? What would they tell us about the feeling of their bones being turned to mush in the basement, some after a lifetime spent under British colonial administration? Do they understand themselves as prisoners of war? It's not unheard of for corpses or even body parts to figure in prisoner swaps – the return of war dead has long been an accepted part of normalising relations after a season of conflict – but what do the British want with them now? Is humiliation felt in the afterlife, or do they look at the museum's machinations of domination as petty and pitiable?

In the east basement, there's still an air-raid shelter from the Second World War. Danny Barwick, who's a bit of a folklorist of the building, gave further details about it: "It's an area of the east basement that would've been very safe anyway, but it was massively reinforced, and it was loaded with gas doors on both ends because we were still terrified that Hitler was gonna use gas."

When asked if it was true that soldiers were billeted in the basement during the war, Barwick responded:

"It would certainly make sense. Before Security was what it is today, it was populated by ex-police officers; preceding them was old soldiers. We had a shooting range here, and all these guys were ex-army, and they liked to keep their iron . . ."

I found this scenario hard to fathom, where a museum basement full of human remains, a good number of whom suffered under British colonial rule during their lives, would then have to endure British military officers turned museum guards, apparently haunting them by performing target practice in a room adjacent to their museum crypt, probably after a two- or three-pint lunch.

I spoke to a former curator who had used the shooting range on a few occasions. They confirmed that it was in operation all the way up until the construction of the Great Court was underway in the early 1990s. Until that time, it was run by one of the museum's locksmiths, and was open not only to Security but to all staff. A small cache of old rifles was kept there for common use. They described it as "good fun", shooting paper bull's-eyes on their lunch break, but of course it was hazardous business: "It sort of reverberated a bit because you are underground and in an enclosed space, so you needed your ears covered, 'cause it would blow your eardrums out."

Once, while alone in a Greek and Roman sculpture store, Sam Moonshadow said she'd "had a pebble thrown at me". The stone came from the direction she was facing, with not a soul in sight. "There was nobody down there. It was physically impossible. And it didn't come from the ceiling downwards, it came from a horizontal direction. It just passed me."

"So you could see that there wasn't anyone in front of you?" I asked over the phone, visualising a pellet-like pebble flying past in a dank basement.

"Absolutely. This pebble was lobbed at me, and I remember going, 'What the hell!' . . . There was no one else down there. It was just me, and that was not for long, I can tell you! I grabbed my paperwork, my pen and my keys, and I was out of there within about a minute."

Moonshadow's colleague also had a large pebble thrown at him in the same Greek and Roman sculpture store, only he got hit in the head and, like Moonshadow, he ran from the store as fast as his feet would carry him.

It has since crossed my mind that the Greek and Roman department is the site of the alleged thefts that rocked the museum in 2023, but at the time of this conversation, Sam Moonshadow's thoughts were elsewhere. Reflecting on the incident, she wondered, "Was it mischievous? Was it malevolent? My gut feeling, don't ask me why, I sensed that, number one, it was a male presence. And number two, I did feel that they just didn't want someone down there. It was really quite as simple as that; it was 'Get the hell out.' It was like an 18th-century farmer lobbing pebbles at the rooks 'cause they're trying to eat the crops or something, you know, that kind of feeling."

This image of the farmer "lobbing pebbles at the rooks" instantly called to mind the foregrounding of the museum provided by Patsy Sorenti. On a Sunday morning in the late winter of 2020, she and I sat in the Espresso Room, a coffee shop in Holborn that's closed since the pandemic. Before setting foot inside the British Museum,

Patsy provided a psychically and historically attuned assessment of the museum grounds:

"Before the museum was built it was farmland, or marshland, and in the industrial revolution, when people came into cities to work, they had to build, and when they built, they displaced farmers and people who worked on the land, and those farmers and farmworkers became refugees, in essence. With that, you're going to get a lot of rancour. So the people who died . . . I'm not saying they died because of this, but it probably hastened their death, and they went to their deaths feeling very hard done by, you know, you've taken their lives, for *that building*."

Patsy observed that from an energetic perspective, the farmhands' feeling of resentment at working the land, of investing so much toil and nurture in it and then being run off, never really goes away. The old animosity persists. "You've got the mummy room, all that going on, and whatever's in the basement, goodness knows what's in there, also with all of that, you've got whatever the land was before the museum was built. So all of that is going to add up. You've got the ley lines, you've got the gallows, you know, just down the road."

The British Museum sits on the Bloomsbury side of the border with Holborn, a notorious site of public hangings. In 1590 a gibbet was erected at the corner of Fleet Street and Fetter Lane, and stood for 130 years. The Catholic martyr Christopher Bales was charged with being ordained overseas and coming to England to exercise his office, and was hanged on Fetter Lane for high treason in 1590. During the English Civil War some 50 years later, Member of Parliament Nathaniel Tomkins lived on Fetter Lane, down at the High Holborn end. In 1643 he was implicated in "Waller's Plot", an attempt to organise an armed uprising in an effort to secure London

as a stronghold for Charles I. Tomkins was snatched from his home and hanged in the street outside.

"Holborn and all along, from here up to Marble Arch and beyond, there were gallows," Patsy Sorenti continued, "and condemned men were taken into pubs to get drunk, and then put on the wagon again to the next pub – by the time they got to the gallows, they were falling off the wagon. That's how we get that saying, you know? Then they were hanged on the gallows."

Motioning past the window of the cafe, towards the row of shuttered shops lining the dormant high street in the sanguine Sunday-morning light, Patsy emphasised the importance of the land and its memory in understanding the restlessness at the museum's foundation.

"Here especially, in the city, at Holborn, there was a huge gallows and they came in from Middlesex, from Essex, from Hertfordshire and Kent. They would come especially to see these people hanged here. It was a day out, an absolute spectacle, you know? They'd have markets and there would be a whole circus around . . ."

With one ear tuned to Patsy, I was transported back to childhood in North Carolina, playing at the edge of the pines and magnolias where I'd later learn lynchings had taken place. White folks used to bring their whole family, and pose for photographs in high paper collars, greeting the flashbulb with smiling eyes at the trunk of a tree where a man hung lifeless, body limp and neck broken. I recognised this tradition that Patsy described: "a day out" at the gallows. I've seen it in photographs of the South I was born into and I know it from the country fields where I'd run, feeling kinetic and free as a small child, where I got visceral flashes that the soil was tainted, and something beyond sight filled me with unease. Here we were sitting at a cafe in Holborn, discussing the traditions that the

English brought with them to their North American colonies, our shared history, and I began to understand that this "day out" at the gallows was every bit as present in my childhood as it is in the Upper Egyptian galleries today. The displacement of working people and spectacles of retributive justice – making examples of hanged men as they give up the ghost before eager eyes in the public square. These are foundational pre-histories of the British Museum, which shape the hauntings people have experienced there to this very day.

Pondering the link between the gallows at Holborn and the lynchings in the Southern United States brought full circle the modes of viewing I've encountered first-hand, countless times in the Upper Egyptian gallery. Visitors are unsure of how to engage with the human remains. Some come to learn, many come because it's something to see, something they're told is of cultural value. What they see is taut skin, holding onto bones in thin, brittle strands, stinging from the already-too-many touristic eyes that came before them. You can't stand there without adding to it. The viewers get to feeling like vultures, like flies circling the vitrine. It's what the museum asks of us, to behave like a turkey buzzard. Most people don't know what to do with themselves. They might snap an obligatory photograph before taking a step back, hoping perhaps to make sense of the encounter once they've left the building.

As we've seen, the British Museum's Storage is not only located under the museum itself: there are several satellite stores in the capital, including the one on Orsman Road. I once approached the elderly gentleman working Security at the storage facility's front entrance. I was a bit underdressed in cut-off denim shorts, with a skateboard tucked under my arm. He kept his distance and tried

to shoo me away, as if I had the wrong address. I waved him over to explain why I was there. When I asked him about staff's experiences of ghosts at Orsman Road, he stared right through me and said, "They've all gone on . . ."

I knew what he meant, but had to be sure. "You mean they're all either dead or don't work here anymore?"

He nodded, stare unbroken, and closed the glass door between us without another word.

I met a Storage assistant who worked with the African collections at the Stag's Head. It was a weekday afternoon. Pensioners sat in silence at the bar as the Storage worker told me that they were planning to leave the museum. They found the atmosphere oppressive and couldn't take it much longer. As for hauntings, they mentioned an office poltergeist and an inexplicably rattling door on the fourth floor that served as "a reminder of who I'm sharing the space with". They also expressed frustration that some objects with particularly traumatic histories are being hidden away in the Haggerston building.

The details of their workplace hauntings were almost too mundane to discuss in depth, when there were other sources of terror and revulsion in plain sight. "This isn't a ghost story, but the slave stocks make me want to throw up," the worker volunteered. Slave stocks are free-standing architectural modules used as restraints and torture devices during the Transatlantic Slave Trade. They're made of thick, heavy wooden panels, with half-circles carved out of their slats, forming full circles when joined, much like guillotines, only here the head, hands and sometimes feet of the enslaved were held in position while they were transported, sold or attacked.

"I felt really annoyed that they were there," the Storage worker vented. "I feel really annoyed that they're a part of the collection, or that they're not on display . . . but that's just my feeling of frustration, generally, with how little is done with this collection, and with this history."

The British Museum's association with the Transatlantic Slave Trade and its legacy can be accurately described as foundational. The collections of Hans Sloane, which formed the nucleus of the museum's holdings when it was established in 1753, were financed in large part by profits made from enslaved labour. In 1695, Sloane had married Elizabeth Langley Rose, a planter's widow who maintained massive sugar plantations in Jamaica, making Sloane an absentee slave owner. He had seen the horrors of slavery up close when he served as a planter's physician, and reluctantly also as physician to the enslaved, during his famed voyage to Jamaica. In 1707, he listed the methods of punishment that he observed on the plantation:

The punishments for crimes of slaves, are usually for rebellions burning them, by nailing them down to the ground with crooked sticks and every limb, and then applying the fire by degrees from the feet and hands, burning them gradually up to the head, whereby their pains are extravagant. For crimes of a lesser nature gelding, or chopping off half of the foot with an ax. These punishments are suffered by them with great constancy. For running away they put iron rings of great weight on their ankles, or pottocks about their necks, which are iron rings with two long necks rivetted to them, or a spur in the mouth.[3]

Sloane reckoned that the torture he observed was "sometimes merited by the blacks, who are a very perverse generation of people".

This part of the museum's founding story is widely known but rarely acknowledged; the presence of slave-trade artefacts in the collections makes the link more tangible. It also raises some questions, most obviously the issue of why these slave stocks have been placed in the African collection. The stocks were part of the infrastructure of British slavery, and were deployed in colonial India too. They are more a part of British history than they are of African, in the same way that a British-manufactured musket, a slave ship or a slave trader's charter would be. Misfiling them in the African collection obfuscates who they were used by, and to what end. These are the tools that British slave traders and planters used to terrorise others, and to enrich themselves. The fact that they were part of a process that decimated and brutalised Africans and their communities does not make them in any meaningful sense African. That they remain hidden in Storage is symptomatic of the determinedly amnesiac attitude of the British to their role in the slave trade, and of the British Museum towards the crimes that are inseparable from its foundation and modes of acquisition.

The national myth is, of course, that the United Kingdom led the way in abolishing slavery, a mantra of opaque, propagandistic insistence that's deployed as a theological truth, or as a magical incantation, as if studied repetition will make it true. In reality, the British were the second biggest slave-trading nation in Europe, second only to Portugal. A conservative accounting of the number of Africans enslaved and brought to the Americas by the British between 1690 and 1807 stands at 2,943,356, though the true number is likely to be considerably higher.[4] Opposition to slavery was practised first and foremost by the enslaved, who mounted

daily acts of resistance, organised revolts and fled enslavement in the night under threat of death or worse.

If any nation can be said to have led the way in abolishing slavery, it would be Haiti. From 1791 to 1804, Haiti was transformed by an uprising of the enslaved that cast out the French and resulted in a republic that outlawed slavery and was ruled by the formerly enslaved. British forces chose to side with French planters, throwing their military weight behind efforts to suppress the uprising. Between 1795 and 1808 the British state bought 13,400 enslaved people at a cost of £925,000 to serve as soldiers.[5] Using enslaved labour in an attempt to protect systems of slavery is one measure of Britain's determined stance against abolition. Its attempts to suppress the revolution in Haiti cost Britain nearly 100,000 men, half of them dead and the other half maimed and no longer able to fight.[6]

There were, of course, broader strategic considerations at play – the British Empire was acting within the logic of a larger territorial war with France – but Britain's overriding concern was that a free Haiti would set a precedent for Jamaica and Barbados, where the British planters' grip on the reins of power was already starting to feel tenuous. These fears were realised in Jamaica on Christmas Day in 1831, which saw planters' estates burned en masse. It was only then, after its humiliating military failure in Haiti, and when Jamaica was already slipping through its fingers, that Britain became convinced of the unsustainability of the systems of slavery that it profited from, and recast its utter defeat as a change of heart. Up until then abolitionist networks in the United Kingdom had struggled to gain traction, despite growing numbers of working-class people supporting the cause.

*

If the museum is a place of public memory, Storage is a place where things are relegated to the realm of the forgotten. The slave stocks are symbolic of things that the official institutions of British culture would prefer to forget. The British Museum has misplaced these slave stocks in much the same way that the British national memory has confused its own role in the slave trade.

It dishonours the memory of the millions of people that Britain enslaved to insist that the slaver be referred to as a liberator. One wonders, has the British Museum forgotten these slave stocks, or hidden them? Or is it hiding from them? Can we be so generous as to imagine this misfiling as a clerical error, or does it point to a deeper, epistemic category error? To file the slave stocks away in the African department's Storage is a material means of compartmentalising slavery as African history, as distinct from British heritage, and banishing to a forgotten room the memory of those that the British violently restrained in the Middle Passage. Storage is the concrete, institutionally enforced reality of "out of sight, out of mind", where no one will hear your silent screams aside from the Security guards who who hurry past with no power over your fate. In Storage the museum's seal of forgetfulness is applied in ways that we may never know.

I often brushed up against this condition of collective amnesia during my years in London, when even supposedly well-educated British people would often ask about the "racial situation" in the Southern United States, as if they bore no responsibility for it. With no awareness that, at least where I'm from, it was the British whose slave ships populated the land with enslaved Africans and the British who skewed the legal system in favour of plantation owners, setting in motion the conditions we see festering today. Here the language of memory falls short. One can't forget what one

never knew. The core school curriculum in the United Kingdom still doesn't consistently or comprehensively address the centrality of the slave trade to the British Empire, choosing instead to remember the Empire's love of bestowing roads and railways, as if the British Empire were a club of globe-trotting train enthusiasts. Historian and activist Walter Rodney said it best: "All roads and railways led down to the sea. They were built to extract . . ."[7]

It may be true that we can't forget what we never knew, but equally, to think that we get to decide what to forget is a foolish vanity. Even if you're as psychic as a house brick, the haints will find a way to remind us of the unknown, to redirect our attention to a dawning necessity, or to aid in the sabotage of the unrepentant.

To the exasperation of many, including the museum worker quoted above, the British Museum hides from its own history. Still the collector's drive to bring the world into possession, to own and control history's constituent parts carries on undiminished, and so the slave stocks languish in Storage, forgotten but for the bar-room complaints of its workers.

Blythe House is another satellite storage space where a significant portion of the British Museum's collection is held. Located on Blythe Road in West Kensington, Blythe House serves as auxiliary storage not only for the British Museum, but also for the Victoria and Albert Museum and the Science Museum, though it has been sold off by the government and its storage is in the process of being disbanded.

Built at the turn of the century as the headquarters of the Post Office Savings Bank, Blythe House is a four-storey Edwardian baroque-style building with a regal clock face above its front door and bell towers looming on either side. Its frame has proven

adaptable to shifting vernaculars of power. Over the past century it's gone from a bank to a major postal sorting office to museum storage, and in each era a high volume of valuables has coursed through its corridors and storerooms under the most stringent conditions of security.

Venturing past the staff at the Security desk, through the turnstiles and swipe-card scanners, you enter into a seemingly unceasing network of identical corridors of off-white glazed bricks. Walls of archival boxes, of varying density and neatness, spill over into the hallways. If you were to get lost, you could identify each otherwise identical corridor by differing smells – plastic, alcohol, leather, tobacco, wood and some less easily placed chemical compounds, which linger in your clothes. Even if you never set foot in the storerooms overfull with crated artefacts, specimens preserved in spirits, cabinets, flat files and card catalogues, the olfactory burn notifies you that the chemical agents used in preservation are often deadly.[8]

Sam Moonshadow told me that the serial killer John Christie worked as a clerk for the Post Office Savings Bank during the mid-1940s. When it was discovered that he killed at least eight women and girls, and concealed several of their bodies inside his flat at Rillington Place in the Notting Hill district of West London, he was tried and hanged in 1953. After his hanging, women in particular felt that they were being followed around certain areas of Blythe House by a malevolent presence: the lights would go out in the loos and the atmosphere would turn very cold. It became a commonly held belief that Christie stalked certain corners of Blythe House. "There was a horrible presence there. Absolutely revolting," Moonshadow said, shivering at the thought of it.

*

Sam Moonshadow was stationed at Blythe House on an intermittent basis. From time to time, a pair of curators from her department were dispatched there to sort a backlog of potsherds: weighing, measuring and cataloguing thousands upon thousands of ceramic slivers and scraps.

Fulfilling one's duty in the interminable snowbank of potsherds was "a bit like being sent to the Siberian salt mines", Moonshadow said – not a punishment, but a shared sacrifice towards an insurmountable task that can only be chipped away at on an unending rota.

In a cavernous open room that recalls Blythe House's previous incarnation as a postal sorting office, Moonshadow and her colleague arrived at a workspace with a table that ran nearly the length of the room, and work surfaces lining the walls. They settled in, feeling that they'd finally reached their remote outpost, and were enjoying the freedom that this imparted to them, away from the interventions and requests of their colleagues, visiting researchers and the public. They switched on the radio for a bit of background music, to lend a backbeat, a sense of pacing to the mind-numbing task that lay before them. Moonshadow's potsherd-sorting partner had spent time at Blythe House before, and in the spirit of letting Sam know the lie of the land, she said, "On the next floor, we've got more storage, we've got things like huge freezers, where they would keep remains, for instance, bog body remains, that sort of thing."

"So we started sorting through, and had the radio on, and suddenly Abba came on." "Dancing Queen" came over the speakers. Sam turned to her colleague and said, "Oh my God, I love this tune. Isn't it brilliant?" At precisely that second the volume went "Whack! Turned right up, full volume."

They quickly spun around, let out a reflexive "Oh my God!",

looked at each other, and Sam's colleague led her by the arm, over to the radio. "We rushed over to turn the volume down because it was *deafening*, and we were still absolutely wide-eyed." They hurriedly discussed what the hell had just happened, but in hushed tones, as you do when you fear someone might still be listening. Her colleague put the conversation to rest by acknowledging the phantom's good intent. "Oh well, whatever's here is obviously just trying to be pleasant, and realised that we liked the music, and so they turned it up . . ."

They returned to the potsherds, to the grinding, meditative rhythm of sifting and sorting, taking in the morning radio broadcast in the salt mines. From Moonshadow's peripheral vision, something was calling out. Her attention kept being turned to the corner of the room. She'd turn her head and look, saying to herself under her breath, "No, nothing there . . ." and go back to the table of potsherds.

From that same corner that pulled at the edge of her eye, Moonshadow kept thinking she could hear a drawer opening and then shutting, and began to question whether her sanity was slipping.

"Out of the corner of my eye I kept thinking, 'I can see a dark figure.' But small, a small woman. She brought to mind my late nan, you know, just sort of diminutive, a tiny little woman. And I kept thinking, 'I'm going nuts. I'm seeing things.'" After about two hours of her attention being continually drawn to this corner, where the shadow of a little old lady was manipulating the drawer, she said to her colleague, "I'm sorry. Do you know what? I'm seeing things. It's driving me nuts. I keep thinking I can see . . ." At which point her colleague looked up from the table and said, "A figure in the corner?" They turned to each other again and shared a clipped, nervous laugh.

"Yes!" Moonshadow let out, feeling somewhat vindicated that it wasn't just her mind playing tricks. Her colleague said, "Can you hear that drawer going?" To which Sam responded with further relief, "Oh my God, I'm so glad it's not just me . . ." They looked at each other, went over to the corner and opened and shut the drawer a few times. It was the same sound. They turned to each other again, laughing nervously, the colleague saying, "Oh, it's not a problem, she's not causing us any harm."

A few hours passed, then Moonshadow's colleague said, "Hon, we've got to go and get something from upstairs . . . I'll take the opportunity to show you the area while we're there." Sam agreed, on the condition that her colleague stay near at all times. They ascended the stairs to the floor directly above, which led into another vast, open workspace. Her colleague pointed out the freezer full of bog body remains. Just then, they began to hear the filing cabinets opening and being slammed shut.

"What is that? Did you hear that?" Sam asked.

This time her colleague frowned over the caterwauling of the sliding and slamming cabinet doors, looking quite concerned. "Yeah, I did."

The colleague shouted out, "Hello, hello! Anybody up here?" There was no reply. They hoped in vain that maybe it was a senior member of staff, or to see the face of one of the older Security guards who had greeted them as they entered. They searched the floor back to front, and no one was there.

The sound of the filing-cabinet drawers is applied with a measure of aggression – as an aural irritant, a provocation, a forceful sign that others are occupying the space. Imagine having lived in Neolithic

times, being mummified over millennia in a shallow swamp among songbirds and amphibia, and then ending up in a refrigerator in West Kensington. Hearing the slamming of that refrigerator door must have been like hearing a jail cell slam shut. It may be that the slamming of drawers is thrown back in protest at the captors who circulate, as if to say, "You're not the only one who can slam a door closed." This is a message held close at the end of the day, as each interior door of Blythe House mercifully acquiesces, granting the museum worker safe passage home.

In May 2020, a curator who had worked at the British Museum for decades contacted me. They contributed several ghost stories to this collection; however, the information they felt the most urgent need to share was not a ghost story, but an insight into the secret contents of Storage.

Decades ago, they found themselves in a dark corner of the Ancient Near East department's underground Storage.[†] They were catching up with a senior colleague when they noticed a roughly hewn, unfamiliar stone slab laid out on the floor. They asked their colleague what it was, and were informed that it was a step from the Pool of Siloam.

The Pool of Siloam is a pool cut from the rock of the first city of Jerusalem, on the southern slope of Wadi Hilweh, fed by the Spring of Gihon; it is thought to have been constructed during the reign of Hezekiah at the end of the 7th century BC. In Jewish tradition, during annual pilgrimages worshippers ascended by foot

† This department has since been renamed the Department of the Middle East.

from the north side of the Pool of Siloam to the Temple Mount to leave offerings. In ancient Jerusalem, its healing waters were known to cure minor ailments as well as those suffering from leprosy. It was still being used in the time of Christ; in the gospel of John,[†] Jesus sends a blind man to be healed in its waters.

> He spat on the ground, and made clay of the spittle, and he anointed the eyes of the blind man with the clay, And said unto him, Go, wash in the pool of Siloam. He went his way therefore, and washed, and came seeing.

The Pool of Siloam and the 5th-century church that stood next to it were extensively excavated by British archaeological teams from the Palestine Exploration Fund in the 1890s, a group whose patron was the Crown. The PEF was founded in 1865 as a Victorian learned society. Despite its assertions that it was not a religious society, clergymen dominated the list of patrons, and early on it was described as a "Society for Exploring the Holy Land for Biblical Illustration".[9] The Archbishop of York chaired the first meeting, and the society was promoted in a sermon by the Dean of Westminster.

Archaeologists and engineers within the PEF's ranks began surveying the topography of Palestine. But the country they wished to explore was an imagined geography, centred around the idea of the "Holy Land", a biblified, orientalised Palestine of British invention. Palestinians were largely othered and treated as a living residue of ancient times, seen almost as if they were artefacts themselves.[10]

† Chapter 9, verses 6–7.

From its inception, the PEF demonstrated a Victorian sense of imperial ownership over Palestine, as reflected in the words of the Archbishop of York who, at that first meeting in 1865, declared, "This country of Palestine belongs to you and me, it is essentially ours."[11] Its patrons and membership came from a narrow, upper- and middle-class section of British society, with strong ties to the military. As time wore on, ethnographic studies executed by the PEF crept into the gathering of military intelligence.

In the introduction of the PEF's Quarterly Statement for 1897, archaeologist Sir Charles Wilson greeted subscribers with news of a historic find:

> The principal feature in this year's excavations has been the determination of the dimensions of the true Pool of Siloam, and the discovery of the church built, or perhaps only rebuilt, by the Empress Eudocia, on its north side. Here we have, without doubt, the pool mentioned in the Bible, and it is to be hoped that the site may be purchased and the whole pool thoroughly cleared out and restored to its original condition as far as this may be possible.
>
> Next in interest is the paved street with steps, which is apparently that by which Antoninus descended to Siloam.[12]

The Palestine Exploration Fund's proprietary aims were soon realised in the British administration of Palestine, laying the groundwork for the dispossession and calamitous conflict which continue into the present. An aside in the same Quarterly Update makes light of the PEF's excavation of contested land:

A touch of comedy has been added to our relations with the landowners by a grim Siloam lady, who lays claim to a large part of the territory in which we have been excavating, and who declares the owner with whom we have negotiated to be a usurper. She appears periodically on a Monday morning and tries to stop the work, sometimes going to the extent of threatening to throw herself down the shafts. The transfer of a silver coin, however, temporarily appeases her.[13]

"I just found it quite astonishing that it wasn't on display," the curator told me. "It struck me as something that people all over the world would want to come and see."

Having been raised in a religious household, my interlocutor found it unconscionable that this particular relic sat uncared for, in darkness on the cold basement floor. When they asked why the step has never been made available for public viewing, their colleague was casually dismissive: "Can you imagine the religious nutters, the fanatics, we'd attract if we ever put that on display?"

This response is indicative of the prevailing curatorial culture behind the scenes at the British Museum. As this former curator explained, " 'We don't want anything to do with religion,' you know, 'We are a scientific, artistic body who doesn't want to get involved with the spiritual side.' They weren't really interested – if it was to do with a religious belief rather than a scientific basis, it was not to be encouraged. That's the general gist."

*

The discourse around contested objects generally operates within a frame of challenging the ethical and legal right of the museum to store and display material heritage that was stolen or questionably obtained, or which qualifies as the inalienable cultural property of the community of origin. The disclosure of the Siloam step summons a different register of questioning. What right does the British Museum have to suppress the existence of this object in its collection, an object which would be understood as holy by millions of people? What right do they have to decide that no one needs to know it exists?

The Pool of Siloam was rediscovered in 2004 during excavations made in the course of improving Jerusalem's sewer system, and brought considerable worldwide media attention. The incident in the British Museum's basement had taken place decades earlier, and it was clear back then that the step had already been in the museum's possession for a very long time. Was its presence there withheld out of a bias against objects that embody a spiritual rather than an artistic value, as the curator had observed? Or is it that the British Museum could not explain how such an object came into their possession without calling attention to their methods of acquisition? The excavations of the Palestine Exploration Fund certainly involved removing objects, as their publicly available records attest; did the step from the Pool of Siloam arrive in the British Museum following their excavations?

Of course this is not the only object of inestimable value to have been hidden away in the British Museum's basement. The same curator told me that when rifling through cabinets in Storage they once came upon "a huge chunk of beautifully honed crystal", roughly the size of a fist. "It was in a Victorian box. A cardboard box with an old decaying label, the label said it was from part of a

throne found in Babylon . . . And yes, I did show it to somebody quite senior, I won't say who, and he just said, 'Oh, we don't want that kind of controversy.' "

These two extraordinary relics, whatever exactly they might be, offer but a glimpse of all that is unaccounted for in the British Museum's storage spaces. As a matter of policy the museum has long resisted calls for external oversight of their holdings; the intentional result is that no one really knows the totality of what it holds, and no one knows how much is hidden away in its depths.

EPILOGUE

England recedes. The forked white gull
screeches, circling back.
Even the birds are pulled back by their orbit,
even mercy has its magnetic field.
Derek Walcott, *The Fortunate Traveller*[1]

I never did much care for museums.

The colonial museum presents us not with a carefully ordered cross-section of history, nor does it recreate a natural order. The colonial museum is a material embodiment of profound disorder, our shared world torn limb from limb, for all to see.[2]

The sins of the father visit the child when the child visits the museum. How do you teach children that stealing is wrong, and then send them on school trips to the British Museum? The British Museum is one of the most visible outposts of what remains of the British Empire. It teaches us little about empire. It boasts of empire with its very being, and no wall text has yet managed to mitigate that. What then does it mean to claim loot as heritage? What exactly does one inherit in claiming corpses and other sacred beings harvested from British-engineered catastrophes as heritage? How long will this toilsome dance go on, where the national museum shows off proof of crimes that the nation has yet to admit to?

If the Neolithic stone circles at Stonehenge and Avebury were sawn in pieces and split between Rome and Copenhagen, whose people felt entitled to keepsakes from the periods when they occupied England, if these shards of Neolithic stones were kept indoors and positioned without any regard for their role in solstice rites, many English people would feel deprived of their heritage, and rightly so. If Edward III was dug up from Westminster Abbey and laid out in the Cairo Museum, some might be heard to ask, do these people have no shame?

The British Museum is not only a black hole, cradling a centrifugal whirlwind swirling with spirits mournful and aggrieved, homesick and playful, holy and ungrounded. It is a black hole with a morgue and a shooting range, it's an orphanage and a makeshift place of worship, a travelling circus with engine troubles, and a chor bazaar – a thieves' market of restless presences estranged and entangled, with a weekly prisoners' singing group that strains to shake the walls. It's a colonial-era experiment that has outstayed its time, yet gone nowhere. The colonial museum has lingered too long and become an unfortunate ghost, a relic of an earlier time.

The British Museum may not yet realise that it's passed, that the world outside has changed. "They've all gone on . . ." I hear the voice of the old Orsman Road Security guard with the thick glasses. He's telling me it's time. This time I remember to turn away before the glass doors close.

It's been a long, long night – several years long inside the museum's orbit. The ghosts are giving me up. Hallelujah, it's done. I stumble out towards the front steps. Sunlight beckons. Or damp, patchy asphalt. It doesn't matter. To leave the museum is to rejoin

the world of the living. One foot in front of the other as I descend the steps. Over a century ago, Lady Beatrice Gascoyne-Cecil broke her leg on the way out after mocking the priestess of Amen-Ra.[3] Couldn't be me. I've been too long with the dead and the stranded. I bid them farewell and promise to tell what I've learned, as best I can. What time is it? I need a pint, to celebrate making it out alive and unmolested, to calm my nerves after a long season of visiting with the ghosts of the British Museum.

AFTERWORD

Dry Bones in that valley got up and took a little walk
The deaf could hear and the dumb could talk
I saw the light from heaven shining all around
I saw the light come shining, I saw that light come down.
Paul prayed in prison, them prison walls fell down
The prison keeper shouted, "Redeeming Love I've found.
I saw the light from heaven shining all around
I saw the light come shining, I saw that light come down."
from "Dry Bones", a traditional song found in North Carolina[1]

It started in the pub, but once I fell down that hole, it led down so many winding side streets that I lost count. In cluttered, paper-strewn offices and yet more pubs, on long-distance phone calls and email correspondences and over direct messages, receiving secret knowledge of the museum. The stories just kept coming. I met every rung of worker shy of the director, not that I was courting the bosses. I learned early on to keep my distance from the museum.

There was the time someone from the British Museum's press department cornered me at Café Oto in East London, at a performance by The Sun Ra Arkestra. She had just returned from working on an exhibition at the Cairo Museum, for which they'd licensed some of Sun Ra's music. Sun Ra was an African-American born in Alabama, a jazz composer and theologian who claimed both Saturn and Ancient Egypt as home. When I let on that

I was collecting stories of ghosts in the British Museum, her body language shifted. She became tense and alert, sizing up whether or not I was a threat. "Is the project official or unofficial?" she asked. When I smilingly assured her it was unofficial, meaning that I'm not partnered with the museum, she tried to either threaten me or to make me an offer, one can't be too sure with these folks.

"Oh, then we really must bring you into the fold. We can't have the employees concerned about whether or not it's OK to talk to you . . . Unless you want to make a scandal, in which case we'll have to manage it."

I leaned in, aiming to be heard over the buzzing pre-gig chatter. "That's what I'm worried about," I smiled. "I don't want you to manage it."

As the musicians took their places, she handed me her business card and insisted I get in touch, suggesting that perhaps we could do a podcast. I nodded and thanked her, making space for the music to begin.

The Arkestra might typically begin a set with a swinging rendition of Billy Strayhorn's "Take the 'A' Train" as they dance towards the stage from Oto's kitchen, trombones jutting and trumpets ringing. Or they might ease us in with a crepuscular chorus of warbler-like flutes, over beds of bells and synths. That night was different – the music was furious from the opening bars. Every instrument screeched, howled, stomped, mashed, clanged and wailed. About two minutes in, my new friend from the British Museum was gone. I glanced at the double doors as she pushed her way out. I smiled to myself – the situation read clearly enough: she had tried to compromise the project and was promptly chased out of the room by Sun Ra's band. I was to continue working from the outside.

*

Another afternoon early on, I was still approaching random warders on the museum floor, asking if they'd ever had any experiences of ghosts in the course of their work. Soon enough, a group of ten or so Security personnel formed around me, not a familiar face among them, saying that they heard I'd been asking questions about the museum's engineering. I told them that I don't know a thing about engineering, that I was asking about ghosts, and suggested they get back on their radios to confirm.

"Ghosts? You've come to the right place, mate," said a portly old timer with a wide, unconcealed grin. He knew.

The warders radioed back through routine crackle that indeed I was only asking about ghost stories, and the ring of Security personnel that had formed around me relaxed.

A Security supervisor stepped in and explained that he couldn't have me distracting the warders, and that if he could get permission from the higher-ups, I could interview staff when they were off duty. As he spoke, I already knew that there was little the museum could offer me in terms of access. Since it increasingly relies on staff outsourced from agencies under zero-hours contracts, the old timers, those with years of experience and detailed knowledge of the museum's internal folklore, have either moved on, or find it laughable that after decades of service they should feel threatened for telling ghost stories.

Later on the museum drafted a contract, delivered through liaisons in the press office. The contract offered me access to staff in exchange for all manner of editorial control. It read as a pretext to shut the project down. I ran the contract by a lawyer friend who confirmed that I shouldn't sign it, and so I walked away.

*

The museum is big enough to come and go undetected, so I continued my work without anyone's permission, but sooner or later you get to feeling like a ghost. Too much time at the margins is dangerous, and it had been years since I fell down that hole. After the project got some coverage in the press, a senior member of staff came forward and informed me that I wasn't the first to endeavour to collect the internal lore of hauntings at the British Museum.

"I can't remember why I approached the directorate," they wondered aloud, "either to get more information from them, or to run it by them that it was OK. In no uncertain terms, they told me I was not to do this. I was absolutely not allowed to publish anything to do with ghosts in the museum because it was not the kind of thing that they wanted their name associated with. In no uncertain terms they absolutely forbade me. I then heard that a couple of other members of staff had tried to write books on ghosts in the British Museum and they were told the same thing."

The British Empire sought to extract much of the Earth's resources via violence and forced labour, crushing communities into subjugation and then daring to put the spoils on display at the British Museum, as opulent and obscene a trophy case as this world has ever seen, all the while hoping that the ghosts risen in their wake would never follow them home. Or perhaps luring the ghosts back to London was the plan all along.

"When you start at the museum, you do loads of different training courses that are required," according to a museum worker who attended an orientation session in 2018. "Most of them are super practical, to do with health and safety, or data protection, or fire-safety awareness. But one of them is the induction to generally

working at the British Museum, and someone comes from every department and talks to you, someone from senior management comes and does a presentation, and in this case it was the director who people refer to as Hartwig. He gave a really long presentation about the history of the museum, and at the end of it, he mentioned the spirits in the building. He mentioned the fact that 'We're here because of the spirits.'

"I just remember being really struck by that, because it was the first time anyone had brought it up in my experience of working at the museum, one of the only times. I just really, really didn't expect it to come from the director. He was framing the presentation as, what is our role? Like welcome to the British Museum, this is what you're a part of, this is the legacy that you're a part of and this is what you're trying to curate, because curate just means 'look after', for the future. He acknowledged they're there. He used the word 'spirit'."

Hartwig Fischer, the former director in question, made this claim in the course of an induction as if presiding over an initiation into a cultic order. It's not only that artefacts are being held in the British Museum's collections in contravention of the will of their communities of origin but, by Fischer's telling, and as evidenced in these stories, ancestral spirits, inseparable from those artefacts, are being held there too. To what end?

The abundance of restless spirits in the museum may not be a side effect of amassing collections, as I'd originally thought, but the museum's *raison d'être*, as the directorate told his employees. What precisely Fischer meant is unclear. Statements like this are often heard as paternalistic – implying that the communities to whom these beings belong don't have the tools to care for them, or don't know how.[2]

*

After all of this, some may protest that they don't believe in ghosts or spirits. I can only offer that a lack of belief offers no protection from reality.

Since Fischer's 2023 resignation following the news of possible insider theft, the museum's leadership structure has been thrown into turmoil, and its caretaking and security practices have been shown to be disastrously inadequate. Mark Jones was appointed interim director, but at the time of writing it's unclear how long this interim will last, and who will go on to play prison keeper to the house of spirits in days ahead.

What is clear is that the mountains of unaccessioned items under the museum, of unprocessed and unsecured loot, have corroded it from the inside. In 2002, Peter Higgs, the very man currently under suspicion of involvement in the disappearance of thousands of artefacts from the museum's collections, told an undercover reporter, "It's chaos down here."[3] The chaos of but one storeroom has seeded and spilled over into an international scandal that threatens the museum's future.

Prior to its admission that it had lost thousands of irreplaceable items, the British Museum was preparing for a fund-raising campaign to finance a refurbishment of its nearly 300-year-old building, and a new off-site storage facility, at a combined cost of well over a billion pounds. To properly catalogue the museum's backlog of loose artefacts – a prerequisite for the re-establishment of trust needed for any serious fund-raising effort, will require years to complete.

Or they could open up Storage to representatives of the communities whose treasures they have held for too long and let the house of spirits fall. We live in a time of colonial reckoning, and a time of the reclamation of Indigenous knowledge. The British

Museum likes to pay lip service to local and Indigenous perspectives on their holdings, right up until the point when it's made clear that an article of material heritage is by no means reducible to an "object", that they are ancestral beings, deities or entities for whom there is no name or equivalent category outside of their host communities, and that they have no place inside the British Museum. At that point the Indigenous perspective is condescendingly cast as cute, fantastical or unevolved.

The spectra of the museum reach for home and for wholeness, as plants reach for light, as we all do. For even a fraction of the sacred structures of the world to be made whole again, the colonial museum must be dismantled. There's no two ways about it. There is more to be gained in letting the house of spirits fall than in building a new prison. The colonial museum is itself a colonial-era relic, a cursed object, unfit for sacred presences. It's a ghost of a bygone world that's afraid to admit the reality of its passing, a ghost that deserves to be put to rest.

ACKNOWLEDGEMENTS

Thanks foremost to the current and former museum workers, researchers and others who contributed testimony to this book. I'd like to thank Francis Gooding who was my partner on this project in the early days. Thanks to my literary agent Zoe Ross and her assistant Olivia Davies at United Agents, to the Editor of this book Jake Lingwood and Managing Editor Sybella Stephens, and all the staff at Monoray and Octopus Publishing. Thanks to Hendrik Wittkopf, for contributing the illustrations.

I'd like to thank all those whom I collaborated with, and those who supported *Ghosts of the British Museum* as it evolved: Maziar Afrassiabi at Rib Exhibition space in Rotterdam; Tamsin Clarke at Tenderbooks in London; petals and Burning House Press; Killian Fox whose *Economist 1843 Magazine* article "Are ghosts haunting the British Museum?" brought this work to the attention of many; Lucy Cotter for her work on "The Entangled Museum" with the folks at *Mousse* magazine; Fourteen30 Contemporary and with Oregon Contemporary in Portland; Sam Basu and Elizabeth Murray at Treignac Projet; Nora Razian at Art Jameel in Dubai; the whole team at SAVVY Contemporary in Berlin, and Eugene Yiu Nam Cheung at Decolonial Hacker. Thanks to the many punters who came along on the walking tours of the British Museum that I led from autumn 2018 until early 2020. Thanks also to the Southern Folklife Collection at UNC Chapel Hill, who provided me with a research opportunity that furthered this work in a roundabout way.

Thanks to Allison Devereux for publishing advice. I am grateful to Christy Hyman for our visit to the Great Dismal Swamp, and to Chloe Emmott for her generous insights into the Palestine Exploration Fund. To James Moss for informal legal counsel, and Dan Lowe for his insights into the British occult world. To the people I spent my days and nights with as a museum worker at the Philips Collection in Washington DC, I've often thought of you while drafting this book.

To those whose conversation and close readings helped to shape this work once I finally sat down to write: Nilo, Simina Neagu, Nikolaus Perneczky, Jacob Lee Neal – the best storyteller I know, Ginger, Satch Hoyt, David Thorpe, Laura Arena and Ashoka Mukpo.

To teachers and friends I remember as teachers: Miss Lee at Hope Valley elementary who read ghost stories at nap time that had me too scared to sleep, and Miss Shields who taught English at Jordan High School in Durham, to Pam Griffin at North Carolina School of the Arts. To Pat Mckinley, Akinde Ayodeji, Ryan Ogilvy, DT, Ball, Jon G, Jason Osborne, Sam Roberts, Sky Ferren, Joe Mills, Bernard Welt, Thomas Bowden, Kendall Buster, Matthew Young and Kavitha Rajagopalan, Andrea Pollan and Jeff Spaulding, Kristin Hileman, Nokwenza Plaatjies and Shabaka Jones, Carl Slater, Henrike Donner, Susan Trangmar, Ingrid Pollard, Helen Kaplinsky, Shahin Afrassiabi, Ramzi Saouma, Cathrine Baglo, Christian Nyampeta, Duncan Brooker, Adam Laschinger, Kay Dickinson, Lee Grieveson, Glenn Hinson, Connie and Lisa Steadman. To the numerous others who shall not be named here, you know who you are. Thank you.

Finally, I thank my family, especially my parents, Jim and Cathy Angell, my siblings Cait and Dylan and my grandparents, Brad and Imogene Angell and Mary and Julian Butler.

ENDNOTES

Chapter 1

1. **With Hans Sloane's death in 1753** Delbourgo, James. *Collecting the World: The Life and Curiosity of Hans Sloane,* London: Penguin, 2017, p. 314.
2. **Nevertheless, not wanting to lose the collection** Caygill, Marjorie. *The Story of the British Museum.* London: British Museum Press, 1992, p. 6.

Chapter 2

1. **In the one scant, searchable trace** https://londonist.com/2005/09/suicide_attempt#disqus_thread

Chapter 3

1. **. . . a gate to hell, a hell only recently and still not wholly extinguished** In 2023, a Holocaust denier interrupted the reading of the names of those who died at Weimar. https://www.telegraph.co.uk/world-news/2023/08/26/fascism-normal-east-germany-thuringia-afd/

Chapter 4

1. **. . . the government's Department for Culture, Media and Sport** https://www.gov.uk/government/publications/the-british-museum-annual-report-and-accounts-2022-to-2023

Chapter 5

1. **"I found it face upwards . . ."** Belzoni, Giovanni. *Belzoni's Travels.* London: British Museum Press, 1820
2. **Henry Moore, Britain's pre-eminent modernist sculptor** Caygill. *The Story of the British Museum*, p. 44.

Chapter 6

1. **One warder said she's heard the sound of scratching** Candlin, Fiona. "Night Shift at the British Museum" in: *Night Shift Seminar Series.* London: Birkbeck, University of London, 2011 (unpublished) https://eprints.bbk.ac.uk/id/eprint/8372/

2. **Arbinas's tomb was also built** Michailidis, Melanie. "Empty Graves: The Tomb Towers of Northern Iran" in: Gacek, Tomasz, and Pstrusińska, Jadwiga (eds). *Proceedings of the Ninth Conference of the European Society for Central Asian Studies.* Cambridge Scholars Publishing (2009).

3. **The Greek historian Plutarch wrote** Plutarch. *The Parallel Lives, Vol. III.* Cambridge, MA and London: Loeb Classical Library, 1916.

4. **When the Caryatid was removed** St. Clair, William. *Lord Elgin and the Marbles.* Oxford: Oxford University Press, 1967.

5. **It was also said that some Greeks . . ."** *Ibid.*

6. **"It was to be regretted that the government had not restrained this act of spoliation . . ."** *Ibid.*

7. **"The Honourable Lord has taken advantage . . ."** *Ibid.*

8. **Duveen insisted the sculptures should be more white** Painter, Nell Irvin. *History of White People.* New York: W W Norton, 2011.

9. **The disgraced former director** https://www.theguardian.com/artanddesign/2019/jan/28/british-museum-chief-taking-the-parthenon-marbles-was-creative

10. **Prokopis Pavlopoulos, the former President of Greece** https://www.telegraph.co.uk/news/2019/04/15/greek-president-brands-british-museum-murky-prison-elgin-marbles/

11. **Meanwhile, those with ears to hear the caryatids' spectral cries . . .** Plutarch. *Pericles*, p. xii.

Chapter 7

1. **In 2018, Rapa Nui governor** https://edition.cnn.com/style/article/easter-island-british-museum-moai-return/index.html

2. **The African collection's place** Rodney, Walter. *How Europe Underdeveloped Africa*. London and Dar es Salaam: Bogle-L'Ouverture Publications, 1972.

3. **The gesture of pointing** Willersen, Kelly. "Collecting Souls: On Haunted Museum Objects and their Meanings." MA thesis, 2021 (unpublished).

4. **The kingdom was by all accounts extraordinary** Adébísí, Dr Folúkẹ́. "Benin Bronzes – a controversial past and present". Talk delivered at Bristol Museum, 20 May 2018.

5. **Among the Edo** *Ibid*.

6. **It took ten days of heavy fighting** Hamilton, J B. "The Evolution of the Dum-Dum Bullet." *British Medical Journal* 1, no. 1950 (1898): 1250.

7. **I wish it could be made known** Read to Thompson, 17 March 1897. National Archives FO 800/148/11, ff. 47-8. I came across this passage in Dan Hicks's *The Brutish Museums: The Benin Bronzes, Colonial Violence and Cultural Restitution*. London: Pluto Press, 2020, p. 148.

8. ***You Hide Me* leaves us** *You Hide Me*, directed by Nii Kwate Owoo, 1970. Currently available for streaming on MUBI. https://mubi.com/en/de/films/you-hide-me

9. **When we met in Berlin** For more on Satch Hoyt's work on unmuting museum collections, see his *Afro-Sonic Mapping*, Berlin: HKW/Archive Books, 2022.

10. **These objects not only contain** Transcription of the letter as shown in "Nigeria's Battle to Reclaim Looted Benin Bronzes", which aired on Channel 4 on 10 September 2021. The original programme can be viewed at: https://www.channel4.com/news/nigerias-battle-to-reclaim-looted-benin-bronzes

11. **"return of the Bronzes and Ivories . . ."** *Ibid*.

12. **When presented with formal repatriation requests** Marshall, Alex. "This Art Was Looted 123 Years Ago. Will It Ever Be Returned?" *The New York Times*, 23 January 2020. https://www.nytimes.com/2020/01/23/arts/design/benin-bronzes.html

13. **"I had once the visit of the Ooni of Ife . . ."** British Museum Events, *British Museum Youth Collective presents: Quizzing the British Museum's Director.* YouTube, 14 April 2021. https://www.youtube.com/ watch?v=0GApxVRsmLQ&t=746s&ab_channel=BritishMuseum EventsBritishMuseumEvents

Chapter 8

1. **I shall give you some farther Eminent Remark** Archdale, John. *A new description of that fertile and pleasant province of Carolina: with a brief account of its discovery, settling, and the government thereof to this time with several remarkable passages of divine providence during my time.* London: printed for John Wyatt, 1707, pp. 2–4.

2. **Now the *English* at first settling** See Isenbarger, Dennis L. *Native Americans in Early North Carolina: A Documentary History.* Office of Archives and History, North Carolina Department of Cultural Resources, Raleigh, 2013, p. 72.

3. **The Akan drum was obtained** Delbourgo. *Collecting the World,* p. 230.

4. **In 1521, Hernán Cortés** Castillo, Bernal Diaz del (trans. Cohen, J M). *The Conquest of New Spain.* London: Penguin, 1974, p. 369.

5. **Pedro de Alvarado ordered one** *Ibid,* p. 397.

6. **The burning of shrines** Crewe, Ryan Dominic. *The Mexican Mission: Indigenous Reconstruction and Mendicant Enterprise in New Spain, 1521–1600.* Published online by Cambridge University Press, 13 June 2019.

7. **When the serpent was purchased** https://issuu.com/ accpublishinggroup/docs/turquoise_issuu

8. **The museum's hunger for acquisitions** "The very strange thing about choking is that one can choke even while eating the most delicious foods out there. To diagnose the choking, one might have to look at hubris." From Ndikung, Bonaventure Soh Bejeng. *Those Who Are Dead Are Not Ever Gone.* Berlin: Archive Books, 2018.

Chapter 9

1. **The certitude that everything** Irby, James E. (translator), *Labyrinths*, New Directions, 1962
2. **"King's Library" is a holdover** Caygill. *The Story of the British Museum*
3. **I thout that they beckon'd to us** https://webarchive.nla.gov.au/awa/20110403094436/http://southseas.nla.gov.au/journals/cook/17700429.html
4. **When his superior was called to the scene** Caygill. *The Story of the British Museum*
5. **"It is useless to go into more details . . ."** Johnson, Barry C. *A British Museum Legend: The Extraordinary Death of Henry Symons Sometime Deputy Superintendent of the Reading Room.* London: 1984.
6. **"the structure of the archive is spectral"** Derrida, Jacques. "Archive Fever: A Freudian Impression", *Diacritics* vol. 25, no. 2 (Summer 1995), pp. 9–63.

Chapter 10

1. **The British reconquered Sudan** Newsinger, John. *The Blood Never Dried: A People's History of the British Empire.* London: Bookmarks Publications, 2006, p. 106.
2. **In 1889, Wallis Budge unwrapped a corpse** Budge, Ernest Wallis. "Prefactory Remarks Made on Egyptian Mummies on the Occasion of Unrolling the Mummy of Bak-Rom." London: Harrison, 1890, pp. 5–6.
3. **It's thought that Gebelein Man was killed** https://www.world-archaeology.com/world/africa/egypt/gebelein-man-stabbed-in-the-back/
4. **Upon the way home in the train** Summers, Witchcraft, p. 110.
5. **The mummy case was eventually** Ghost Club minutes, July 1900, vol. IV, 86 and 88.
6. **According to a publicly available list** "List of Human Remains in the Collection of the British Museum", version 3, updated August 2010.

https://www.britishmuseum.org/sites/default/files/2019-10/British-Museum-Human-Remains_August-2010.pdf

7. **This important collection** https://www.britishmuseum.org/our-work/departments/human-remains

Chapter 11

1. **The purpose of the attack at Maqdala** Heavens, Andrew. *The Prince and the Plunder.* Cheltenham: The History Press, 2003, p. 69.

2. **"You can't loan God to a church"** https://www.wsj.com/articles/british-museum-stolen-artifacts-elgin-marbles-tabots-benin-bronzes-6fe8ad47

3. **The punishments for crimes** Delbourgo. *Collecting the World*, p. 78.

4. **A conservative accounting** Rawley, James A, and Behrendt, Stephen D. *The Transatlantic Slave Trade.* Lincoln: University of Nebraska Press, 2005.

5. **Between 1795 and 1808** Buckley, Roger N. *Slaves in Redcoats: The British West Indies Regiments 1795–1815.* New Haven: Yale University Press, 1979, p. 55.

6. **Its attempts to suppress the revolution** Williams, Eric. *Columbus to Castro: History of the Caribbean.* London: Vintage, 1970, p. 251.

7. **"All roads and railways led down to the sea"** Walter, Rodney. *How Europe Underdeveloped Africa*, p. 400.

8. **Venturing past the staff at the Security desk** Humphreys, Laura. *A nose through Blythe House*, 29 March 2023. https://wellcomecollection.org/articles/ZBrIABQAANdrI3wU

9. **The PEF was founded in 1865** Grove, George. *Society for Exploring the Holy Land for Biblical Illustration*, 1:sup1, 1-4, 1865. DOI: 10.1179/peq.1865.1-2.023

10. **Palestinians were largely othered** Abu El-Haj, Nadia. *Facts on the Ground: Archaeological Practice and Territorial Self-Fashioning in Israeli Society.* Chicago: University of Chicago Press, 2008, p. 38.

11. **. . . the words of the Archbishop of York** Stanley, Arthur Penrhyn. "A Sermon Preached at the Church of St. Lawrence Jewry, London,

December 28th, 1867" in *Palestine Exploration Quarterly*, 1:sup1, 1-18, 1868. DOI: 10.1179/peq.1865.1-2.014

12. **The principal feature** Palestine Excavation Fund's Quarterly Statement for 1897, volume 2930 (1897–1898), p. 2. Antoninus was a 6th-century Christian pilgrim who wrote a narrative of his travels to the Holy Land.

13. **A touch of comedy** *Ibid.*, p. 25.

Epilogue

1. **England recedes** excerpt from Walcott, Derek, "The Fortunate Traveller", in *The Fortunate Traveller*. New York: Farrar, Straus & Giroux, 1982.

2. **The colonial museum** Azoulay, Ariella. *Potential History: Unlearning Imperialism*. London: Verso Books, 2019.

3. **Over a century ago** Luckhurst, Roger. *The Mummy's Curse*. Oxford: Oxford University Press, 2012, p. 33.

Afterword

1. *Dry Bones in that valley* From "Dry Bones", a traditional song found in North Carolina. This came to my attention via Bascom Lamar Lunsford's *Ballads, Banjo Tunes and Sacred Songs of Western North Carolina* (Smithsonian Folkways – SF CD 40082). This compilation was edited from his "personal memory collection" of hundreds of songs, banjo and fiddle tunes, and stories recorded in 1949 for the Library of Congress. Lunsford recorded it for Brunswick Records in 1929.

2. **The abundance of restless spirits** Marshall. "The British are very good at telling you, 'We are looking after it. If you'd been looking after it, it would have been stolen by now.'" "This Art Was Looted". https://www.nytimes.com/2020/01/23/arts/design/benin-bronzes. html

3. **"It's chaos down here"** https://www.thetimes.co.uk/article/ breakages-and-bungling-at-british-museum-3h2rjbt6g7h

INDEX

Apartments proposed for Resident Officers.

Line of the present boundary Wall.

Officer

Officer

GALLERIES PROPOSED FOR MISCELLANEOUS ANTIQUI

Great Russell Street

Entrance

Entrance Hall

The Department of Manuscripts

86–77

Manuscripts.

Rooms now used as Reading-rooms.
44–45 44–59

Room proposed for
Receiving Sorting, &c.

Proposed
for Pr

Line of the present boundary Wall.

Apartments proposed for Resident Officers.

Robᵗ Smirke, June 11ᵗʰ 1836
R.I.B.A.

C J Richardson, del.